1994

GEN 770.973 B963
Bunnell, Peter C.
Degrees of guidance :

3 0301 00083223 4

P9-ARA-209

Degrees of Guidance: Essays on Twentieth-Century American Photography brings together a selection of essays written between 1969 and 1987 by one of the foremost historians of photography at work today. Arranged roughly chronologically, the thematic and monographic essays collectively examine a variety of trends of photographic style and aesthetics, and the artists, primarily American, who developed them over an eighty-year period; they also reflect the growing acceptance of photography as an art medium – among critics, private collections, and museums – in this period. Through the study of such topics as photographic portraiture and the nature of pictorialist vision in photography, as well as his essays on such artists as Alfred Stieglitz, Walker Evans, Diane Arbus, and Jerry Uelsmann, Peter C. Bunnell effectively directs attention to the fundamental creativity, intentionality, and significance of personal expression in the work of the committed photographic artist.

DEGREES OF GUIDANCE

Degrees of Guidance

Essays on Twentieth-Century American Photography

PETER C. BUNNELL
Princeton University

CAMBRIDGE
UNIVERSITY PRESS

Published by the Press Syndicate of the University of Cambridge
The Pitt Building, Trumpington Street, Cambridge CB2 1RP
40 West 20th Street, New York, NY 10011–4211, USA
10 Stamford Road, Oakleigh, Victoria 3166, Australia

© Cambridge University Press 1993

First published 1993

Printed in the United States of America

Library of Congress Cataloging-in-Publication Data
Bunnell, Peter C.
Degrees of guidance : essays on twentieth-century American
photography / Peter C. Bunnell.
 p. cm.
Includes index.
ISBN 0–521–32751–2
1. Photography – United States. 2. Photographers – United States.
3. Photography – United States – History – 20th century. I. Title.
TR23.B86 1993
770'.973'0904–dc20 92–26464
 CIP

A catalog record for this book is available from the British Library.

ISBN 0–521–32751–2 hardback

770.973
B963

For George Heard Hamilton

College of St. Francis Library
Joliet, Illinois

150,279

CONTENTS

CONTENTS PART SIX

ILLUSTRATIONS

PREFACE

IN THE PAST forty years much has changed in photography, especially in the United States, with regard to theories of aesthetic significance and the integration of fine art photography into the mainstream of public art. It started slowly, with its beginning perhaps signaled in 1952 by the debut of *Aperture,* a journal of imagery and critical opinion. The first publication since Alfred Stieglitz's *Camera Work* of 1902 to be devoted to fostering an individualized, creative intelligence about photography as it relates to aesthetics and style, it did so without any reservations about its mission to express a belief in the medium and the self. The founders of this new journal, led by Minor White, were convinced of the correctness of their approach as well as of the need to chart this direction on their own because of the lack of a forum for discussing the art of photography. After World War II, journalistic and amateur photography were at the center of the public's mind regarding photographic endeavor. Despite this widespread prejudice, even indifference to the subject matter, these photographers and writers were convinced that an alternative approach to photography could restore the moral order of the universe, which had been agonizingly scarred by the war.

During the 1950s and 1960s only three or four institutions paid any serious attention to photography, among them, notably, the Museum of Modern Art and the George Eastman House. University art history departments, and by extension their libraries, ignored the medium's literature and history. Only the studio art departments, especially those in midwestern universities, incorporated photography into their curricula. Still more dismal was the situation abroad, where changes in attitudes took place even more slowly.

It is important to remember that from the very beginning

of photography's history there has been a desire to affiliate photographic endeavor with customary artistic notions of medium and form – particularly to ideas of structure, order, and beauty to which form is attached. Issues of quality have been the same universally. Similarly, the importance and nature of meaning have grown out of a long humanistic tradition that preceded photography's invention. The cycle of these ideas and their relevance has ebbed and flowed through the 150 years in which photography has existed. Several peaks, such as in the 1850s in France, the 1860s and 1890s in Britain, the pictorialist period at the turn of the century in the United States, and the 1920s in Germany, are clearly evident. Expressionist ideas then seemed to retreat until after World War II. Thereafter began a period of about three decades when the notion of an individual consciousness was affirmed.

There has, of course, always been a significant literature, written for, and within, the photographic community itself, that has played a fundamental role in the creation of a repertoire of technical accomplishments, pictorial qualities, and aesthetic perception within the internal tradition of the medium. This has had positive and negative features. Because at any one time the leading contributors comprised a small group, everyone knew what the whole was trying to do, and thus the culture of the group was shared and mutually understood. For instance, one senses this through the first two decades of *Aperture*'s existence. But this hermeticism also prevented infiltration of an outside perspective – breadth and variety – and it inhibited a cross-stimulation of ideas from the other arts that are essential for the advancement of any medium.

Over the past twenty years the pace of change has increased dramatically. Gradually, most general-interest and art periodicals and many newspapers printed photographic criticism and news, including business reports on investment possibilities for photographs as collectibles, auction sales, and gallery gossip. Before 1972 this was unheard of. Unfortunately, though, most scholarly journals have resisted publishing pieces on photographic history, and the field, even to this day, has had to sponsor its own specialized scholarly literature.

Institutional involvement, beginning with the Museum of Modern Art's establishment of a department of photography in 1940, has expanded internationally, especially in the past two decades. Photography has become an integral part of

nearly every museum's programs, including exhibitions and, most important, acquisitions. Associated with these developments has been the increased study of photographic practice and history in the academic world, the latter providing the historians, curators, and critics necessary to ensure this change across the institutional spectrum. My own career illustrates the considerable advances that have been made. To study creative photography and photographic history in the 1950s was to pass into a marginal world at best. When I entered graduate school in art history at Yale in 1961, I was considered very much an outsider by all but a few modernists who, as true avant-gardists, recognized that the study of the visual arts from the nineteenth century to the present would now have to include photography and photographic history if it was to have any credibility at all. By contrast, this is a common assumption today, and the program in photographic studies, as well as the history of art, at Princeton University has been based on this understanding since I founded it in 1972.

To relate this history is only to indicate how institutions and ideas evolve and change. Images will always be a critical part of one's knowledge and sense of self. These essays both reflect the concerns of the recent past and indicate the change and reappraisal of current ideas that I anticipate will occur in the not too distant future. They are, therefore, artifacts, like old photographs, related to the cultural life of their time and of other times.

During the past decade, much of the writing on photography has increasingly concentrated on the ontology of the medium, on strategies of presentation, and on the mass media connotations and connections of photographic imagery rather than on the inspired message of the individual photographer. The aim of postmodernism is to explore the dilemma of "experiencing" in a time when originality is questioned – questioned in every way, including our ability to experience life itself, and otherwise to be forced to live lives as slaves of what might be called virtual experience. For those desiring to experience the enrichment that may be gained from certain deeply moving pictorial images – that is, the enrichment that originality as an aesthetic ideal provides – the focus of any inquiry should be on the motivations behind the creation of a work, what artists are offering of themselves, and the dimension of their human understanding. The techniques of craftsmanship are only the exercises of creating, and we must never overlook the connoisseurship of authentic feeling. Art-

ists seeking to expand this understanding express the continuity of our intricate human spirit. By this reasoning, one recognizes that a photograph is not the mere depiction of things, nor their replication, but rather the representation of sensory data reflective of a state of mind, something that embodies values and that has its origin in a long and distinctive iconographic tradition. The degree to which this sense of spirit is felt within us is commensurate with the depth of expression and the authenticity of meaning in the photograph. Throughout the years that I have been writing about photography my aim has been to draw the viewer toward an understanding of the image maker's sources and the challenges of conscience and knowledge demanded in producing a work of art. I have sought to portray the artist-photographer as a seeker who explores meaningful truths and risks much in that search. In addition, when we understand the artist's personal condition we are better able to reflect on his or her statement. Throughout the period in which I wrote these essays, I was guided by Minor White, who believed that photographs can be read. In interpreting imagery in this manner, I have been drawn to the link between intentional photographic creativity and the complex interaction between the psychology and experience of the photographer and the viewer. Although this approach will not be accepted by all readers, I hope some will recognize a point of view that may serve the interpretation of photographic art in a more enduring manner than would other present-day ideologies. This surely reveals a bias on my part. Although I recognize clearly the attributes of and the reasoning in postmodernist tenets, I am not confident of their ultimate significance or reward. I still hold to the view that to create a photographic work out of deep personal need is the cardinal issue, that it is the forthrightness of the individual which is most illuminating, and that, in the end, will provide the most profound statement.

The idea that a magnificent photograph can be a poignant, rewarding, and fulfilling, even luxurious, experience has been one casualty of the current trend toward texts laden with social polemics. Instead of writers admiring the genuine, much interpretation is imposed on photographic images that is ingenious and pedestrian. I believe that the expectations of today's public have been considerably lowered by such efforts, which simply reinforce the contamination of our social environment by half-truths. The goals have become the study of problems, not people; issues, not individuals; ideologies,

not inspiration. Currently, there is little commentary on the deep satisfaction that *learning* from photographic artists can bring. The assured eye and rich insight of the visionary photographic artist are suspect in today's postmodernist environment of new authoritarianism. Those who can make something familiar look new and wonderful, so that one is surprised not to have seen its beauty previously, or to have cast it away in ignorance, are disparaged. But these sorts of artists are still working, and they are making accomplished photographs in an attempt to understand and reveal universal and essential truths. Theirs is a giving, compassionate exercise of what may now be seen as artistic freedom. I hope these essays will make it clear that the problem for each of us as a viewer is the same one every artist really faces: how high do we set our aspirations, how do we express our values, and what is the dimension of our faith? Contemporary artists in photography cannot ignore history, nor can they separate themselves from the tradition of the medium. The postmodernist embrace of political and social issues, like politics itself, is but a form of escapism from the subjective self, which is what provides our ultimate judgment in assessing human potential.

A photograph can have the significance of art if we, as an attentive audience, truly desire that it do so. We can praise a photograph in terms of its craftsmanship or innovation, but without reaching for its inner content we will not be truly rewarded. Only if we allow the artist to enter our lives with a shared trust will we be fulfilled. The emptiness of the un-shared reflects more than the vacuum of inaction; it is evidence of the shadowy loneliness of the unmeditated spirit.

This volume of essays, the first collection of my writings, consists of pieces that were addressed to a variety of audiences between 1969 and 1987. They were written for publication in periodicals, as book reviews, introductions to monographs, exhibition catalogues, or introductions to portfolios of original photographs. Two essays, "Photography as Print-making" and "Photography into Sculpture," derive from wall labels prepared for exhibitions at the Museum of Modern Art in New York, where I was curator of photography from 1966 to 1972. In preparing for publication in one volume texts written at different times and for various occasions, I did not feel justified either in removing repetitive passages or in rewriting pieces to alter the analysis or to change the contemporaneity of a concept. However, several of the pieces

have been edited slightly in order to focus attention on the central statement. Together, these twenty-nine essays represent a body of thought that reflects what I consider to be the central idea of creativity in photography – the individualized sensitivity of the photographic artist. Each essay describes a particular photographer's approach so that the reader can understand how a work was conceived and why it took the form it did.

Organized roughly chronologically, the essays chart the development of art photography in the twentieth century. The focus is almost exclusively American. The texts alternate between theme pieces and monographic essays on artists and their photographs. The volume begins with "A Photographic Vision," in which I trace the origins of modern photography and articulate my philosophy of photography as a medium of creative expression. This text, published under the same title, was the introduction to an anthology of historical writings on the pictorial movement early this century. Two studies follow on major Pictorialist photographers of the Photo-Secessionist period: Alfred Stieglitz and Clarence H. White.

One of the most challenging events within the medium in recent years has been an enormous increase in the awareness of, and monetary demand for, the photographic print. "Observations on Collecting" is concerned with this issue and, by implication, the very important role connoisseurship now plays in the consideration of photographic art. Then comes "Why Photography Now?" and "The Current Acceptance of Photography," two general essays on issues that, although important today, address concerns regarding the public reception of photographic art as discussed half a century earlier.

The next four pieces present comments on photographers whose primary subjects were people and their environments. These artists – Walker Evans, Robert Frank, Diane Arbus, and Lisette Model – worked from the 1930s through the 1970s and were particularly concerned with social issues. "Taken from Life / Photographic Portraiture," a theme piece on how portraiture in photography may be approached and understood, follows. Three essays then consider the work of Brassaï, Wright Morris, and Elliott Erwitt, whose penetration of secular affairs enlarges our sense of human customs and community.

The next selections are essays on Edward Weston, Barbara Morgan, Aaron Siskind, and Harry Callahan, whose works reflect the dominant style of art photography in the period after World War II. The Callahan text, which first appeared

in the catalogue of his exhibition that I directed for the American Pavilion at the 38th Venice Biennial in 1978, has added interest because he is only one of two photographers so honored. (The first was Diane Arbus, whose work was shown in a special exhibition soon after her death in 1971.)

In most recent reviews of the development of the department of photography at the Museum of Modern Art, particularly in the past twenty-five years, two of the exhibitions I directed there are singled out as encapsulating the dynamic and experimental period of the sixties: "Photography as Printmaking" in 1967 and "Photography into Sculpture" in 1970. The two essays reprinted here derive from these exhibitions. They were originally published in two journals that were committed to highly unusual material whose importance they perceptively and presciently recognized: *Artist's Proof,* the beautifully designed and produced annual of the Pratt Graphics Center in New York (for the printmaking piece) and *Artscanada,* a periodical unfortunately no longer published (for the sculpture piece). The third essay in this group, "Observations on Photographic Sensitivity," further extends my concern for the creative attitudes of the sixties.

The choice of artists for the final group of monographic essays reflects my involvement in the diversity of recent photographic art and also reveals my deep interest in the particular currents of contemporary photographic expression that I believe will have lasting value. All seven of these artists, Jerry N. Uelsmann, John Pfahl, Lynton Wells, Ray K. Metzker, Paul Caponigro, Emmet Gowin, and Nina Alexander, are my friends. Their work has given me great pleasure. It is not easy to write about a living artist, especially one whom you know, but I can say without reservation that, although each of these artists provided me with the data necessary to clarify and chart his or her work, I was completely free to express myself. With only one exception, the Metzker text, these essays first appeared in monograph publications of the artists' work. This circumstance increases not only the challenge to a writer but the risk for the artist involved. In supporting my endeavors, each of these individuals provided me with a degree of guidance equal to and of a kind that is revealed to all of us in their pictures.

A PHOTOGRAPHIC VISION / PICTORIAL PHOTOGRAPHY, 1889–1923

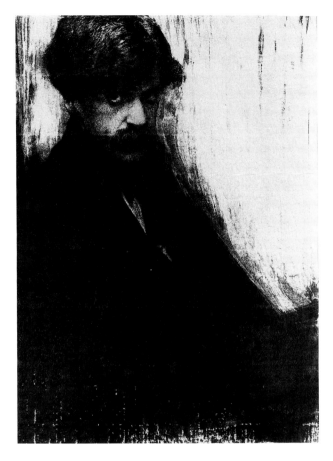

Gertrude Käsebier,
Alfred Stieglitz, 1902

WHAT DOES A photograph look like? What should a photograph look like? Although seemingly simple, upon reflection these are vexing questions and ones which underlie all thinking about photography since its inception early in the nineteenth century. The diversity of photographs and the richness of photographers' concerns are inestimable. Yet the commonly held belief is that all photographs are similar and that they derive from similar motivations. This is not true. Photography has been a medium of constant change and variety not only in terms of processes but more importantly in terms

"Introduction," *A Photographic Vision / Pictorial Photography 1889–1923* (Salt Lake City: Peregrine Smith, 1980). © by Peter C. Bunnell.

I

of the aims of its picture makers. A few years after its invention Albert Bisbee, the author of a book on daguerreotyping, stated the prevalent view of the medium as follows: "One of the greatest advantages of the Daguerreotype consists in this, that it acts with a certainty and extent, to which the powers of human faculties are perfectly incompetent. . . . Thus may scenes of the deepest interest, be transcribed and conveyed to posterity, not as they appear to the imagination of the poet or painter, but as they actually are. . . . The objects themselves are, in one sense, their own delineators, and perfect accuracy and truth [are] the result." Forty-three years later, in 1896, Bisbee's viewpoint would be opposed by that of another practitioner and author, H. P. Robinson, who, borrowing from the writer Emile Zola, stated: "Even a photograph is a piece of nature seen through the medium of a temperament." What occurred between the time of these two interpretations is not that the physicality or methodology of the medium was fundamentally altered or that the latter view superseded the former, but that by the beginning of this century photographs were being made in an infinitely more complex and pluralistic environment of ideas and actions. In Robinson's time there were those who still believed deeply in Bisbee's view, but now this belief or set of values provided the photographers with but one perspective among many through which to envision the relationship of photographs to nature.

Pictorialism is a concept which originated in the latter part of the nineteenth century as an attempt to differentiate at least one approach to photography from others. Since its origin in the work of H. P. Robinson, it has functioned under a variety of names down to the present. Until shortly after World War I, the concept was known as *Pictorialism*. Later, Alfred Stieglitz referred to it as *Camerawork*. In the twenties and thirties the German avant-garde gave it the name *The New Vision*, while in the fifties other Germans called it *Subjektive Fotographie*. At the same time, in the United States, Minor White revived Stieglitz's term *Camerawork*. Today *Pictorialism* seems to be gaining renewed currency as a term, and the aesthetic tenets of the original movement are being reviewed with new interest.

Pictorial photography is frequently interpreted as the attempt by photographers to dissociate their work from the look of applied photographs (those made in such areas, for instance, as science and industry), and to make photographs which mimic works of art in other media. This is true to a

limited extent, but as the readings contained in this book show, pictorial photography as a movement reflected much deeper social concerns and aesthetic values, and these should be seen as the pictorialists' linkage to the world of art. In the first place, they considered themselves to be artists in every sense; and pictorial photography should be understood as a reaction against what they perceived as the dehumanizing effects of science and applied technology. As did other visual arts of the time, pictorialism placed its greatest emphasis on the individuality of the artist as witnessed in the work of art and in the idiosyncrasies of its production. Or as one contemporary photographic critic stated, "In all art there is artifice." After its first half century, photography, which had its origins in the positivist and materialist revolution of the early nineteenth century, was ripe for this kind of new thinking; ripe, indeed, for what was to become a total transformation of the medium.

The first photographs made in the nineteenth century – and those from much of that century – tended to translate the externals of life into visual form almost as an act of preservation. Emphasis was on recording the salient points of an object, or its principal characteristics, so that the photograph would serve as an aid to memory. Such was the intention of the portraitists and the documentarians of landscape or architecture. In only a few areas of interest did the equivocal or emotive aspects of the medium become apparent. By and large the nineteenth century may be seen as a period of exploration and determination: exploration of those characteristics of photography that had been so unexpectedly granted – mobility, instantaneousness, continuous tone, and optical veracity – and determination to utilize these qualities in whatever way seemed clear or expedient at the time. However, as the century drew to a close the camera and the processes of photography lost a measure of their fascination and they came to be recognized more as products of a technological age to be valued less in terms of themselves and more as tools available for use in a society which sought not description but interpretive analysis.

Science versus art became then the conspicuous issue underlying pictorialism and the most critical concept behind this modern movement. Because of the integral duality of technology and art in photography we might say that photography was one of the first aesthetic media to experience the reappraisal of science in modern culture. P. H. Emerson was one of the few to substantially articulate this issue in

3

terms of a new photography, that which he called "naturalistic," and he was followed by George Davison and A. Horsley Hinton writing throughout the 1890s. Basic to their thinking was the realization that a photograph could be more than a record, something which heretofore had been the prevailing view of the purpose of a photograph, and that it could instead be a "picture." It was universally accepted that a picture reflected its creator and that it functioned in the realm of interpretation and revealment. A record was mechanical and scientific. A picture did not so much have purpose as it had a meaning central to human experience. With consideration of the photograph as a picture the medium was brought, both by implication and necessity, into the realm of art. This change was understood at the time. It was enthusiastically fostered (and vigorously opposed), and it became the hallmark of the pictorial movement.

One of the driving forces in the articulation of pictorialism was the belief that the pure, or straight, photograph was too perfect, that it represented too much of actuality, of what was there. That it did not discipline nature, and nature, or at least natural process, meaning the optics and chemistry of the medium, was seen to be the inhibiting or corrupting force within it. This was the challenge to the view of photography expounded by Bisbee and quoted earlier. It was believed that this comprehensiveness and integration with the subject robbed the photographer of the artist's role of selection and reduced the opportunity to suggest or project one's personal "impression," a thought clearly at the center of modernist artistic conception in all media. The temperament about which Robinson wrote suggested an interest in the more emotive aspects of picture making by photography. In the area of selection, for instance, landscape photography radically changed from the work typified by Francis Frith and others working after the 1850s to that of the naturalistic school of Emerson, Davison, and Steichen in the last decade of the nineteenth century. This change was characterized by the abandonment of subjects with a documentary interest to those more anonymous in themselves but more reflective of the photographer's personal concept of the beautiful. Further, what were termed the "vulgar" characteristics of the documentary photographic print were abandoned in favor of effects gained through the manipulation of the printing medium by selective development, dodging and burning (or sunning as it was then termed), hand-coating on rough papers, and the use of platinum and gum-bichromate. All of these tech-

niques were given their *raison d'être* by Hinton in his remarkable essays, "Methods of Control, and Their Influence on the Development of Artistic Photography" and "Individuality – Some Suggestions for the Pictorial Worker." Hinton was a most convincing spokesman for this point of view, as skilled or even more so than Sadakichi Hartmann would be less than a decade later when the reaction against the excesses of manipulative techniques gave rise to an appeal for the revival of straight or unmanipulated photography.

This new concern with personal expression in picture making is the basis of what must be called modern photography. It dates from P. H. Emerson's publication in 1886 of his prophetic paper, "Photography A Pictorial Art," in which he stated the essential creed: "Pictorial art is man's expression by means of pictures of that which he considers beautiful in nature." What separates certain of the work after Emerson's own brilliant examples from that which preceded it is the photographer's realization that photographs could transcend their factual prejudice and that they could, regardless of their physical appearance or method of production, embody individual expression and personal values. The photographer came to realize that one could mature through the medium and that the photograph could be seen to embody one's belief in what constituted the beautiful through subject selection and through articulation of the techniques of the medium. The photograph itself was to be considered a beautiful object. These new photographers became leaders in redirecting photography from a kind of hollow documentation to a synthesis of the particularities and meaning of art to life.

The concept of the beautiful became the second significant issue to which pictorial photographers addressed themselves. For guidance they not unexpectedly turned to works in other media which were, by general agreement, considered to reflect the proper canons of aesthetic merit. Such models ranged from the "consummate masters" Leonardo and Michelangelo, to certain Dutch seventeenth century realist painters, to the more recent Impressionists; and, of course, British artists such as Constable and Turner were held in high esteem. In choosing such models with relation to photography there was the special issue of truth to nature because before everything else photography had to confront "what was there." This necessity was turned into the highest aesthetic virtue, and nature became synonymous with truth. Emerson, commenting on his choice of a name for his school or approach, wrote, "We prefer the term 'naturalism' because in the latter

the work can always be referred to a standard – nature." The combination of the natural world with artists' interpretations was, of course, sometimes problematic but, by heralding those artists who were felt to be "true to nature" or who based their approach on "a close observation of natural appearances," the pictorial photographers believed they succeeded in identifying the proper models or inspiration. However, too slavish a copy of nature was considered common and only imitation. The dilemma was that the notion of what was beautiful often conflicted with what was to be found in nature. Thus selection as well as treatment, which was often referred to as "composition," became pivotal in the concept of beauty in photography. One searches in vain for a single definition of beauty and in so doing one realizes that, of course, there was none and that this fact allowed for and even promulgated the immense variety of positions and the general argumentative tone which so characterized the late Victorian period. Finally, as in all modern criticism, the only canon agreed upon was the individuality of interpretation and the necessity of good taste. In 1895 H. A. Mummery summarized the state of affairs as neatly as anyone when he wrote: "As art is not the copying of nature but the true reading of hidden truths, that art which gives man the greatest liberty of treatment must, of necessity, be the highest."

Fundamental in this desired union with the arts was the recognition that photographs and photographers would now have to be judged by the standards demanded by a more sophisticated taste, something which had been inappropriate for the medium except in its earliest years. We now recognize that this new sophisticated and cultivated taste represented the values of an increasingly bourgeois society and that for some, particularly those of lesser accomplishment, photography's linkage to the arts was often more a confused search for stylistic models and a fervent desire for acceptance and authentication than it was an effort to achieve shared substantive critical thought. But the point remains, nonetheless, that a new vocabulary and a rising standard of taste became a part of photographic endeavor. Some men of letters like George Bernard Shaw, himself an amateur photographer, even went so far as to support photography as an art above the standards of painting. Writing in 1901 with characteristic fervor he baldly stated:

I know nothing funnier in criticism than the assurance of the painter and his press parasite, the art critic, that all high art is brush work; except, perhaps, the humility of the photographer, who is not yet

6

allowed a parasite of his own, and must timidly beg for a contemptuous bite or two from that of the brusher. For surely nobody can take three steps into a modern photographic exhibition without asking himself, amazedly, how he could ever allow himself to be duped into admiring, and even cultivating an insane connoisseurship in, the old barbarous smudging and soaking, the knifing and graving, rocking and scratching, faking and forging, all on a basis of false and coarse drawing, the artist either outfacing his difficulties by making a merit of them, or else falling back on convention and symbolism to express himself when his lame powers of representation break down. . . . If you cannot see at a glance that the old game is up, that the camera has hopelessly beaten the pencil and paintbrush as an instrument of artistic representation, then you will never make a true critic: you are only, like most critics, a picture fancier.

This development of a new photography echoed the already articulate pronouncements by the painters that their role was not simply to represent but to integrate authentic moral and artistic substance in culture. In photography this understanding was longer in coming, due, in part, to the restrictive pace of technological development. The marketing of manufactured materials at last freed the photographers from the necessity of making their own, thus releasing them from the inhibition and practical domination of their craft. This should not be confused with the progressive interest in hand-manipulated media for the making of the photographic print. The important point here is the more strict separation of the medium into the production of the negative and that of the print. In the use of manufactured materials for the negative, and, in particular, the use of orthochromatic materials, photographers were free to consider the negative as the standard or base for the subsequent conceptualization of the print. It is the print which becomes the work of art, and the negative remains the link to the subject as it was in nature and the focal point of the complicated debate concerning focus and sharpness. This slowly evolving revolution of technical independence, which occurred in the latter quarter of the century, should be seen as a far more profound development than any single invention earlier.

Allied to the modification of the photographic process was the resulting separation of the medium into defined and purposeful groups of practitioners – professional and amateur were the primary divisions. A further breakdown evolved within the amateur category, particularly after Eastman's marketing of the startling Kodak system in the summer of 1888: that of the artist amateur in the traditional or classic sense and the mass amateur.

7

This division among the practitioners of the medium is the central element in the whole of modern photography. It provides for the concept of responsibility in making a photograph. The popular or mass amateur has always sought memorabilia; the professional has been for hire to provide images which were also personally important to a client. But finally, and most significantly, the class of amateur who could aspire to be an artist, as many did, would willingly accept the attendant responsibility. Thus they were enabled to concentrate upon the aesthetic idea of their pictures and encouraged to make these images public with the intention and hope that viewers would not only be informed by them but would be changed by their contemplation. The import of this belief was that photographers came to sense that modern life could be a personal exploration and that one accepted responsibility for one's philosophical and aesthetic intent.

No other photographer so fully exemplified this attitude as did Alfred Stieglitz. He is the pivotal figure. There were others, of course – such individuals as Gertrude Käsebier, Edward Steichen, Robert Demachy, Frank Eugene, F. H. Evans and Clarence H. White – but it was Stieglitz to whom they all looked for leadership. Even his detractors had to admit that it was he who set the example through his photographs. As the period moved forward and twentieth century attitudes became established, it was soon evident that to many of the more advanced photographers their pictorial goal should be not to offer a finely articulated demonstration of ideas or conventions presently held, but to illuminate them in ways never thought of – to make pictures which have the "bite" of something different from what the viewer might already have in mind and to reshape his vision. It is in this regard that at the end of this period the work of Alvin Langdon Coburn and Paul Strand becomes so important.

In order to provide a forum for pictorial photography the public salon and the gallery exhibition system were developed as early as 1889 and, gradually, a commitment was made on the part of museums as well. In this arena of establishment acceptance photography did not particularly lag behind other arts of the time if it is recognized that as a modern art photography was fighting a battle similar to that of other contemporary media such as lithography, for example. This struggle was made somewhat more difficult for the pictorialists because, for them, photography seemed to have no tradition of true "old masters." One of the more curious aspects of photography's modernist development is that so

little was respected or taken into account from the earlier periods of photography's existence. Pictorialist thinking about picture making seemingly pitted itself against all that preceded it, and, perhaps with the exception of the work of D. O. Hill, Julia Margaret Cameron and possibly O. G. Rejlander and Antony Adam-Salomon, it did not allow for the admiration of earlier accomplishments. (H. P. Robinson, while an historical figure, lived until the turn of the century and was considered very much a contemporary force.) Even the French had a limited view of their photographic history, and the Americans had practically no view at all. The American pictorial movement was fashioned after European and, especially, English models. In 1892, the young Stieglitz, only recently returned to the United States from Germany and about to begin his crusade, wrote "A Plea for Art Photography in America" in which he said with noble candor: "There is no reason why the American amateur should not turn out as beautiful pictures by photographic means as his English brethren across the long pond, and still the fact remains that he does not do so."

The salon system raised a key issue in the "photography as art" debate and that was the question of who would judge photography's artistic accomplishments. In the beginning it was assumed that artists, notably painters, would make the best judges since it was they who established the pictorial values which the photographers sought to emulate. This view was gradually challenged by those who had gained confidence in their own work and who felt that the specifics of photographic expression required a specialized knowledge which the artists lacked, and further, that as long as artists of other media were asked to pass on their potential rivals, no true acceptance would be achieved. The question was not put to rest even when the Linked Ring Brotherhood abandoned judging for medals altogether. As late as 1902 Stieglitz was compelled to write his "Painters on Photographic Juries," but this article is ultimately of greater import because it points out the degree of Stieglitz's belief in the independence of the pictorial movement and why, in founding the Photo-Secession in this same year, he made clear his position that only through the separatist structure of an elite group and only through selective participation in publications and exhibitions would real progress be made to fully promote artistic photography. In other words, it was his policy that the art establishment would have to come to the photographers.

As with any medium, the development of photography's

theoretical construct has been a process of evolution with a type of cyclical flow. We have an evolution in pictorial photography, beginning from an initial articulation of the principles, developing through the protracted interaction between photographers, writers, and critics to the gradual codification of the effort into formulae as new values threatened the accumulated body of theory. The movement was international throughout but, as has been stated, its initial center of activity was Europe. Later it was centered in the United States under the entrepreneurial leadership of Stieglitz and, after 1902, through his Photo-Secession organization. The pioneering position and influence of the British in this formulation cannot be overstated, and London must be seen as the center of progressive leadership during the formative years of the movement. Continental Europeans were always influential, but because they seemed fixed on the practice of one technique, the highly manipulative and sensuous gum-bichromate process, they never experienced the diversity of involvement that came to distinguish the British and the Americans.

The literature of the history of pictorial photography is found primarily in periodicals whose articles provide an overview of the period. The authors concern themselves with issues such as the concept of beauty and nature; artist models pertinent to the photographer; judging and competition; the role of women, of amateurs, of professionals; the salon and exhibition activities and controversies; the conflicting views over the synthetic photograph and the straight (or pure) photograph; the practices of focus; new theories of creative composition or idea expression; the ethics of retouching; the organization of hundreds of camera clubs, the Royal Photographic Society, the Linked Ring Brotherhood, the Photo-Secession and the Photo-Club de Paris; the progressive evolution of the aesthetics of modernism as a set of formal pictorial ideas; the giving way of post-Renaissance values in painting to concepts of naturalism and realism as witnessed in early nineteenth century painting and literature; the values of Impressionism and Symbolism; and finally the reaction for and against Cubism. In most cases no single article completely articulates one or more of these topics or issues, but rather several articles will acquaint one with the evolution of the ideas and the controversies. Distinctive twentieth-century ideas and values did not begin at a fixed point but rather evolved over about three decades, or roughly between 1890 and 1920. The attitudes expressed in these articles are those

which form the basis of twentieth-century artistic photography down to the present.

The sources for the articles generally reflect the movement from British authorship to American. During this time span a great many photographic periodicals were published, and ideas were very rapidly disseminated throughout the world. Not only were major articles translated and reprinted in various publications but most journals had a section reserved for what was termed "foreign news and notes." In comparison to photography today, the medium in those years was much more internationally perceived.

Articles which shed light on how one learned to be an artist photographer and what guidelines were passed from one generation to another were particularly important because the learning process in amateur photography was not based on an academy structure or on formal training and apprenticeship, but on self-teaching and inspiring peer guidance. The nature of the organizational base of the pictorialist movement is central to its understanding. Through the publication of *Camera Notes* and later *Camera Work,* we know a good deal about Stieglitz's activity, first with the Camera Club of New York and later with the Photo-Secession. But other groups in Lyon, Glasgow, Hamburg, Buffalo and elsewhere with less regular or comprehensive publications were nonetheless critical in the development of pictorial photography, and the camera clubs in these cities and elsewhere throughout the world were the main support of the early amateur movement. These clubs were as near in activity as any groups to the nonexistent academies referred to previously.

The fact that pictorial photography did not end, but rather evolved into a variety of strains which remain today, is significant. The progressive influence of formalist aesthetics and the destruction of the romantic or idealist taste in art altered the development of pictorialism. Thus the post-World War I avant-garde went one way – generally toward the revival of naturalistic photographic disciplines – and the conservatives remained with pallid principles of illustration which continue even today in the amateur and professional salon movement. Most of the primary figures of the new purist or straight approach of the twenties – that approach which some writers have mistakenly considered to be pioneeringly modern – began their work as first- or second-generation pictorialists. Edward Weston is an excellent case in point. These photographers had already accepted the principle that pho-

tographs were the embodiment of a subjective intelligence, and that if their pictures had a purpose it was not simply to show, but to *reveal* the truth beneath appearances. In this sense they were only practicing latter-day modernism because the basis of their endeavor, if not their success, was inextricably linked to the achievement of the first pictorialists – those who originated modern photography.

ALFRED STIEGLITZ AND
CAMERA WORK

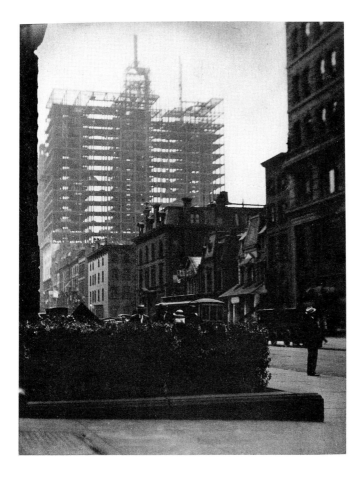

Alfred Stieglitz, *Old and New New York*, 1910

TWO BOOKS DEALING with the work of Alfred Stieglitz reassure us that not only is publishing in photography sound but Stieglitz' great contribution to photography will not be easily forgotten. The first book, a personal memoir and partial biography of Stieglitz by Dorothy Norman, is the culmination of her nearly twenty-year association with Stieglitz and her subsequent efforts to bring the full measure of his work into print. The second, by Jonathan Green, provides for the first time a major anthology of Stieglitz' publication *Camera Work*. The importance of these two books cannot be overemphasized, nor should they be considered just one more

"Alfred Stieglitz: An American Seer and *Camera Work* / A Critical Anthology," *Print Collector's Newsletter* 5 (Sep./Oct. 1974): 95–96.

example of the increasing popularity and interest in photography. Both are superior examples of book production, and each illuminates the work of the founder of what may be considered modern photography.

Stieglitz structured modern photography, and his principles are as relevant and viable today as during his lifetime. This is because, as a kind of architect, he not only originated ideas but acted. No one ever made photographs like Stieglitz. The essence of his spirit, which expresses not so much an individual personality as a particular relationship with the world, lies within his imagery. His photographs embody not a concept of form, or representation, but the resolution of a dialogue between creator and conscience. Thus his photographs must be read, and in this way are documents. They are psychological documents, not physical, and are more like medieval manuscript illuminations than conventional descriptive photographs. They appear simple, but they are genuinely complex.

Stieglitz' belief in the photographic medium was total, and often he wrote that he owed "allegiance only to the interests of photography." But his view of the medium was far from restrictive. It went beyond the visual present to embrace historical completeness. He understood the individual frame of a photograph marked only a provisional limit; its content pointed beyond that frame, referring to a multitude of phenomena that could not possibly be encompassed in their entirety. This idea he termed "equivalence," and this extension of photographic aesthetics reveals the unmistakable originality of his thought. The first manifestation of the conceptual methodology that resulted in the theory of equivalence is *Camera Work,* the publication Stieglitz edited from 1902 to 1917. *Camera Work* must be thought of as a whole, with a meaning that pervades its every element. There is no argument that is not constructive. There is no image that is not revealing. Put another way, Stieglitz believed that the exercise of vision and intellect, incorporated in all creative disciplines, served to illuminate the ultimate meaning of pictorial content. Thus, within its pages one finds, often juxtaposed: Steichen and George Bernard Shaw, Matisse and Charles Caffin, Julia Margaret Cameron and Benjamin de Casseres, Clarence H. White and Frank Eugene, Picasso and Gertrude Stein, Stieglitz and Henri Bergson.

Camera Work is generally considered first in terms of its unequaled craftsmanship, but more than style, it makes evident a generosity and spirit that have never been equaled. It

is the most intelligible literature on photography yet published. Likewise, Stieglitz' photographs bear on more than the character of straightforward photography. Ultimately they serve as a body of work to define the very framework of the medium. Before Stieglitz, photography had been a thing apart from the arts of expression. Because of Stieglitz, this can never again be true.

Jonathan Green, a member of the creative photography faculty at M.I.T., succinctly records in his introduction the developments surrounding *Camera Work*. The description is without error, and his presentation of the publishing facts behind the magazine is illuminating. Without resorting to blind praise, Green clarifies the vision behind the publication and the virtues and failings of the movement it documented. His period breakdown of the magazine's content is insightful, reflecting one who has carefully read the contents. He fully understands that Stieglitz and Steichen recognized the surest way to describe their photographic aesthetic was to show what it was not. For this reason, to the considerable perplexity of subscribers, Stieglitz sought to launch a full-scale investigation of modern art; at least, insofar as he knew it. By concluding the publishing of the magazine with the work of Paul Strand, photography was set on a new course for succeeding generations in this century. Strand did not so much discover a new photography as he reaffirmed belief in photography as practiced in the 19th century. In short, it was a photography that dealt with subject selection more than treatment as an approach to the consideration of meaning. Similarly, Strand understood that for photography to be contemporary it should reflect the most contemporary – or modern – forms of seeing and analysis. Photography after *Camera Work* no longer reflected the art of the past but showed that it was an art of the present.

What is also significant in terms of *Camera Work* is the realization that the publication of a magazine of quality, reproducing the finest work available, was the surest way to achieve dominance in the field. Stieglitz knew that to launch a revolutionary movement it did no good to argue with a few and haunt the recesses of the radical avant-garde. Thus his first exhibition of the Photo-Secession was held at the highly prestigious National Arts Club, and in the pages of his magazine the foremost photographic manufacturers were advertisers. Their authority was lent to the cause for which the magazine stood, as did its quality of production. Nothing but the very finest was acceptable, thus clothing pictures and

writing alike in extremes of respectability. The magazine had a wide circulation, although its edition of one thousand would, by today's standards, be considered minute, but its influence as an arbiter of taste was enormous. Without *Camera Work,* the Photo-Secession would have been simply one more organization of local interest.

The format of Green's book is superb both in its feeling for the overall sense of quality with regard to *Camera Work* and in its tasteful echo of the typography and layout. There is some slight confusion as one moves from article to article, but this is minor. A unique contribution of Green's research is the presentation of a complete index to the *Camera Work* texts and plates, as well as brief biographies of the major contributors. The reproductions have been clearly made with the care that reflects all Aperture books, but they suffer slightly in the process of being made from the gravure originals. In the rephotographing of these gravures, the texture of the paper and ink in the originals inevitably interferes with the copying process, giving reproductions a somewhat more "grainy" appearance than the originals. The color plates are superb. The only other publication of *Camera Work* is the full set published by Kraus Reprint (1969) and here the reproductions are so poor as to be useless. A meaningful comparison might be made with the full reprint, in that while everyone might have a favorite article Green has not included, the sheer volume and repetitiveness of the original make his book invaluable for the general reader of the period. The history of photography must ultimately be found in the periodical literature, and the bulk of scholarly research in the field rests in this area. With the publication of Green's book, one major area of study in the field is in book form, and scholars and students seriously interested in this period no longer must seek costly original issues or use the reprint. Here in one volume are the major developments and ideas in photography between 1903 and 1917.

Dorothy Norman's book on Stieglitz is entirely different from Green's work, in that it reflects the fruits of insight and impression gained from long and deep personal experience, as opposed to objective research. Many persons will find this book wanting, preferring instead the perspective of a historian or scholar who treats each fact without emotion or reminiscence. However, this is to overlook, or indeed to demand, something not within the aim or background of the author. The note at the beginning of the book clearly states the goal and the primary source of these pages – the personal recol-

lections not only of Mrs. Norman but of Stieglitz himself.
By the time Mrs. Norman met Stieglitz in 1927, he was truly
famous and secure in his contribution to American art. His
recollections of how this was achieved were not so much
biased with a vision of himself as reflective of his knowledge
of events. Such knowledge was sometimes very limited.
Stieglitz was also contradictory, and if one goes through the
thousands of letters he wrote, now contained in the Stieglitz
Archives at Yale University, one can clearly sense and un-
derstand the psyche of this artist. Mrs. Norman, through her
presentation, seeks to simply present the psychology and ac-
tion of this man, but she does not seek to explain the why
or give the perspective of the details surrounding his actions.

The sheer amount of information, in terms of both com-
mentary by Stieglitz and the data covering Stieglitz as an
artist and arts impresario presented by Mrs. Norman, makes
this the most significant work on Stieglitz to date. In part,
it is in the tradition of the affectionate collective portrait,
America and Alfred Stieglitz (1934), for which Mrs. Norman
was also an editor. The chronology and exhibitions lists are
invaluable, the details presented in her notes are likewise
unique, and the bibliography is a significant contribution.
Most of all, the reproductions will be most rewarding to the
individual discovering Stieglitz through his photographs for
the first time. No other publication presents so many repro-
ductions of his life's work. The quality of these reproductions
is not the finest that could be desired, but they are well above
adequate. One of Stieglitz' contributions to photography was
his articulation of the immense subtlety in the original pho-
tographic print. No other photographer before him managed
to draw out of the photographic print the same sense of
tactility and spirit. The ineffable quality one feels from a
Stieglitz original cannot be gained from a reproduction, and
while Mrs. Norman does not make an apology for the quality
of reproduction, she does clearly urge that the reader seek
the originals and look well and deeply into them.

It is not the purpose of this review to rewrite or re-edit
either of the books under consideration. I would question
certain aspects of Stieglitz' interpretation of events and of
Mrs. Norman's presentation of them, but, as I have stated,
I do not feel it was her goal or her concern to set herself up
as an objective scholar intent upon documented truth. This
is especially the case in matters in which the impression of
uniqueness in Stieglitz' actions and work are concerned. For
years, everyone who has spoken for him has imparted some-

thing of an image of purity, resembling not so much a being untouched as something on the order of having been brought forth from the brow of Zeus. Every artist suffers this fate, and the best triumph over it, and in what amounts to a dual autobiography one should not seek impartiality. Stieglitz, apart from his photographs, left two primary autobiographical sources for the study of his life and action – his written correspondence and the reminiscences he told to Mrs. Norman and others. Another volume of material similarly based on the latter material is Herbert Seligmann's *Alfred Stieglitz Talking* (1966), published by the Yale University Library, and the student of biographical and critical methodology would be wise to compare these two volumes, as well as Mrs. Norman's earlier uses of the same material. With this book the stage has been set for the next study, which will require a cooler or more dispassionate approach. Jonathan Green's approach is reflective of this methodology, but he, like all of us, must be indebted to Dorothy Norman for her gift of sharing over these many years.

CLARENCE H. WHITE/THE REVERENCE FOR BEAUTY

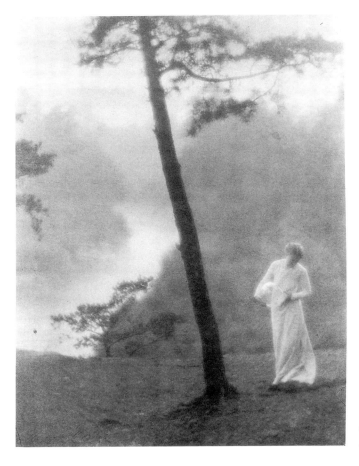

Clarence H. White,
Morning, 1905

BETWEEN 1898 AND 1917, THERE flourished in this country a movement in support of expressive photography that was rooted in the principles of art that had been traditional for centuries. Pictorialism, as it was called, had as its basic concept the notion that certain photographs were the product of the creative imagination and the insightful, craftsman-like effort of the self-conscious photographic artist.[1] In addition, and more importantly, the artist photographer was seen in a new light with regard to his responsibility for the work pro-

"Introduction," *Clarence H. White: The Reverence for Beauty* (Athens, Ohio: Ohio University Gallery of Fine Art, 1987). © by Peter C. Bunnell.
1 See Peter C. Bunnell, *A Photographic Vision: Pictorial Photography 1889–1923* (Salt Lake City: Peregrine Smith, 1980).

19

duced; that is, the content and rendering of the photograph were seen to be reflective of the picture maker's originality and not of the mere re-presentation of undifferentiated facets of exterior reality. What this meant, in practical terms, was that in pictorial photographs subject was indivisible from content, and that selection was the critical gesture in picture making. These attitudes about photographs and photography were far different from those held by most people at the time: ones based on the belief that photography entailed simple observation, reaction, and routine mechanical procedures.

Photography was most often viewed as a sequential medium in which the photographer was the pivotal figure in a series of events that began with revelation and proceeded through action. The idea was that the recognition of what was photogenic caused a sequence of responses, the very minimum of which were the manipulations of the craft of photography that lead to the creation of a visual document. Although by this definition the photographer was not prevented from exploring beneath the surface of things to expose the significance of outer appearances, he was clearly not a participatory instrument in the scene.

In contrast to this approach a new style was formulated in the late nineteenth century in which the photographer became involved with the actual contrivance of the subject. By necessity, to work in this new way required a less reactive and more premeditative sensibility. Photographs produced following this approach functioned as a kind of literature, in which the formulation of elements was not only to be sensed, but read. Photographers working in this arena were interested in revealing how things are, rather than showing things as they are, and their pictures often displayed that precise combination of emotion and reason that caused them to imprint themselves on our consciousness. In his photography, Clarence H. White was concerned with this latter style.

Clarence H. White was born in West Carlisle, Ohio, in 1871. Between 1887 and 1906 he lived in Newark, Ohio. The son of a salesman in a wholesale grocery company, he followed his father in seeking similar employment and he became a bookkeeper in the same concern. In 1893, at the age of twenty-three, he took up photography as a substitute for painting, a profession, or even an avocation, that had met with his parents' disapproval. Although wholly self-taught, by 1899 he had achieved an international reputation for his innovative photographs. In the succeeding decade he exhibited in such cities as Boston, Dresden, London, New York,

Paris, Turin, Vienna, and in the important American salons in Chicago and Philadelphia – also serving on their juries of selection. He was a founding member of the Photo-Secession, a group of vanguard photographers organized in New York by Alfred Stieglitz in 1902.

White's work was published in the Photo-Secession's magnificently printed journal *Camera Work,* exhibited in its gallery "291," and it formed the largest individual contribution to the last Photo-Secession group exhibition at Buffalo's Albright Art Gallery in 1910.

White moved from Ohio to New York in 1906, and the following year he became Lecturer in Photography at Teachers College, Columbia University. In 1914 he founded the Clarence H. White School of Photography in New York, and during the summers he also conducted schools in New York, Maine, and Connecticut. He was a sensitive and dedicated teacher and included among his students were Margaret Bourke-White, Anton Bruehl, Laura Gilpin, Bernard Horne, Dorothea Lange, Ira Martin, Paul Outerbridge, Ralph Steiner, Karl Struss, Doris Ulmann, and Margaret Watkins. In 1916 he became the first president of the Pictorial Photographers of America. This group, founded at a time when the character of pictorial photography was under attack, sought to perpetuate the values of expressive photography as they had been defined at the beginning of the century and also to apply them to the newly developing fields of commercial and illustrative photography. In 1925, while leading a student tour in Mexico, Clarence H. White died.

The qualities that make White's photographs so memorable have to do with both form and content. In his finest pictures the disposition of every element, the arrangement of each line and shape, is dominated by a confidence that elevates the common aspects of camera vision to an expressive intensity few photographers have managed to attain. It is clear that White was aware of the stylistic principles and devices of oriental art, and indirectly with the pictures by certain American and European contemporaries through his familiarity with reproductions of works by the painters Chase, Puvis de Chavannes, Sargent, Watts, and Whistler among others. But perhaps a stronger influence were the literary illustrators of eighty or ninety years ago whose work he saw in such popular American magazines as *Brush and Pencil, Everybody's, Goodey's, The Monthly Illustrator, Munsey's* or *Scribner's.* Unlike so many of his pictorialist colleagues who sought to incorporate what they believed to be "impression-

ist" principles in their photographs, White was able to transform the sensory perception of light into an exposition of the most fundamental aspect of photography – the literal materialization of form through light itself. His prints, mostly in the platinum medium, display a richness, subtlety, and a luminosity of tone rarely achieved at any time in the history of photography.

White's vision was based on his Newark, Ohio society, but unlike many of the lesser photographers of his day, and those who followed him in what continued as the pictorial photographic movement, his poetic imagination transformed these local facts into greater truths. Within a style that was evolving as he worked, he created a body of work that was unique in photography. He showed that photography relied on contemplation and planning, and that through the continued use of picture subjects that did not vary greatly, he could come to a deeper understanding of their intrinsic meaning. His legacy reinforces our contemporary realization that photographic vision can encompass ideas and attitudes that intensify and mature through the determination successively to plan and to penetrate. The work of Clarence H. White confirms that photography affects us like experience; it shows us what we see.

In his first years, between 1897 and 1906, White concentrated on genre subjects, selecting as his models members of his family, such as his son Lewis shown with his wagon, his mother, or members of his wife's family, notably the tall, lithesome and introspective Letitia. She appears most frequently in a dark gown or drape, in such a picture as "The Bubble." Later, White would photograph a variety of women, including some well known, such as the actresses Nazimova and Maude Adams. It is clear that even though White was an enthusiastic portraitist of men, his greatest interest lay in the pictorial depiction of women. This subject choice reflected the pictorialists' belief that it was the most artistic and spiritual in art's long tradition, and White's particular fascination was derived from a confluence of many sources: Symbolist imagery and rhetoric, the earlier Pre-Raphaelite school, and even the contempory American Gibson girl. Women were seen as the primary subject of the story-teller's art, of parables, and as the epitome of nature – woman viewed in nature's primordial garden – and it was this literary origin, together with the notion of seriousness in art that concentrated upon notions of truth and beauty that infused White's attitudes. In his article, "Seriousness in Art,"

the author George Gibbs advised his readers such as the young Clarence White:

Let us look upon seriousness, taking into consideration the definitions of Truth and Beauty. . . . So long as the artist is very evidently in earnest may we not be appealed to on a plane a little lower than the attempted sublime? Nature, human, or otherwise, is a many-sided mirror which, if we only appreciate her, can tell us many things we do not know. In the woods and field she has a reflection for every heart, a mood for every humor. He who can translate the language of these moods is a great artist, even though he may choose to introduce some ideas of his own. The well-beaten purple path winding away over the tender green hillside toward the gabled farmhouse! The rosy milkmaid resplendent in her healthy beauty, surrounded by a halo of pink and violet buds that seem to rejoice in the youth of the maid and of the year! Tangled fleecy clouds which skim lightly through a sky that is Purity! . . . If these were translations of Nature's moods could they not teach us something that was not known before?[2]

Such an image as "The Watcher" of 1906, one of the more overtly Symbolist of his pictures, demonstrates White's translation of one or more of the reproductions of contemporary European art that he saw in journals such as those mentioned above. It is a haunting image that has the effect of casting a humble but spiritual vision in a strange, portentous light. It is important to note that the costumes and draperies his figures wear, as in this picture, were not contemporary dress but were created to evoke the mood and look of an appropriate period of the past, sometimes even suggestive of the early Greeks.[3] At the same time the pictures were undoubtedly interpreted by his contempory local audience as having very specific temporal manifestations; in this picture, for instance, the model's identity would be known as she posed above the Licking River outside of town, and the glass sphere she is holding would be recognized as a product of the A. H. Heisey Company in Newark.

One of the important aspects of White's photographs noted by his critics (especially those who were adverse to his work) was the sense of locality. One wrote:

In order to properly understand the real nature and character of Mr. White's work it will be necessary to discover if possible the precise reasons for its condemnation on the one hand and its ap-

2 George Gibbs, "Seriousness in Art," *The Monthly Illustrator*, 6:67–74, September, 1896. Another, on religious imagery, is also typical: Will H. Low, "Madonna and Child in Art," *McClure's*, 6:33–47, December, 1895.

3 See James H. Chapman, "In Greek Costume at Pelham Bay," *The Monthly Illustrator*, 5:274–285, September, 1895.

proval on the other, and an analysis of the situation based upon careful personal observation has led to the conviction that those who condemned it did so from some of the following reasons: Some did not like – could see nothing in it because they did not like the model. This was a prejudice akin to that of the individual who could never see any beauty in the Venus of Melos because he did not happen to fancy its face. Others found the use of the same model throughout tiresome. This from a typical New Yorker who has become accustomed to life on new experiences – new excitements – new tastes – who to a great extent has become blasé and detests repetition and demands the new – as the most natural object in the world. Lombroso would find in it an evidence of degeneration on the part of those who raised it. As nearly every great artist in the age of great art made repeated use of the same model, Mr. White is not entirely without precedent. Apropos of this, one of the gentlemen of the club very wittily remarked that Mr. White's was a one-man and at the same time a one-woman exhibition. The marvel of the thing is that with one model he has been able to do so much.[4]

This review by Joseph T. Keiley is perceptive in that he has not only differentiated White from other workers, but he has articulated one of the key ideas of pictorialist aesthetics. Keiley has described the power of the photographer's imagination, rather than his ability to travel or to select from a wide array of models. When White left Ohio late in 1906, he was not in the search of new subjects; rather, he was seeking a way to devote himself to photography and to place himself more fully within the larger world of serious, artistic photography. That movement was based in New York and Stieglitz was its leader. In retrospect, we can see that White's move actually diminished his abilities as a photographer. Not only was his time to be consumed by other work, he was also in an environment which lacked entirely his rich sources of imagery and inspiration. It is clear that while White retained his belief in the primacy of making art, progressively, after 1907, he seemed to lose the absolute need to translate the experiences and joyous emotions that gave meaning to his life into pictorial form as he had so clearly done in his native Ohio.

In his teaching White quietly fostered the most fundamental goal of artistic endeavor: the search for spirit. This belief in spirit would seem to be in opposition to photography, what with its primary focus on the real world, or real time, or realistic depiction. But as with some other photo-

4 Joseph T. Keiley, "Exhibition of the Pictures of Clarence H. White," *Camera Notes*, 3:123–124, January, 1900.

graphic artists of his time, White came to understand the penetrating dimension of photography – that in the act of seeing one is sometimes able to infiltrate behind surface appearances and in their very reality render underlying truths. His adherence to teaching, clearly at the sacrifice of his own work, reflected his belief in the enhancement of human life by imparting this understanding to other photographers. Just as photography had given him life, he now turned his life into teaching photography to others. While his School educated numerous professional photographers, his goal was to instill in every student, and in whatever discipline, the idea that artistic creation gave substance to one's search for human values. In a catalogue for the School that was published shortly after his death there appears a statement that summarizes his philosophy of teaching:

Every resource of thought, feeling and skill is needed to win the rewards of personal satisfaction and business success. For not a few, however, the studies and associations of the school have yielded values for which there is no material measure. Men and women have found themselves, worked out a better adjustment to life, and discovered new sources of interest and happiness. [5]

In the last decade of his life the force of strong, new formal concerns in image making became manifest. Abstraction is the term most generally applied to these concerns, but in photography this is a relative term at best. Formal simplification, flatness, and a greater dependence on line would better describe the direction. Certain of the extreme techniques of this new style such as changed viewpoints, close-up, and sharp cropping were never adopted by White in his photography, although slight evidence of these tendencies may be seen in the 1917 boat construction pictures made at the Bath Shipyard in Maine, or in a detail of rocks on the Maine coast made in the early twenties. These, together with pictures taken near the end of his life at the Croton Reservoir outside New York, reveal White's awareness of the changing mainstream in contemporary photography as seen in the work of his colleagues Stieglitz, Paul Strand, and Karl Struss among others. One feels that had White lived longer his work would have changed somewhat, although it is doubtful that he would have revised his fundamental beliefs to the point of accepting the very reductive presentation of the objective

5 *Clarence H. White School of Photography* (New York: Clarence H. White School of Photography, n.d. [after 1928]), n.p.

150.279

College of St. Francis Library
Joliet, Illinois

25

world that came to be the hallmark of what was called straight photography. But this analysis skirts points that White understood very well, and which he had demonstrated throughout his work. The first is that design in the construction of photographs is as integral to photography as it is to all the other arts of whatever period. It had always been his desire to give substance and credence to the formal considerations of the photographic picture along with the subject matter while maintaining harmony one with the other. White saw no need to stress a real or imagined uniqueness in photography or to endorse the separation of photography from the other arts as proponents of the straight style seemed to demand. Indeed, in his teaching curriculum, he had enthusiastically acknowledged the contribution that painting, especially including modern painting, could offer to the photographer in understanding once again the contiguous linkage between photography and the traditional arts. This was the basic tenet of pictorial photography itself. The second point is that he did not personally adopt the subjects of the new style: still life of utilitarian objects, for instance. In his own work he would not give up what he felt was the subject matter of ideas in favor of the subject matter of formal principles. In so doing he was remaining steadfast in his respect for the aesthetics of pictorial photography that he had done so much to define and to demonstrate.[6]

In 1918 White stated his position with regard to these issues in reply to an interveiwer's question, "Has any development along the lines of what we might call cubistic art got into pictorial photography?":

Yes, it has gotten into photography to a slight extent, but I am loth to call it cubism or any similar ism. The development of modern art, I think, is in the direction of construction; and construction, picture construction applies to photography as definitely as it applies to painting and other art. Indeed, a great feeling of the need of this has expressed itself in connection with photography.

The rules of composition as usually understood have been too narrow. We might say there are no rules, but there are certain fundamentals. These fundamentals have been made to apply in a great variety of ways. Take this print for example [not identified]. . . . Here is a little of what we might call cubism in modern pho-

6 See Bonnie Yochelson, "Clarence H. White Reconsidered: An Alternative to the Modernist Aesthetic of Straight Photography," *Studies in Visual Communication,* 9:24–44, Fall, 1983. This article reflects some of the most important new research on White to be done in several years. Yochelson's interpretation requires serious consideration in the effort to rethink the development of photography after World War I.

tography. We first look at it and we get pleasure from the play of light and dark on the object. It produces a sense of satisfaction to the eye, and yet when we examine it more closely we feel that the artist has violated the rules of what might be called composition. We must construct our rules of composition from examples, rather than make the construction that is demanded by our art out of formal rules.[7]

Recognizing that one of the hallmarks of the new photography was a greater emphasis on pure image making, White continued in the same interview, "I think the greatest weakness of the young worker is the lack of something to express. He is too much interested in the photograph for the sake of the photograph alone – that is, in the medium or in the taking of the photograph itself. The photograph should express something."[8]

Edward Weston, whose mature work of the late 1920's would be seen as the epitome of straight photography, came to New York in 1922 to see Stieglitz and others. He met Clarence White and wrote back to a friend in California a most complete analysis of the older man:

> . . . luncheon and afternoon with Clarence White – at his school – Quiet – unassuming almost retiring – extremely sensitive to pattern – sure of himself as a teacher and critic – and very critical – yet always apologetic over his own prints and admitting difficulties in obtaining his ideal – despite a very fine attitude. His work was disappointing – lacking any vitality – though he told me he would not work the same if the chance came now – for ten [years] he has practically given himself up to teaching – I am afraid in his over-emphasis of design he has lost spontaneity – Not that I undervalue pattern – form – for without it no picture has lasting value – But I feel too much calculation in his work. He found too much empty space in my work – and as he talked I could easily admit of his argument (from *his* viewpoint) – nevertheless knowing if I were to do them over I would do them the same!
>
> He is a great admirer of the Japanese print, and the way in which they fill space, but I feel only a resulting messiness and over-elaboration – if photographers were to emulate the complexity of some Japanese prints.[9]

Weston's opinion of White is critical, and as he himself suggests with reference to White's argument, his own also

7 Clarence H. White, "The Progress of Pictorial Photography," *Pictorial Photography in America 1918.* (New York: The Pictorial Photographers of America, 1918), pp. 5–16.

8 Ibid.

9 Edward Weston, "Weston to Hagemeyer: New York Notes," in Peter C. Bunnell, *Edward Weston on Photography* (Salt Lake City: Gibbs M. Smith, 1983), p. 42.

reflects a particular viewpoint. It is, however, an important analysis for it is written by a member of the next generation who sees in White's work the manifestation of conservative visual solutions and, particularly, past subject values. White's contemporary critics, those from the 1890's through the early teens, had been mostly positive in their remarks, understanding and sympathizing with White's goals, and seeing them as relevant to the contemporary concerns they shared. Later writers, and especially those in recent years, have been largely critical of White. The true measure of his late pictorial achievement, and of his open-minded and eclectic teaching philosophy, have been little investigated. It seems that what happened is, that as the fundamentals of White's photographic approach became applied to commercial and illustrative uses, his own work came to be perceived as more and more removed from the on-going mainstream of art photography.[10] This is the sort of attitude expressed about him by Weston, for instance, but White was not alone in this respect. A not too dissimilar critical attitude confronted Edward Steichen in the twenties and later as well.

Perhaps what most impressed people about Clarence H. White was his sensitivity as a human being and, especially, as a teacher. The photographer Anton Bruehl, a late student of White's, has said: "He was a simple, humble man, nothing phony, as only a great man can be. Kind, sympathetic, never nasty. or sarcastic in any way. He showed each of us a way to think for ourselves. He let each of us follow our own desires. Very little pressure was exerted on us as students. Rather, his approach was to guide us to do it well, follow our inclinations and imaginations, and to be sincere! It was mainly by association that you received what you learned from Clarence White."[11] It was this sensitivity and respect for the feelings of others that reinforced White's adherence to his traditional beliefs as the post-World War I era of self-indulgence took hold. Materialism and assertiveness became the mode of action and the widespread pressure to use photography gainfully placed him in the difficult situation of having to make a living by teaching students how to succeed in the new environment while at the same time upholding the principles of idealized expression.

White was a socialist who apparently formed his ideas under an early influence of Eugene Debs and Clarence Dar-

10 Yochelson, op. cit.
11 Interview with Anton Bruehl, July 7, 1960.

row, and through such books as Edward Carpenter's *Towards Democracy,* a work he greatly admired. But White, like many of the artists whose idealistic politics he shared, held the view that art might best serve the humanist cause not by the depiction of social conditions or by expressing indignation, but by essaying positive values that suggest the aspiration of spirit and the results of intellect and hard work. The entire body of White's work reflects a view of life that is essentially affirmative and which seeks, in its affirmation of beauty, the spiritual goal of progress and betterment in American society. That this approach became progressively more difficult in the years after his move to New York, and especially after the War, may also be at the root of his unsettled conflict with life in the seething metropolis.

White's portraits, which he undertook to do more and more after his move to New York, owe a great deal to the qualities of his genre images. The focused clarity of the early statements, usually composed only of the single figure, and the immensely sensitive handling of tonal structure enabled him to treat the portrait medium, with its emphasis on the individual figure, expertly. A 1909 portrait of an unidentified man holding a book is a good example. The rhythmic pattern of the tilted head, matched with that of the open book, sets up a configuration of double diagonals in a kind of light zone that conforms and runs parallel to the darker diagonal of the picture edge itself which, as an imaginary line, runs through the man's middle body. The picture would be lifeless, however, if it were not for the crisp white highlights of the shirt and the subtle tonal variation in the lighter zone above and behind his head which, as reflective of the sitter's actual environment, give depth and three dimensional harmony to the photograph. A more complex use of this sophisticated tonal juxtapositioning in an image may be seen too in the advertising photograph for domestic linens of about 1919.

One characteristic of White's work that was commented upon by all of his admirers was his mastery of the photographic printmaking media. His skill in platinum and palladium printing was always singled out, as was his adventurousness in multiple processes such as gum-bichromate. His free, sometimes spirited surface manipulations done early in his career placed him squarely within the pictorialist aesthetic that the photograph as a work of art was a crafted object like any other, in any medium, revealing of the artist's hand. These physical qualities of his prints are our surest links to the traditions in the graphic arts that lie behind the pictorial

movement. The British, who originated this school of photography in the mid-nineteenth century, and who truly began the movement of pictorial photography in the early 1890's, recognized the validity of this tradition (one that was truly their own) and enthusiastically adopted the character of the printmaking media as a fundamental attribute of the new photography. Until after World War I, one could say the American photographers like Coburn, Eugene, Käsebier, White, and many others also fostered this idea in their work. "The Round Table" of 1904 is a prime example. One of the most accomplished of all White's photographs, its indebtedness to Japanese sources is obvious. Without timidity and directly on to the print surface, White added decorative elements to the background of the picture and articulated and enhanced lines and tones that he felt were required for the print to truly function as a picture. This clear and open recognition of the pictorial reality of the print – and not the scene – is a characteristic of the best of fine art photography from this period. Later on, as tastes changed and the purism of straight photography took hold, critics tended to deride this attitude.

In addition to the quality of White's handling of the photographic material itself, but related to it, was his exquisite achievement with the effects of light. His range encompassed the "broad and frank in contrast," as one writer put it, to the sensitively subtle in delicate discriminations of tonality. Charles H. Caffin, one of his most steadfast supporters in the critical press, wrote, "I doubt, indeed, if there is any photographer in this country who excels him in the matter of tone."[12] This was written as part of his introduction to White's first portfolio appearance in *Camera Work* in 1903. Caffin continued, "more than anyone I know does he succeed in making his prints most beautiful studies of the variety and expressional value of luminosity."[13]

Since the turn of the century this quality, this "value of luminosity," had been the hallmark of the entire American school of pictorial photography. It drew awe from the Europeans and it established for the Americans, and White in particular, the international status of pictorial artists of unique accomplishment. It was this aspect of photography that proved to be White's most important influence on others. In works, from the dark and evocative images of Letitia seated

12 Charles H. Caffin, "Clarence H. White," *Camera Work*, 3:15–17, July, 1903.
13 Ibid.

or standing, where the light highlights her fresh features, to the sparkling overall tones of the "Pipes of Pan," to a 1912 nude with baby (made as a portrait commission), one can recognize and appreciate this mastery. In certain of White's early pictures, especially those that appear to depict actual characters from literature, there is a quality of light to suggest that night is the time through which the distinctive personality of the subject is being felt. This light is, in some images, as Shakespeare's Romeo described it himself, "an artificial night" of his love's own making. Throughout his work White maintains a brilliant shutter-movement of black and white, of misty overcast and sparkling sun, of midnight and morning. White's emotional affection for the ideas he was portraying is symbolized in his handling of light: something that shines with its own strength and from its own source. The light itself becomes subject; as it is hidden in darkness, it can then shine within the viewer's imagination.

In one instance, and a very rare one in photography, Clarence White photographed jointly with his mentor, Alfred Stieglitz. A 1907 figure study reflects a brilliant control and articulation of the medium. It is fascinating to consider the contribution of each artist. Stieglitz would later infer that the presence of the glass sphere was all White's idea, suggesting that such "props" were alien to his approach. Considering Stieglitz' later portraits of Georgia O'Keeffe, this is perhaps not altogether true unless, of course, he saw the globe symbolically as representative of an era no longer interesting to him. As we have already seen, we know the globe was owned by White and frequently used by him. The skillful use of light both to illuminate the model and to reflect on the glass surface to create a kind of reverse spatial environment, would be more characteristic of White than of Stieglitz at this time. The use of the overall dark, deep tone suggests equally of Stieglitz and White; though it was a characteristic of Stieglitz' work to have the figure seem to emerge from the environment of the picture itself as the sitter does in this case. Aspects of this photograph, and of others taken at the various sittings, suggest that Stieglitz' later portrait style of the teens owes a debt to Clarence White's and the same could be said for another close associate of White, Alvin Langdon Coburn.

Clarence H. White made very few landscape photographs, and in a curious contrast to the incredibly strong manner in which he contained a figure in a composition, his work in landscape reveals just the opposite. In an 1897 Ohio snowscape, and in a 1907 Newport, Rhode Island, view, one rec-

ognizes a very different visual resolution. In each case, the edge defines only the picture space and not the real limits of the subject. This is surely conscious on White's part, as if to suggest the continuousness of the land or architectural forms. It, perhaps even more than certain aspects of posing the figure in other pictures, reflects his admiration of Chinese pictorial modes as they might appear in a hand scroll. Comparing these early pictures to that of a Maine coastal view of about 1921 we feel a different equilibrium, and we sense how his viewpoint might have been changing during this period of his life.

White's treatment of the nude is also interesting. Most always discreet in revealing the female body, explicit sexual rendering was avoided and his few pictures of standing, undraped nudes are something of an exception in his work. These 1909 or 1910 compositions, perhaps taken in Morningside Park near Columbia University, are nonetheless reflective of his respect and affection for the subjects. The light and dark tones temper a harsh, erotic view of the figure which, characteristically even for this period, is still posed in an idyllic forest glade. One photograph from the "Pipes of Pan" series of 1905 is meaningful. This is a picture of one of White's young sons. In other pictures in this series the sex of the boys is fully revealed with no immodesty on the part of either the model or the photographer. The revealment of a boy's body was perfectly acceptable, since the adolescent male was seen to echo the Classical past and the photographer could thus work with impunity. The inspiration for this series of pictures was clearly White's close friend and photographic colleague, F. Holland Day. It was Day's invitation that brought White to Maine in 1905 for the first time. Day, an accomplished photographer and deeply interested in literature and poetry, was a genuine eccentric who was a significant influence on White for the whole of his life.

In 1900 Sadakichi Hartmann, one of the most astute critics of his day, wrote a series of observations that posited White within the structure of pictorial photography as it was then defined: "What he does is consistent, often beautiful, and entirely independent of other photographic work, for even if he takes his matter at second-hand from those he venerates, he understands how to imbue it with a spirit of his own."[14] This perceptive analysis of White's work at this early point,

14 Sadakichi Hartmann, "Clarence F. [sic] White," *The Photographic Times,* 32:18–23, January, 1900.

indeed, only about six years after he first took up photography, may now be seen to characterize the distinctive qualities of his life's work too:

Consistent
Beautiful
Derived from extant artistic prototypes
Imbued with an independent and personal spirit

The elaboration of these observations provides a framework we might use to depict not only White, but the broad complex of the pictorial photographic movement during its primary period: consistency of style with personal identification, a search for beauty as defined in its canonical precepts, the production of a beautiful object, finely made, and presented in the context of artistic craftsmanship reflective of past print-making techniques. Underlying these tenets may be recognized an attitude that while not stated was nonetheless understood. It had to do with the element of personal responsibility in the creation of works of art. More than any other aspect, this attitude should be seen as the most significant concept to come from the tradition of the arts in other media. It reflects the ultimate understanding that the photographer has something to say. The assumption that the photographic artist could indeed speak to, and for, a society may be seen to be the most fundamental element in the new order of art photography. That Hartmann recognized this implicitly in White is not unusual for Hartmann, but it is important that he gave to White, at the very beginning of his career, the imprimatur of acceptance and the confirmation that art of this sort could be produced anywhere – including in Ohio. Indeed, that localism, that quality so openly commented upon by many others, was both the source of White's expression and the well from which he drew his individuality.

The issue of what we might term locality is an important and instructive one. The pursuit of art photography had been from the beginning mostly an urban endeavor. In the first years it was centered in the major European cities such as London, Paris, Dresden, and Vienna. In this country, with Stieglitz' assumption of an international leadership role in 1902, New York took over from F. Holland Day's Boston where there had been significant activity early on. But there was ambitious work being done in Chicago, Pittsburgh, Philadelphia, and St. Louis too. The fact that White emerged from the small town environment of Newark, Ohio perplexed some of his critics, and some of those who would attempt to copy him, but it also informed them of the basis

33

for certain envious qualities felt in his work. These had to do in part with what was believed to be the expression of an idyllic way of life in contemporary, modernizing America. White's art was frequently compared to what was called rural literature: novels and short stories by writers like Mary E. Wilkins Freeman of New England, whose realistic picture of the country life was frequently mentioned in the criticism of White's pictures. Sherwood Anderson, White's compatriot from Ohio was yet to write his greatest stories, but later he also would be seen as having a vision similar to White's. Another comparison, more visual in nature and particularly related to his depiction of women and children as, for instance, in "The Ring Toss" of 1899, was that made with the work of John Singer Sargent or William Merritt Chase. White's work may also be seen to reflect the mood of the pastoral school of American painting, notably late Impressionist in style, as in works by artists such as Otto Henry Bacher, Frank W. Benson, Thomas Dewing, Theodore Robinson, or J. Alden Weir among others.

White's handling of the genre subject, that of everyday life depicted realistically, derived, as we have said, in large measure from his understanding of those rituals of ordinary life that gave space and completeness to that life. In their celebration of elemental things his pictures told a story. Each image, when taken with others, was part of a larger narrative. His critics recognized this quality and frequently remarked that each picture was as if from a story, but never telling it completely. Hartmann wrote, "in his pictures one can read as in an open book."[15] His was a photography of a spare but wondrous clarity, and the facts of his life, such as his family, became metaphors in his work.

It is understandable then to recognize the influence on White's work of the popular illustration used in such magazines as *Everybody's, The Metropolitan Magazine, Munsey's* or *Scribner's* as sources for his compositions of incidental life. One artist in particular, Albert E. Sterner, whose popularity was very high in the 1890's, might be singled out as representative of many others.[16] What is especially fascinating, however, is what occurs when White is commissioned, as he

15 Ibid.
16 Throughout his life White kept collections of magazine issues such as those mentioned here and earlier, and clippings of articles from similar sources pertaining particularly to art [see notes 2 and 3]. Another such article, "American Art and Foreign Influence" by W. Lewis Fraser, *The Quarterly Illustrator*, 2:3–10, January–March, 1894, is devoted to the work of Albert E. Sterner.

was in 1901, to take up literary illustration himself. Through the assistance of Stieglitz, White received the commission to illustrate a new edition of the novel *Eben Holden* by Irving Bacheller. From this commission he received another, in 1903, to illustrate a narrative for *McClure's Magazine,* "Beneath the Wrinkle" by Clara Morris. The photographs used in these publications have interest in comparison to his others. One can sense in them a relative incompleteness in their depiction; a stronger sense of the dramatic moment as the scene has been excerpted from the continuity of the verbal narration, a sort of narrative dissolution. In the context of the publications, the pictures are successful and, like motion picture stills today, they struggle in any attempt at summation. When compared to his other pictures, which had struck some critics with their sense of narration, one recognizes how these writers intuitively understood that White was not illustrating, but summarizing experience. In illustration one seeks only to reinforce information already held. Joseph Keiley, in praising White's work, set aside the aspects of illustration when he wrote, "[the] subject with subtle poetry leaves much to and stimulates the imagination of the observer."[17] It is this attribute which differentiates our response between the straightforward illustration pieces by White and his painter sources, and White's more original works.

When White decided in 1904 that he had to devote himself fully to photography, he also realized that eventually he would have to join the mainstream in metropolitan New York. In 1903 he began to travel there more frequently to see Stieglitz and others. As an aspiring artist we can suspect that he was becoming victimized by Midwest claustrophobia, but whether he knew that in moving he would be abandoning the key to his success is not clear. Nonetheless, he felt the pressure building in his work. In his letters to Stieglitz from this period he indicates that he was in a "rut" as far as his photography was concerned. Once away from Ohio, in addition to taking on the pressure to earn a living through photography in an unfamiliar environment, White was forced to abandon the unique inspirational source of picturesque possibilities that were his Ohio imagery. Some have argued that his work did not change appreciably once he moved to New York; that even though he did not address urban subject matter found there, his pictures were, nevertheless, very much like his earlier ones. This is clearly not the case. It is

17 Keiley, op. cit.

not only a quality of lyric and local poetry that they have lost, it is a quality of knowledge that they have lost.

Half of the photographer's work is the discovery of his subject. White had grown up in a world that was more or less explained. He photographed against a background of knowledge. While in Ohio he was still close to the rituals and social ways of village America and his photographs celebrated them, the life of an Ohio village, and the events that gave grace and completeness to that life. They also celebrated elemental things, the time spent in the fields or woods, the simple pleasure of unhurried living, the playing of games in interior spaces. They gave beauty to the Ohio village life, every little variation, all of the varied emotions. White, growing up within an extended family, knowing nothing else, had no real sense of other societies and his pictures thus had a kind of fortification against the outside. They were his private epic. When White moved to New York one could say his youth was over, his supports went, and it is clear that he was not fully secure. While in Ohio, White had eased himself into knowledge. To photograph was to learn. Once he was forced to abandon his photography in the intensity he practiced it in Ohio, he was to find himself with incomplete knowledge. All of the varied emotions that had made up the rural order of his birthplace were no more. As experience provides the material for all of us, so White needed new experiences in the city to make his photography work.

As a photographer, we can rightly speak of White as having a primary career that spans the period of about 1897 to 1907 or perhaps 1909. In this space of ten years he made a remarkable number of images, most with an intensity of feeling that may be said to inspire true admiration. After that, the less frequent pictures lose the indelible mark of conviction and affection.

What this shows is that locale is important, as well as the degree of commitment which is required to sustain important artistic endeavor. Photographers of the first rank understand this innately; those who do not, still recognize the critical density of thought and emotion required to photograph and seek to attain it. Knowledge is what feeds both thought and emotion. White understood this, and though he did not speak much about it, there is evidence in his observations on teaching to suggest that he understood what had happened to him and how he must alert others to the same pitfall. Some writers rebuked him for being a teacher of female dilettantes, especially in his summer classes. In some measure he probably

was, but the core curriculum in the New York school, founded in 1914, reflected a belief in professionalism at the highest level.[18]

Clarence H. White was surely a good man. One writer, no doubt meaning well, called him a "simple man." There are numerous portraits of him, including a self-portrait of 1925 made as part of a collection for members of the Stowaways, a social organization of artists, graphic designers, and others. Most formal, posed portraits, such as this one, show him in the guise of the artist photographer as is customary with such images. In 1912 Alvin Langdon Coburn made a portrait of White for the collection *Men of Mark*. This work was published and White's colleagues presumably had their opinions about this portrayal of him. White and Coburn were close friends and we assume that White assented to the way Coburn depicted him: heroic in stature, with only the head and upper torso shown from slightly below, clothed in a light shirt with a dark artist's scarf tied around the neck. White's shoulders are tilted in a rakish manner and his gaze is to the right, away from the viewer, and no doubt toward the source of some unseen inspiration. It is altogether the romantic conception of the artist photographer. A truer rendering of White would have him much more humble, even pedestrian in appearance. It would be a candid image showing that he was practically never without a suit and tie, except when in Maine with his family where he affected wearing a sailor's outfit, somewhat in the spirit perhaps of his friend Day, who was often attired in a North African burnous. White, in contrast to his description in some posed representations, was a very gentle man, soft spoken and probably loving to a fault. He never sought material reward, something which caused hardship for his large family of a wife and three sons. But his strengths lay within him and were seen in his perseverance and in his steadfast adherence to the honest beliefs that he vested in the medium of photography and the pursuit of art. After he moved to New York he had adventures of a sort, but it was the affecting and fulfilling strength of his imagination from his early years that carried him along throughout the rest of his life. His career was a slow progression out of

18 White's summer schools, beginning first in Maine in 1910 and later in Connecticut, were undoubtedly modeled on the earlier summer courses offered in Ipswich, Massachusetts by his Columbia University colleague, Arthur Wesley Dow. Dow also came in for similar criticism. See Frederick G. Moffatt, *Arthur Wesley Dow (1857–1922)* (Washington: National Collection of Fine Arts, 1977), pp. 92–103.

a homespun tale which had been his childhood and youth and early fame. He died young, seemingly in mid-sentence we might say, in his early fifties while photographing with students in Mexico City in 1925.

Modesty, simplicity, conviction, and decency; in retrospect these are the feelings we derive from the portraits of White – both the formal images and those candid pictures of him teaching in Canaan, Maine, or in New York. Max Weber, a painter and an instructor in White's schools, once said about White that he was a kind of poetic pioneer in photography and Weber likened his work to the pictures by Vermeer.[19] Weber went on to speak of White's aestheticism and his sensitivity. These traits are those of a contemplative man, suited more to repose than to boldness of action. White and Stieglitz infrequently saw eye to eye as the years passed, but as Alvin Langdon Coburn has suggested, they were similar in their love for photography and in the promulgation of it as an art form.[20] In the pictorial photographic movement there were those like Hartmann and Caffin who could write perceptively about its sources and techniques, and even its applications, and there were those like Clarence H. White who could demonstrate in his reverent way exactly what its accomplishments were.

Reverence and beauty are both terms and ideas that appear early and throughout the commentary about Clarence H. White and his work. Criticism about his work most always reflected also a respect for White himself – the photographer's photographer, one who lives in and through photography. Julia McCune, his first pupil in Newark and one of his most important early models who appeared in "The Orchard" and other pictures, remembered him as "the greatest man I have ever known, a radiant soul, who urged me never to do anything carelessly, but with considered beauty."[21] And Charles Caffin, in introducing White's 1908 portfolio in *Camera Work*, referred to his "instinctive reverence."[22] Thus in trying to find the center of Clarence H. White it would seem that we may cast aside the various facts of his life and the nuances of his times and we need only identify his unfailing reverence for beauty to know we have found the man.

19 Interview with Max Weber, September 8, 1960.
20 Letter from Alvin Langdon Coburn to Peter C. Bunnell, September 1, 1960.
21 Letter from Julia McCune Flory to Peter C. Bunnell, February 24, 1960, and interview, October 29–30, 1960.
22 Charles H. Caffin, "Clarence H. White," *Camera Work*, 23:6–7, July, 1908.

OBSERVATIONS ON COLLECTING PHOTOGRAPHS

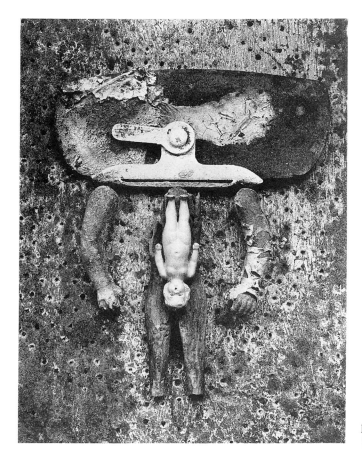

Frederick Sommer,
Valise d'Adam, 1949

FOR ANY PERSON seriously concerned with the visual arts there is no question as to photography's significance with regard to modern art. However, understanding photography as a medium of creative expression is a more individual and complex matter. It is not my intention to make a case for photography here. But it is my belief that photography, whatever its position, suffers more from a lack of confidence on the part of curators, critics, professors, and collectors than from any reasoned critical analysis regarding its aesthetic position. This guarded stance is manifest in the outright rejection of the medium or in an extremely cautious view of its creative

"Observations on Collecting Photographs," *Print Collector's Newsletter* 2 (May/June 1971): 28–30.

potential. The reason for this insecurity is clear enough – photography lacks a comprehensive literature, and the primary responsibility for this situation rests with the restrictive art history departments in our major universities which do not encourage young scholars to enter the photographic field, not necessarily as specialists but as informed members of the arts community. Until this situation is corrected, and the full substance of the medium is more widely known and respected, articles such as this on collecting original photographs will have to deal simply with the preservation of historical photographic documents, ephemera or "photographica," gossip about speculative purchases or rising auction prices, and, in general, commentary on practically every subject other than the issue of quality.

Quality in photography rests with the works themselves and to collect photographs is to become conscious of a certain kind of object. The essence of a photographer's conception is realized only in the original photographic print. Similarly, the unique qualities of the photographic medium may only be found there as well.

In general the concept of collecting photographs is as old as photography itself. The very spirit which gave rise to the invention of the medium was the desire for a method to reproduce in multiple fashion the most significant images of the past. With the altogether unexpected characteristics of the first processes and the freedom of the camera, the question of reproduction was rapidly put aside only to be replaced by a more problematic one: Was the traditional concept of veracity as a criterion of excellence open to challenge? And, if so, did this then make of photography some form of art? The nineteenth-century photographer, not having sought so direct a confrontation with tradition, understood neither the enormity of the debate nor the complexity of the potential solutions.

Over the last century and a half, there has been a progressive development clarifying the creative basis of the medium, so that, what we have today is a body of work which *is* the tradition of photography: the legacy of artists like Atget, Stieglitz, Moholy-Nagy, Weston, White, Cameron, O'Sullivan, and others, who believed in the medium and formed it through their vision. This has all been made more meaningful by the simultaneous exploitation of mechanical reproductive techniques which resolved the demands that photography could not meet in its basic form. Photography

is understood today in terms of our visual imagination, and photographs are now seen to embody ideas which transcend the pictures themselves.

Much of the present-day activity in collecting historical photographs (works from the last century) is related to an ignorance about the medium; which is to say, that for some a little knowledge generates the fascination to acquire what is believed to be rare, irrespective of its visual significance. In most instances, we do not know precisely how many prints were made of a given work or exist today. But in many cases, the printings were rather large. Before the mechanical reproduction of images caused a revolution in publishing, photographers were their own publishers as well as picture makers. Frequently they were called upon to produce sizeable numbers of prints for wide distribution in illustrated books and as single images. Alexander Gardner's two volumes of Civil War photographs is a case in point. This album of one hundred original prints, which has recently become a collector's prize, was published not for presentation to a few but as a commercial venture involving many copies. Similar examples occur in the work of Timothy O'Sullivan, George Barnard, Wm. Henry Jackson, Francis Frith, Maxime Du Camp, Nadar, Julia Margaret Cameron, P. H. Emerson, and others. Today it is not difficult for us to imagine the establishments that were necessary to fulfill the demand for quantities of original photographic prints. The practices in the traditional printmaking media, beginning before the last century, are clear enough.

After mechanical reproduction the photographic medium changed drastically. Photographers no longer produced quantities of original prints. They relinquished their role as publishers and dealt more with the "right" to reproduce from their pictures. This single fact importantly differentiates the practices of the last century from those of the past sixty or seventy years. Thus the most difficult aspect of contemporary photographic practice for collectors to grasp is the ease of multiplication which is an integral part of the medium and which may or may not be exploited. The mistake most commonly made is that since there is no limit on the number of prints obtainable from a single negative – vast numbers of prints must exist. *Conceptually* and in terms of any physical deterioration of the negative, this is true. But in actual practice this capacity for unlimitedness is not pursued, and a study of the more recent history of photography

clearly proves that most photographs would be described as rare. Reasons for this are numerous. The most important is the photographer's compelling motivation to pursue his creative vision with the camera and not pursue printmaking as an end in itself. The majority of photographs derive from this pictorial mode, and when one considers how different this is from the "inventive" process of the printmaker in other media, the point becomes clear. Frequently a photographer will make only one or two prints from a given negative, and apart from specific requests for an exhibition or a purchase, these prints may be the only examples in existence. Such requests are often limited in their number, and from my experience, they are far fewer – even at their most numerous – than the present-day editions being established by other printmakers. The key point, of course, is that there is no declaration of the number of prints produced. Unless the negative is destroyed, the potential to have additional prints made will always exist. The death of the photographer establishes one form of guarantee – that no further prints will be made by his hand. Then it is up to scholarship to establish how many prints exist to that point.

There has never been a significant motivation for declaring "editions" of photographs. Until a greater number of collectors begin to significantly support living photographers, there is no necessity to change. A photographer finds it difficult to dispose of even twenty-five prints of a given work. There are also limited edition portfolios of original photographs, and recent examples include works by Ansel Adams, Diane Arbus, Paul Caponigro, Walker Evans, Leslie Krims, and Brett Weston. In each case the size of the edition varies, and in only one case, to my knowledge, is there the written guarantee that no further prints will ever be made of the works appearing in the portfolio. One of these portfolios is produced in an edition of one hundred copies. While such a declaration of an edition establishes a rarity for the portfolio itself, it may also be that this practice frequently causes the production of many more prints than would otherwise be the case. In effect it is a return to the practices of the last century. The photographer once again becomes picture maker and publisher. Additionally, few photographers wish to limit themselves to an exact and arbitrarily determined number of prints from a negative which may prove to be one of their most important or popular photographs. In most respects the declaration of editions has more to do with the

packaged object's assumed value than of the image itself. For the serious and discriminating collector, both institutional and private, it would seem that the greater challenge is to build a collection based on personal taste and the best of a photographer's work.

To follow this latter suggestion is to learn of the many complications in the photographic medium. In preparing the photographic print there is constant variation and many photographers, who regard the printmaking aspect of their work as an integral part of the photographic process, view each printing of a negative as a unique creative experience. Their craft is always changing, not only with the subtleties of technical accomplishment and taste, but by the forced variety brought on by the manufacturer's alteration of materials. The range of processes available to the photographer over the years is one of considerable variety: daguerreotype, calotype, albumen, carbon, Woodburytype, Aristotype, gravure, palladium, platinum, silver compounds, gum-bichromate, etc. To understand how these processes relate to the photographer's pictorial vision, and subsequently to the reputation of a collection's quality and selectivity, demands considerable knowledge and expertise. For example, a modern silver print made from a negative taken in 1923, but originally conceived to be printed on platinum paper bears only a partial relationship to the original or first print. Platinum paper is no longer commercially available and thus circumstance, quite outside the photographer's control, establishes a singular rarity for the first print. Conscientious collectors should first seek the 1923 print. Each print must be considered on its own terms, and the uniqueness of printing or the additional variants of cropping and presentation can only be detected by careful scholarship. Such research is analogous to that expended on the various states of works by Dürer, Hans Burgkmair the Elder, Gauguin, and practically every printmaker. It is to the point to note here that not a single *oeuvre* catalogue exists on the work of any photographer.

The current manifestations of photographic editions pose questions of serious import to collectors and future collectors. Is the reprinting of existing negatives and the making of prints from negatives not made by the photographer at all, but through the copying of existing prints, acceptable? Exceptional caution should be exercised in these areas, not simply in matters relating to the expenditure of funds, but in honestly facing the question of whether such practices are consistent

with the aesthetic of the photographer whose original work is involved. Many photographers printed their negatives during their lifetime on various materials noted above. Some have allowed others to print under their supervision – or at least they signed the finished prints – but this is a practice frequently used to excess, and the serious collector should study the matter thoroughly and gain, for himself, a sense of the importance of such works and the consistency of the efforts in terms of the whole of the artist's work.

In certain cases, works by several photographers have been printed posthumously by their former associates or relatives, and the documentation of these works has been kept at a high level of honesty and clarity. However, there is always the possibility of fraud. As the field of collecting expands, considerable emotionalism gains over true critical expertise in establishing value and quality. In the case of printing from copy negatives and marketing the prints with all the trappings of assumed and dubiously acquired rarity, institutional and private collectors must exercise extreme caution. If the collector places emphasis on the techniques of original printing in photography, particularly in terms of the now extinct processes, and not solely on pictorial documentation, then these latter prints are relatively worthless. On the other hand, if an institution is interested in certain educational functions of photographs, certain facsimile copies are perfectly acceptable. The point is that the purchaser must understand exactly what is being bought and why.

In this short a space all of the many problems involved in collecting photographs cannot be mentioned, much less discussed. But by way of a conclusion there is one area of growing concern, especially on the part of institutions already involved in collecting photographs: that is conservation and restoration. Again, as with the photography field in general, not enough study has been undertaken in this area. Photography is a chemical process of the most changeable sort. Improper procedures at the time of production or in the care of photographic prints can lead to their serious deterioration. In recent years several conferences have been held to discuss these matters, but as yet no conclusive literature has been brought together in a convenient form. The manufacturers of photographic materials have also been lax in their attention to this matter. In general it may be said the care of photographs once the property of the collector is related to the care of any print – essentially one of paper conservation. However,

such a declaration is not enough. There is perhaps no more fragile printmaking medium than photography, and it can only be hoped with the increased interest in the medium, proportionate funds and attention will be directed to assure the future existence of the masterworks of photography.

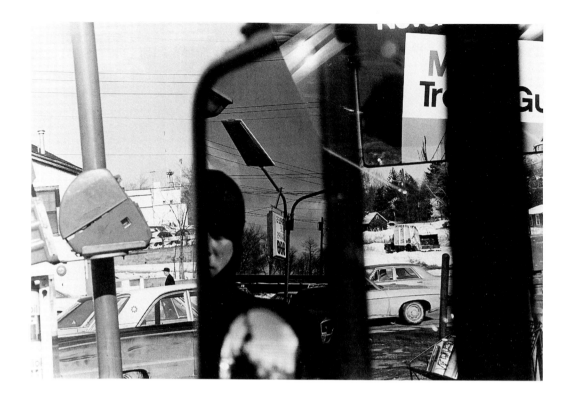

Lee Friedlander, *Filling
Station – Rearview Mirror –
Hillcrest, New York,* 1970

IN RECENT MONTHS one has been able to recognize a tense
anxiety in many of the people in the photography community
having to do with whether the considerable interest in serious,
expressive photography, felt by a large segment of the ed-
ucated public, will last. Is it a fad akin to those which may
be consistently found in popular culture, or is this interest
reflective of something more meaningful? Has it come too
late? Is the medium acquiring an overly safe historical per-
spective and is this interest, or more accurately this acceptance
of it as an art, the signal of the medium's own academicism
and eventual demise?

This interest in photography may be seen to be reflective
of the fact that people are deeply interested in science. Today
they have turned to it in increasing numbers, not only for
pragmatic solutions to physical problems, but also for a cer-
tain spiritualism. The church understands this and it is jus-
tifiably concerned. In this context photography, which at its
most fundamental root is a scientific medium over which the

"Why Photography Now?" *New Republic* 177 (October 29, 1977): 25–27.

artist exercises control, is seen by many to be the art form of the modern era. I am convinced that because of its understandable practicality and its austere, machine-made appearance photography is being appreciated today as a positive manifestation of modern scientific endeavor. The realism of the image is also an issue of consequence, in that this progressive sort of realist art is seen to be akin to scientific observation. Information gathering of every sort is the norm today and photography is a part of this apparatus of contemporary information systems. Even accepting it as an art has become assuredly without danger.

Man's role in the manipulation of science is becoming understood. Photography was never a theoretical science, but rather a practical technology. The earliest 19th century argument that photography was a kind of miraculous, self-operating art was replaced by the understanding that man had always been the manipulator of the process and this is now taken for granted. Moreover, in recent years photographers have been seen to be not so much artisans of a manipulated craft as they are now admired as social and esthetic commentators relying heavily on their powers of selection and significant presentation. After years of trial and error in making images and promoting them, the public has now come to recognize that the photographers who have done this are educated, intellectual and emotional beings whose values are to be respected and whose endeavors in the arts are akin to those who chose writing, painting, or musical composition all during these same years. That is to say, the expressive content in photographs has at last been perceived.

To select a subject for a photograph is an act of responsibility. Taking possession of a subject by photographing it immediately establishes an identity for the photographer. The public has ascertained these choices and we understand their stylization and their validity, and we have learned from them. Seeing photographs frequently, as one cannot help but do now in museums, commercial galleries, at the universities, and in the press, has created a fundamental revision of habits in thinking and feeling about the medium. Likewise, the frantic and transitory nature of the video image, most commonly seen as television, has increased interest in the still photograph, including the fostering of a nostalgia for old journalistic and documentary images, some of which were once the mainstay of the printed media. We can witness events live on television, but curiously it is not possible to reflect on these images. Such reflection is an aspect of our historical

sense and likewise, may be seen to be fundamental to the documentary photographic esthetic.

A sense of history is a very large issue today. Interest in our past is at an all time high and the past which seems most vital and within reach is that which spans the photographic age, roughly since the mid–19th century. Historical and personality photographs are most in demand and apparently most deeply appreciated not only by collectors of the medium but by those persons interested in the picture as an artifact from a precious lost time. The fact that all photographs exist in the past must never be forgotten, and that the precise moment the picture is made is the decisive conclusion of the immediate present. The one thing a photograph cannot do is record the past – real or imagined. The medium operates solely in the present and its product instantly *becomes* the past in and of itself. This places the photographer at a unique position from which to project his commentary, but it is also one which demands revolutionary creativity. The power such a sense of image has over one is immense and, it seems to me, is the basis for so much of the interest in straightforward photography today. Contrived or manipulated imagery, out of the more painterly synthetic tradition, while of interest to an inner circle in photography, has less esteem with the general public because of the cliché of the recognizable and the scientifically direct.

In the 19th century the sheer abundance of photographic imagery and the pace at which it was created was immobilizing. It was something which could not be controlled, and for the intellectual community, accustomed to works of a more measured and reflective sort, photography was a threat to the established order. Quite apart from the favorable attention on the part of some artists and writers in observational or realistic art, the photograph, like so many advances in science and scientific thinking, undermined the prevailing value structure. Photography may be seen as the first true substitute for experiential reality. The photograph gave the illusion that what was in the picture was real and by experiencing it one could experience truth itself. Not only that, but the photographers believed that what was true, or at least apparently so, was also relevant and interesting. Instead of attempting to understand these interpretations more fully and to either accept or expose them, the intellectual community shied away altogether. Writing about photographs was pretty much left to those who also made the pictures.

At the beginning of this century Alfred Stieglitz attempted

to change this, and in some measure during the years of his Photo-Secessionist organization, he was strikingly successful. However, beginning in the '20s when he sought to articulate his philosophy of photographic esthetics through his photographs which he called "equivalents," the world of self-conscious artistic photography again closed. Unfortunately this turn to estheticism had the reverse effect of essentially turning off for several years a great number of people, including perceptive critics. I believe that even though this school of photographic thought continues, two essential changes have happened to alter the general critical situation today. The first is the continuous evolution of the journalistic or documentary realistic photograph which, since the '30s, has been typified by the work of Cartier-Bresson and Walker Evans respectively. These artists have been generously promoted by major museums around the world and the clarity and apparent directness of their vision has liberated many from the prejudice of a narrow elitism for or against the medium. Their work, and that by the younger contemporaries who have followed them, has caused an enormous interest in the medium by critics and the public alike. A second occurrence, less precise, is that the literature of the more esthetic side of the medium has increased over the years, especially since World War II, and so has the reservoir of rich substantive imagery; for instance, that by Minor White, Aaron Siskind, and Frederick Sommer. Perceptive critics, sensing a meaningful evolution which was seemingly occurring without them, have now begun to express a serious respect for the medium in spite of some early hesitancies and, indeed, even a continued hostility toward the work of the Stieglitzian school. The important point, however, is not the opinion of these critics, but the fact that they have joined a kind of literati which always existed in the most inner circles of the medium and thus have closed a gap and brought photography into the arena of public concern and opinion. Commercial dealers were quick to follow on board when it was discovered that the public's interest, once encouraged, extended to the purchasing of actual images, and that this public which was being so impressed did not necessarily harbor the reservations of some of the critics, but tended to follow the guidance of the historical chroniclers who had identified the major figures in the development of the medium regardless of esthetic or stylistic persuasion. Collectors and curators are still largely following the age-old approach to self-confidence in such matters; that is, to select acquisitions from the list of

historically established figures indexed in the most respected or widely read history texts. This situation should not surprise anyone who has similarly followed the rise in the postwar print market.

These same issues and manifestations which have appealed to critics and the public have attracted practitioners to the field. There are probably no more serious photographers working today than in the past, but through the vehicle of publication, of gallery and museum exhibition, their notoriety has increased. There used to be a strong sense of working in a precious, yet privileged vacuum. This situation has now been replaced with a certain pride in the medium itself, perhaps even a sense of political avant-gardism, which is pleasantly combined with the first opportunity to receive some monetary reward for their efforts. But in spite of these positive manifestations the photographic community still harbors an apprehension about it all. I think this is nonsense and that the state of the art is only now approaching maturity.

THE CURRENT ACCEPTANCE
OF PHOTOGRAPHY

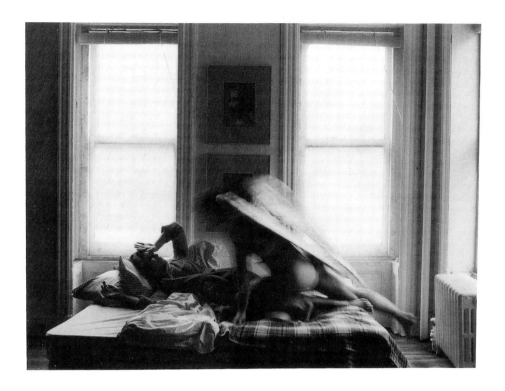

DURING THE YEARS since World War II, a certain malaise has been rather widely felt within the community of expressive photography having to do with a frustration over the public's indifference to serious work in the field. This feeling was nothing really new – it may be seen to be as old as photography itself – but for these more recent devotees, even the Photo-Secessionists' term "the struggle" remained poignantly apt sixty years after they coined it out of a similar frustration. Well the struggle now seems over, at least in some measure, and I thought I would never hear from some of these same people that photography is now being overwhelmed by acceptance. Judging from the number of new books and magazines devoted to photography, the quantity of articles in art and general circulation periodicals, the honors heaped on some of the most famous photographers, and the significant exhibitions in our museums and galleries, one very

Duane Michals, from the sequence *The Fallen Angel*, 1968

"The Current Acceptance of Photography," *American Federation of Arts Newsletter* (October 1981): 2, 6–7.

important issue is becoming recognized at last. It is that some photographs are made by artists, and with respect to the medium itself, more persons now realize that it is not the referential component of photography that is paramount, but rather that the poetic content and motif are reflective of the artists who have used these devices to reveal their vision and especially their morality. But be cautious – the current state of affairs may not be all it seems.

The most tangible interest that has been focused on photography is notably that of the marketplace, which seems to abound with photographs for sale. Quite apart from the effect this activity has had for the stimulation of the field generally, and the art market economy in particular, its importance to the practicing photographer is beginning to be significant. Expressed through tangible monetary support, this public acceptance of photographs as works of art has now made it possible for some artists to commit themselves to the field and to earn enough to truly concentrate their attention on it. This fact goes far to point out one of the most important and vital developments occurring today, and this is the maturation of a new generation of committed and highly accomplished photographers whose creativity will surely reveal much of our changing identity during the 1980s. These middle aged photographers are the inheritors of such living American masters as Ansel Adams, Harry Callahan, Aaron Siskind, Brett Weston, Frederick Sommer, Barbara Morgan, Eliot Porter, Edmund Teske, and Walter Chappell, to name only a few members of the older generation. It is this flowering of another generation as mature artists that will assure the vigor of the field tomorrow. In this context, I am thinking in particular of these photographers: Jerry N. Uelsmann, Lee Friedlander, Ray K. Metzker, Emmet Gowin, Robert Heinecken, Paul Caponigro, Robert Adams, Garry Winogrand, and Duane Michals. The oldest of these artists is fifty-three, and the youngest is forty.

The joy of witnessing a younger artist wrestle with the adoption of an evaluative and individual stylistic stance is a pleasure for anyone deeply interested in contemporary art, and it is also a stimulating reflection of an expressive medium in its own process of growth and development. For some an even greater joy is derived from witnessing the unfolding of a lifetime career into that nearly effortless gesture of the mature artist. For many years, it was not possible to observe either of these processes in any depth, because we did not have the forums to regularly view current work by photog-

raphers, young or old. The number of museums showing photographs was incredibly small, and the commercial galleries, where this activity is now regularly situated, were practically non-existent. Since 1970, all this has changed, and it should be seen that this is the truly significant revolution in photography today. Think of it – possibly more photographs have been published by the international auction houses and the commercial galleries since 1970 than were published in scholarly and critical studies of the medium in the past century. Some may doubt me, but I believe all of this exposure ultimately serves to focus attention on the spiritual, rather than the material, quality of the work produced.

While we are all much impressed with the vitality of the current market for original photographs, prices remain ridiculously low for quality work in photography. This is due, in part, to a misunderstanding of the multiple quantity of the images. Impartial scholarship in the field demonstrates that there are far fewer images of a particular photograph than would be the case with a print, a lithograph, or etching by an artist such as Rauschenberg or Johns for instance, and this is especially true for those photographers of less notoriety. About the only case one could cite that is really similar to the widely accepted artists in other media is Ansel Adams, but his work must be seen to be an exception within the entire field. As some dealers would say, his work is accessible, a sure thing. In the case of several photographers such as Alfred Stieglitz, Edward Weston, and Frederick Sommer, there are instances where only single examples of particular pictures exist. Because these facts are not widely known, the potential for substantial sales is undermined, and most photographers of reputation still earn disgracefully little from their work. And in spite of what I have said about the vitality and meaningfulness of the group of middle aged photographers, the old adage that it is a hindrance to be a living artist unfortunately still holds. When one compares prices in other media to the modest price for a work of considerable originality and true significance in photography, say a few hundred dollars, one quickly realizes that economic security in photography is yet to be realized. Prices do not guarantee that great art will be produced, but then neither do no prices at all.

There remains a serious lack of available literature to determine the connoisseurship issues – the number of prints of a particular image, the variant prints of negatives, and even the range of a photographer's work and the institutional hold-

ings of it. Probably the traditional catalogue raisonné is not the answer, but some more substantial form of career documentation must be developed before a change in the dynamics of acquiring photographs – by collectors and institutions alike – can occur. It is not that purchasers lack the necessary funds or even taste, rather it is a lack of courage to accept the aesthetic value of the work and the lack of confidence in the originality of the photographer's vision.

As to this latter aspect, we recognize in it one of the most demanding needs for scholarship in the field. The critical studies of photographers' works are few. We are only at the point in the study of the medium where we have undertaken a kind of census of just what is known about the medium's history, specifically what pictures there are. There are few true masters yet unidentified; indeed, one of the interesting things we discover about the medium's history is the degree of insight that critics and connoisseurs had for the significance of artists at the time they executed their primary work. It is only that the larger public remained unaware. What we do not have is the in-depth knowledge of the body of a photographer's work researched and analyzed from the perspective of individual creativity and personal expression.

Most of the major critics of photography who receive popular recognition tend to focus on the nature of the medium itself, from an ontological or social point of view, rather than illuminating the goals and aspirations of the artists themselves. If we had such information we would be in a much better position to understand, and in my view, to appreciate the true contribution of the photographer to the art of the modern period. Even sound general knowledge about the field of art photography is lacking. Too much publishing in photography concentrates on the element of nostalgia for people and places and too much on journalism and documentation. Students can study the history of art at our universities today and never encounter photography at all; that is, other than perhaps in the sense that an author or teacher wishes to deride a painting by saying it is "photographic," or if one wishes to point out the source for a photorealist work. Few seem to go further to ask *why* an artist would use a photograph as his source at this point in time.

But returning to the larger issue, it is no small criticism of the art historical establishment, for while its previous members may be excused because of a lack of readily available data (including simple knowledge of the photographs themselves), this does not excuse the current generation from ac-

cepting the responsibility to explore the field utilizing the more abundant resources and information now available. There is not a single survey art history text available today that includes photography. The numerous discussions of the influence or significance of photography vis-à-vis painting in the nineteenth century are pertinent, especially for painting, but they also serve to obfuscate the inherent qualities of the photography done during those years, and it unnecessarily carries over into the study of the work in the twentieth century, where for instance from the time of Alfred Stieglitz forward, there has been unique expressive substance in photography and inventive formal creativity. There should be no misunderstanding, however, and it should be firmly stated, the medium has affinities with all cultural expression during any period. It is not that photography seeks to be outside culture: what is being asked is that it be seen as integral to it. With respect to any point of view, a medium that produced three million images a year as early as 1853 cannot simply be ignored.

For American art, this is particularly critical. Photography as a medium of modern creative expression is a particularly American phenomenon. Taking his lead from the British, French, and German precursors of just before the turn of the century, Alfred Stieglitz and his colleagues in this country vastly expanded the movement of pictorial photography. The effort was supported through his organization the Photo-Secession, which functioned between 1902 and 1917, and their publication *Camera Work* was the most influential showcase and journal of aesthetics in the medium until *Aperture* was founded by Minor White and others in 1952. The important point here is that throughout this century photography has played an integral role in American visual art and even in its literary movements. Photographers were a part of, and sometimes in the vanguard of, major movements of artistic expression throughout the century, and the body of their work serves to articulate the ideals and concerns of our aesthetics in discernible ways. As long as persons persist in looking at photographs as images of things, rather than as images of ideas, this point will be elusive if not simply rejected.

The way in which serious photography existed and flourished in the United States was through the very educational system of which the previously mentioned art historians were a part. Those photographers who did not succumb to commercial illustration or journalism were forced to take teaching positions in our colleges and universities. This fact alone sep-

arates the construct of the medium in this country from its European counterpart, where a similar opportunity never existed. Were it not for the academic community of artist photographers, the field most surely would have withered and possibly died, remaining just one of journalism or illustration, such as was the case in Europe until very recently. In large measure, the fact that some European artists who recently defected from other media now utilize photography to achieve their expressive goals has given the appearance of a well developed photographic stratum in various countries, but in actuality there was no comparative depth to it even if one reminisces back to the heady days of Man Ray, Moholy, and Rodchenko. But even with our own rich twentieth-century background, art officialdom in the United States has only recently recognized the unique station of photography here. For instance, it was not until 1978 that a photographer, Harry Callahan, represented the United States at the Venice Biennial. This is incredible in light of the number of artists in photography such as Paul Strand, Ansel Adams, Imogen Cunningham, Aaron Siskind, and Minor White, who were at this forefront of the medium since the fifties and who would have added considerably to the presence of the United States in such international arenas.

To return to our younger maturing artists, this group will propel the field for the foreseeable future. A challenging aspect of their work is that no single formal concern of stylistic direction seems to be dominant. I doubt this will remain the case. Every technique from large format to miniature camerawork is utilized. The sophistication of printing techniques in such work as Uelsmann's and Gowin's is impossible to describe with respect to their method and their virtuosity, and the expressive delight in manipulating the surface of the image, simulating a wide variety of media, with the work of Michals and Heinecken to name only two, seems a particularly meaningful tendency now as one sees a resurgence of the colorist and the decorative in the work that encompasses them all.

The life of these photographers as artists is revealed in their work. This belief is not so widely recognized. We tend to want to associate the plethora of detail in a photograph with reality rather than with the complex interior being of the photographer. The simple notion that what is there is there overlooks the whole fundamental aesthetic tenet that while the photographer does not have the opportunity to omit from an overall composition certain details, he ultimately has to

control, arrange, and finally accept each and every one of them as part of an intentful totality reflecting his own self. Otherwise he rejects the image altogether, and we never see it. It is this concept of the photographer's responsibility for the photographic image and the demand to read such an autograph that still eludes so many people. This usually results in a misplaced judgment about serious photographs, not recognizing that to a large degree what we perceive the world to be has been, for the last century and a half, what certain photographers have told us it is – based on what they believed it to be. The true subjects of photographs are within the photographers, and they require only a realized selection from exterior reality via the camera to make them tangible in an image. It is not that our younger maturing photographers are more aware of this than their predecessors that makes their work pertinent today; rather it is the fact that they are creating images in a contemporary environment in which this purposeful act is more widely understood, thus giving hope of our increased acceptance of them as artists pertinent to the eloquence of our time.

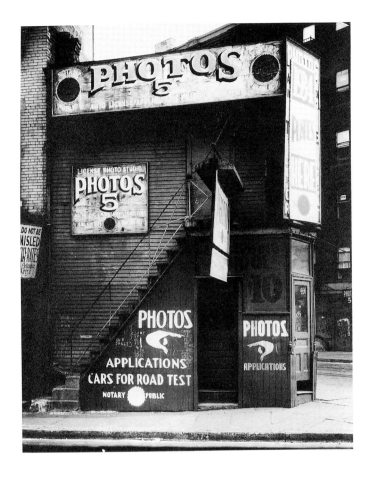

Walker Evans, *License-
Photo Studio, New York,*
1934

WALKER EVANS / AN INTRODUCTION TO HIS WORK
AND HIS RECOLLECTIONS

SOME TIME AGO a reviewer attempted to construct a picture
of the 1930s by listing the names Walker Evans, Busby Berke-
ley and Franklin Roosevelt. While each in a curious way
relates to photography, it is fascinating to consider what the
name Walker Evans would evoke. In the last few years Evans'
photography, through which he probed the physical and psy-
chological environment of the '30s, has come to represent the
era even more vividly than memory, a fitting testament to
this highly selective and interpretative artist.

"An Introduction to Walker Evans' Work and His Recollections," *New Republic*
175 (November 13, 1976): 27–29. Lincoln Caplan, ed., "Walker Evans on Himself,"
New Republic 175 (November 13, 1976): 23–27.

The power of such art to evoke the image of a whole period relates to the photographer's genius in selection. In an analogy rather close to the Darwinian thesis, it may be said that the corpus of Evans' work is reflective of a process of natural selection. From all the visual data, Evans isolated subjects which he then carefully refined, so that like biological modifications, they were transmitted to us as the most vital and the most suitable. These subjects do not merely show a period, they symbolize it.

Walker Evans was a man of acute visual perception. He had a profound sense of the American myth and a marvellous sensitivity to materials. He has become the progenitor of the contemporary approach to photographing which is most frequently referred to as documentary. However, this term is extremely ambiguous and it should be used with caution. In Evans' photographs his subjects are not stereotyped or sentimentalized, but displayed in terms of their inherent qualities and meanings. In stressing the importance of the subject, especially the presence and factual identity of that subject in relation to its social environment, Evans offers us a picture which in formal terms is organically unified around the subject. His photographs strike us as more powerfully revealing of a specific period in time than those by many of his colleagues, and it is the static, frontal approach which Evans adopted that constitutes the measure of his realism. The self-conscious framing and frontality of an Evans image exploits the fragmenting properties of photography by calling attention not only to the specificity of the angle, and to the edge of the photograph, but precisely because of this, to the world outside of the picture's limits. One is forcefully made aware that in every way the subject extends beyond what is pictorially presented; that a world exists beyond the world of the image and it is not the realism of the image that provokes this awareness, but precisely its measure of stylization.

This stylization, which has been identified as unique to Evans, cannot be defined as simply showing things as they are. Evans, as he did again in this last conversation, always insisted that the photographer remain outside of his work. But in saying this he recognized the precise stylization of his detachment, and he also knew how completely he permeated his pictures such that they could not be separated from him. Even his later photographs taken on New York subways with a concealed camera demonstrate this fact. The mistake so many have made is to assume that there is no style at all. In part this may be because even the moral values which Evans

expressed were so universal that they appeared not to be of Evans, but of every one of us. In the projection of his style, from his first pictures in 1928, when he was 24, to the last, Evans did not develop; he simply continued. When he began he had both his themes and his form.

The volume of Walker Evans' pictures from the Farm Security Administration files in the Library of Congress, is a document of considerable importance for it uniquely chronicles the concept of precise selection which has thrust Evans to the forefront of 20th century photographers (*Walker Evans Photographs for the Farm Security Administration 1935–1938*). The book reproduces the entire *oeuvre* of Evans' three years with the FSA, from 1935 to 1938. It graphically demonstrates the photographer's personal dialogue between selection and rejection, and it beautifully illustrates how some photographs do emerge almost perfect. To my knowledge no such volume of photographs, reflective of this sort of catalogue *raisonné* approach, exists for any other photographer, and I understand that Evans was not too pleased with its publication. The artist should have the right to edit his own critical perceptions, but from the standpoint of our need to understand the medium, and of how Evans has come to dominate his field, this work is of major import. It is the sort of thing we need more than the artist. The artist already knows what he has done. This book should not be confused with a pictorial art book, for while the reproductions are of adequate study quality, their importance lies in their totality and their relation one to the other like pieces of an archaeological mosaic. The editors of the book, however, have tried to accommodate both conceptions, and 63 photographs are reproduced in the classic pictorial format of one to a page and then the entire collection of 488 images is reproduced within ruled spaces approximately three by six inches, three to a page. Jerald Maddox's text is informative but not integral to the real content of the book. The book may also be used as a catalogue for ordering prints from the Library.

Two of Evans' most lasting and complete contributions to the conception of his time are the volumes, *American Photographs* (1938) and *Let Us Now Praise Famous Men* (authored with James Agee and published in 1941). In having this complete record of Evans' FSA photographs we come as near to having preparatory studies by an artist for a finished work in photography as one can. In photography the act of selection is primary and private, both in the field and in terms of final presentation. Usually only the photographer knows what

were his options. We can now see concretely that Evans' eye was so fine for the organization and sequencing of each of his books that nothing in them could profitably be changed. It also points out how fundamental the book format was to the conception of his work. He saw it both in its literate and literary sense, and while he felt the photograph could not be "a story," he used the book for precisely this purpose. Evans' pictures were always published in a contextual format, from his first book, *The Bridge,* with Hart Crane's poetry, to the essays in the pages of *Fortune.* This new publication presents what we rarely have in the medium – evidence of what was left out, left out of certain photographs and included in others, and left out of the selection process in sequencing the books. We come to understand the enormous challenge which he faced in making photographs out of the very ordinariness of his subjects; for instance, look inside of Floyd Burroughs' home in Hale County, Alabama, or at Frank Tengle's front porch and one will come to understand the structure of Evans' stylized seeing and the measure of his morality. Like all art, photography is composed of making value judgments and of solving problems.

Evans is one of the few photographers of the first half of the 20th century to have sufficient public documentation of his life and ideas to provide for their reading. With Atget, Evans' visual mentor, so little is known that one questions nearly every aspect about him with the exception of the existence of his work. Stieglitz, one of the other distinctive photographers of the century, is still something of a mystery though his correspondence, now in the Yale University Library but as yet unpublished, is infinitely revealing of the man and his work. The publication here of the transcript of Evans' last public talk is significant for both his biography and the study of the medium. Evans' observations are important because they give insight into his work and his recollection of events and goals. In this context Evans' views on Stieglitz are revealing, and in attempting to clarify Evans' work in terms of documentary or art, it is relevant to discuss the two in some detail.

Evans always regarded Stieglitz with a certain disdain, feeling his estheticism was too egocentric. It was difficult for Evans to realize the battles Stieglitz had won for photography because they were all over by the time he came on the scene and the fact that these victories, in a way, enabled him to begin. I cannot accept Evans' statement when he says that even early on he was never bothered by whether or not his

pictures were art. It seems to me that Evans was always closer to Stieglitz than he cared to admit. In their approaches each believed in the spirituality which is inherent in objects; that to see beneath the appearances of surfaces is to reach a greater truth. The camera, which begins with appearances, can, when respected, reveal these inner meanings. Truth was to be discovered as much as it was to be constructed. In subject selection each man found the point of departure for his beliefs. Values were set by what one made a picture of. Stieglitz expressed his humanity through the subjects which were meaningful to him. Evans did also.

What Evans found most problematic with Stieglitz was reconciling what he felt to be a contradiction between Stieglitz's idealized esthetics and his concepts of social equality. Evans, like so many of his artistic colleagues of the decade, believed in the nobility of poverty. It was not the economic poverty of their own lot, which was indeed a fact, but the poverty of others. These artists sought out the places where the potential for this expression was most visibly apparent – the poor South and the tenement streets of New York. This historical advocacy lead Evans to the style of his work which, like his subjects, was pure, direct, spare and sharp. He sought to find the fiber of spiritual substance beneath the surface of things in order to express his rejection of the dichotomy thought to exist between economic poverty and spiritual wealth. To Evans' credit he never succumbed to a romanticism of poverty or a burlesque of its seriousness. But he also preached no corrective which was, of course, one reason why he was outside of the main thrust of the documentary movement which surrounded him in that time of political reform. It is also why Evans is now seen as the most substantive documentary photographer of the period.

Nature, which was more to Stieglitz's liking, held little interest for Evans who said, "I am fascinated by man's work and the civilization he's built. In fact, I think that's *the* interesting thing in the world." He might have referred to the certain rationality of civilization as compared with the irrationality of nature. In this sense Evans could not accept the capricious photographic accident or make such images as Stieglitz's "equivalents." I do not think, however, that he fully understood Stieglitz's cloud pictures or recognized that their approaches to the medium were really very similar. Stieglitz's stylization was not that far removed from Evans', for whom abstraction and realism – seemingly categorical opposites – were unified in a purely photographic synthesis.

Evans' description and stylization of facts was as personal and as esthetic as that of Stieglitz, or indeed of Flaubert, the writer he most admired. As an FSA photographer Evans never really fit into the scheme of the group. His pictures were too abstract to be illustration which, as we all know, shows us only what is already known. They were not considerations of facts as facts, but realistic statements of literary symbolism. Locating and judging a subject is an act of personal responsibility, because the artist identifies with what he sees by photographing it, and he in turn is identified with it. Evans, when speaking of freedom, is referring also to the responsibility of the photographer who intrudes on privacy and "takes away" the owner's property by photographing. He made these people and artifacts so thoroughly his own that we now locate them most clearly in his photographs, and, if we could encounter them again, we would see them through his eyes. He appropriated whole aspects of our society and gave them back to us as only he could discern them, and in so doing his photographs confer reality upon their subjects.

WALKER EVANS ON HIMSELF*

You are at a point where I embarked about 40 years ago more or less on my own. I am self-taught, and I still think that is a good way to be. You learn as you go and do. It is a little slow, but I think that's the way to work. . . .

I have had a good number of years of more or less compulsive photography; I am devoted to it, and I still get a great deal of excitement out of looking at things and getting them the way I want. However, you won't find me overly intellectual about what we are all interested in doing.

I work rather blindly, and I don't think an awful lot about what I am doing. I have a theory that seems to work with me that some of the best things you ever do sort of come through you. You don't know where you get the impetus and the response to what is before your eyes, but you are using your eyes all the time and teaching yourself unconsciously really from morning to night.

There are several tenets that go with this craft of ours. One of them is that the real gift and value in a picture is really

*Two days before his death Walker Evans spoke to a class at Harvard about the course of his life and work. Here follow his remarks, edited for *The New Republic* by Lincoln Caplan.

64

not a thought; it is a sensation that is based on feeling. Most people in our tradition are basically rather scared of feeling. You have to unpeel that before you can really get hot and get going and not be afraid of feeling.

We are overly literary, really, although I am very much drawn to literature; but I cannot recommend that as an approach, and I keep trying to tear it down because words are abstract things, and feeling in a sense has been abstracted from them. However, feeling remains in the action of producing pictures. Although photography is more descriptive than music, it still is not a story. Although I have a feeling that much of my work is literary – or is done by a literate man because I read a great deal – it is still a way from abstract thought into . . . feelings abstracted from reality.

These words are all relative. No one knows what reality is ultimately. We are rather drawn toward it. That leads me to observe another thing that came into my mind over the years. That is that the young are drawn into photography because in their minds it is associated with the approach, at least, to reality – bearing in mind, as I said, that you don't reach any of these abstract words like "love" and "honor" and "patriotism" even, and "pride." Those are all approaches to an absolute that is never reached. That goes for the word "art" too. Nobody knows what art is, and it can't be taught. I'm repeating a little bit here, but it's the mind and the talent of the eye of the individual who is operating this machine that produces what comes out of it. He selects, whether consciously or not, what he is doing; and that really leads to the question of style.

One really doesn't associate a machine – a little box with a glass in it – with the personal imprint of the operator, but it is there, and it's a kind of magic, inexplicable quality. After years you begin to tell right away who has some style and who hasn't and who is behind what piece of work you might be looking at. You all know a Weston when you see one; you all know an Adams; and you all know a Cartier. That is their style; they have been strong enough and persevering enough to imprint it on that paper.

I started with a tiny, little six dollar vest-pocket camera that doesn't exist any more – a fixed-focus arrangement. I used that at first, way back in 1928. Like almost every boy, I was given a box camera, and I got interested enough to develop films under red light in the bathroom. I still have some of those things around. They have a little style to begin with; they are straight at least! But unartistic.

That's where I was alone. Most photographers were very uneasy in my youth, and they were all uncomfortable about whether what they were doing was art or not. I was never bothered about that.

Looking at what I was doing, most people didn't think it was anything at all. It was just a wagon in the street or anybody, but that turned out to be what I presume to say was its virtue.

I just found that this was my métier and walked blindly into it. That was a good thing because I hadn't had much experience or sophistication or study in the field. Again, I just brought my feelings to it. That left me alone, which is a good place to be; it's a little painful at times. I didn't associate with photographers; my friends were writers and painters mostly, and a few musicians. However, I was lucky enough to discover without working for it what I was, namely an artist; and I didn't have to be belligerent about it or fight through all the prejudices about artists and their place in society or civilization. I just fell into that slot – rather creamily, I might say.

Creamily. The word just popped into my head! It doesn't mean it was easy; it means that I belonged. You know that you're home when you're in the slot that's made for you. A lot of people suffer years trying to find that; it just came to me.

I think too much, though, and reading leads to introspective inaction. It's a Hamlet quality. I haven't got a rational structure and the expressible, critical opinion of what the object in front of me means on second thought. I do these things pretty much by instinct, and I have learned to trust that instinct. It took me a long time to feel sure of what I was doing. Now I know that when something appeals to me, I don't have to think about it; I just go right to it and do it.

If you are at all sensitive, which artists are supposed to be and usually are, it could make conditions psychologically impossible if you're aware of people too much, so I just go about my business unless I find I really am hurting somebody. I *am* intruding mentally, but I know it's not for a harmful purpose, and it doesn't do anybody any harm. If I find myself opposed very strictly, I stop. There is no use getting into an argument about what you are doing. I walk away and think about something else and do something else.

(When I started out I was living) . . . very shabbily and

mostly in Brooklyn or Greenwich Village. It was a pretty good time to be there; there were some remarkably serious people, and it wasn't frivolous. We didn't have any narcotics, and we couldn't afford to drink, so we were sober most of the time. That's why I'm alive today. A lot of people came along later who overindulged in those two things and damaged their lives and health and brains. You know, don't you, that a brain cell disturbed or killed or ruined specifically by alcohol does not – unlike other parts of the body – replace itself; so many people who started drinking rather early in life are braindamaged or dead.

I wasn't interested in the commercial or advertising end of photography or the fashions. Since those were the high financial rewards, they were crowded with competitors. I was quite alone. I didn't feel that I was competing with anybody. I would be now because this crowd is rather militantly noncommercial – quite rightly. It's sort of hard on them, but they are. I didn't have any support; among a few artists and friends I did, and that was enough to keep me going. Since there wasn't any money – that's a ridiculous phrase, there's *got* to be something to eat – but there wasn't any check to put your mind on. Even eating wasn't very easy or very well done.

I had a small circle of admirers, but I wouldn't call it a public. I waited a long time before I got anything like that. I don't know precisely when.

(Recognition) makes anybody happy a little bit. You have to take it with some misgivings, however, because it is shot through with falseness and snobbery and wrong values that you know better about than to get aboard.

I think any man who thinks at all clearly is very wary of it. I've seen too many awfully good people ruined by it. However, I didn't have any financial support for a long time, so I was rather severely disciplined. I had a certain renown before I was able to earn money. I keep saying it, that there wasn't any money around, but you had to do *some*thing about putting food in your mouth. Of course, most of us were outside the pale and would do almost anything to get a can of beans and didn't care whether it came out of the gutter or where it came from.

I have been making them (photographs) all the time. Well, it's generally sort of straight photography. I get interested in objects a good deal more and more now. It's sort of like collecting, and I get started and am attracted to that naturally.

I'm interested in signs a great deal right now, so I find that I do signs whenever I can find them. I usually swipe them too; I've got a wonderful collection!

I *do* have a critical mind, and it creeps in, but I am not a social protest artist, although I have been taken as one very widely. If you photograph what's before your eyes and you're in an impoverished environment, you're not – and shouldn't be, I think – trying to change the world or commenting on this and saying, "Open up your heart, and bleed for these people." I would never dream of saying anything like that; it's too presumptuous and naïve to think you can change society by a photograph or anything else. It's a debatable question, of course, and many people say that some books have influenced government decisions. *Uncle Tom's Cabin* comes to mind as a book that is supposed to have changed a certain atmosphere; I don't know – I never read it. Anyway, I equate that with propaganda; I think that is a lower rank of purpose. I believe in staying out, the way Flaubert does in his writing. Of course, you can't be entirely subjective, but I don't think you ought to intrude. It's rude in a way to say, "This is the way I see things." It infers (*sic*) that you ought to see it that way too.

I am a little more sure at some risk of self-satisfaction of what objects in civilization draw me. I have tested it often enough. I can trust myself to go down paths now that perhaps I wouldn't have had the nerve to penetrate before. That doesn't mean that I think that everything I do makes sense, but I am a little less hesitant about going into some things that I haven't been into before.

Let Us Now Praise Famous Men wasn't published at first because it didn't suit the editors, fortunately. They were at a time, you must remember, when it was rather silly – when there was no money around or business around – to publish a magazine luxuriously called *Fortune;* and they were confused and uneasy, and they didn't think this fitted – and indeed it did not! It didn't even fit the first publishers who asked for it, to see it.

It was finally published in book form by Houghton Mifflin, and it was completely silently received. I think that nobody bought it. (Its eventual success) was a rather spectacular instance of resuscitation of cast-off material, and of course the world is full of unsung riches around. If you put your mind on it, you could go out today and find very fine work that no public has ever wanted to see or been brought to.

Well, I was overawed by (Praise). I immediately felt that

I was reading great prose. I was rather too much overawed by it because I could have been of some critical assistance. In fact, Agee asked me to do some editing, but I wouldn't do it. I still think that is a great book. It has many flaws, of course; but it is a very big and large and daring undertaking and a terrific moral effort, as one reviewer said.

I'd known (Agee) very well. I knew him a long time before we went down there. I was in very close sympathy with that mind; I am very impressed with it. I disapprove of a whole lot too. I had a much more objective approach to artistic raw material. He was very subjective. He used to shock me. I have inhibitions about exposing the personal ego and feelings, and he seems to think that is *the* material and that that is one of the functions of an artist – exposing obscure and hidden parts of the mind and so on.

I think it was Oscar Wilde who said that no poet or even critic who is really an artist is a very good judge of other work. There are notable examples, such as Proust being turned down by André Gide, and Joyce couldn't make any sense out of D. H. Lawrence or vice versa and neither had a word to say to each other. I am a little bit more knowing about photographers, and I have a few friends, but not many. I am very interested in young talent, but that is really the only reason I ever expose myself to them. I like to see their minds and their work, but I don't talk very well (about photography). Also it descends into a form of invidiousness if you begin to talk about artists or producers who are in a sense competitors too. You don't want to be caught running them down because that is unethical really, I believe.

I am very fond of several I would be glad to name: Robert Frank, Lee Friedlander; Arbus was a great friend of mine and great favorite. There are a few others, and then there is a whole crowd of unknown, almost nameless, very gifted students in the universities now. There is a wave of interest in this; I think this is partly for the reason I worked out in my own mind that it looks like an honest medium. Now that is a very untrustworthy idea; you have to be careful how you kick that around because it infers that many of the young are in there because they don't know any better or have been taken by a fad or fashion. That isn't quite true, and it isn't fair to the young to say that.

Every artist who feels he has a style is a little wary automatically of strong work in view. I suppose we are all a little insecure. I don't like to look at too much of Atget's work because I am too close to that in style myself. I didn't discover

him until I had been going for quite a while; and when I did, I was quite electrified and alarmed. . . . It's a little residue of insecurity and fear of such magnificent strength and style there. If it happens to border on yours, it makes you wonder how original you are. Of course the world is full of instances of people intellectually and artistically discovering a style by themselves and being unaware of someone doing the same thing. I've had that happen to me several times.

I have a certain street snapshot affinity to Cartier-Bresson, and I was working that way before I knew anything about him, so that squares me with myself anyway and makes me fear it a little less. Some of that feeling in looking at Atget is despair too that we haven't got the wealth of material that he had except for older towns. You can see what has happened to London and Paris in the last generation; those things that he was doing are hard to find now, and they were just the whole ambience at that time.

When I was young – it was just before the Great Depression – this was a very unpleasant society in the sense that if you weren't interested in commerce and business and commercialism in general, there was no place for you. You had to make one. It was very hard to stay outside of the great sweep of material prosperity, which of course fell on its nose in the '30s. Then there was no use looking for something to do anyway; you *had* to make it yourself. That was a good thing for many artists, I think, because they didn't have any sense of guilt about not being in business or Wall Street or some place like that. They couldn't get in if they wanted to. There was no place for them. You may come to get to know that firsthand yourself! It looks as though there is that sort of thing around the corner. It may produce another good bunch of artists, which is all I'm interested in. Really, I feel rather stony hearted about it, but I have suffered so much from the psychology of it that I don't care very much whether this country prospers or not. I don't want to lead the world or be part of that machinery.

We have a terrible pressure on us all in this country to prosper personally, and you probably feel it already. I think underneath that is really what my parents wanted was for me to do that because they thought they were being nice to me and saving me the agony of poverty; but they didn't succeed! I succeeded.

Every man's feeling about his civilization is formed by himself out of the surroundings themselves, and they often are not very original for that reason. I got prejudiced in my

feelings by the bitterness of the failures of the society which were so evident before any reform took place. You see, anyone my age has lived through a subterranean or almost automatic social revolution of great change. It was a hateful society, and that embittered all people of my age. It was very fascist unconsciously, and all authority was almost insulting to a sensitive citizen. You either got into that parade, or you got a bum treatment. That changed a great deal, of course; its recognized historical landmark seems to be the Wall Street crash, but that's just a convenient peg to hang it on. That was certainly coming, and that awful society damn well deserved it. I used to jump for joy when I read of some of those stock brokers jumping out of windows! They were really dancing in the streets in the Village the day Michigan went off money and the banks all closed there.

I haven't got a hell of a lot of respect and certainly not much love for the structure of American civilization. I think the government is kind of a joke really. However, when you think about it a little deeper than that, you realize that those flaws and imperfections go with the *idea* of democracy, which upon examination is a pretty wonderful idea.

Like all the young, I went through a time when I was too much of a perfectionist and too much of an idealist. You have to discover, as you probably already have, that those are erroneous forms of thought; they don't work very well or stand any tests or function. Thinking along those lines leads you to see with your critical mind what is behind some of the faults and errors. . . . The idea of democracy is laughed at in very sharply critical circles; but it's a pretty lofty conception, and it's remarkable that it has any functions and forms that are working at all.

I am fascinated by man's work and the civilization he's built. In fact, I think that's *the* interesting thing in the world, what man does. Nature rather bores me as an art form. It doesn't bore me to walk through nature and let it play its forces and influences on me. It's restorative, but I don't use it creatively. In fact, nature photographs downright bore me for some reason or other. I think, "Oh, yes. Look at that sand dune. What of it?" But if you're in love with civilization, as I am, you stick to that.

I think a great deal about childhood as my life goes on. I get obsessed by it. That's why you see bookshelves so full of so many memoirs. There is a time when you do turn backward – with some reluctance, I must say, because it doesn't seem to me to be the right state of mind. However,

that material crowds up, and it is so rich and so fascinating that you speculate a good deal on it.

You know, I've gone back far enough to find out that (photographing the scenes of my childhood) can't be done, and it's always a letdown and an ungratifying experience. Things don't look right. You go up to something that you knew in your childhood, and you are full of feeling about it, and that feeling doesn't come through – the object doesn't reflect that feeling. You put something in it that's no longer there, something of yourself. I avoid that strictly now, although I am very interested in the immediate past *im*personally. I've got quite a few rare records of streets – particularly slum streets in New York, and Charleston, South Carolina, and Louisiana – that have all been cleaned out and torn down, so that the whole atmosphere has been changed. They take on a tremendous appeal and beauty far beyond the level of nostalgia. However, that's impersonal; it isn't your childhood home and a bedroom and all that. *Now* I love to go into an *im*personal house. I am very interested in how people live and the material mementos they leave of their lives. That all has style too, but it's preferably to me something I haven't seen before. I don't want to be associated with sentimentality of feeling.

ROBERT FRANK/*FOURTH OF JULY – JAY, NEW YORK*

Robert Frank, *Fourth of July – Jay, New York*, 1955

CERTAIN OF ROBERT FRANK'S photographs hold a position in contemporary photography analogous to Jasper Johns' works in contemporary painting. Both artists approach their medium as a forum for problem solving and both are strongly rooted in the form/content structure of pictorial representation. In photography the issue of the integration of form and content is exceptionally difficult because of the widely held belief that photographs must be a kind of vicarious experience of the subject itself. How something is pictured is frequently ignored in the crush of simple identification, and photographs tend to be treated scientifically as factual statements. To ap-

"Fourth of July – Jay, New York by Robert Frank," *Print Collector's Newsletter* 7 (July/August 1976): 81.

73

preciate Robert Frank's work one must disregard this misguided interpretative practice because his photographs are overtly symbolic and very skillfully composed to reinforce contextual meanings.

Frank seeks to minimize the obviously pictorial in his photographs by stressing the meanings of his subjects rather than the subjects themselves, and it is the identity of the subject in its relation to its broad social environment that he strives to express. In formal terms, his pictures are organically unified around the expressive subject, but Frank rejects the static, frontal approach that was the hallmark of his most sympathetic predecessor, Walker Evans. Instead, Frank exploits the fragmenting properties of photography by calling attention not only to the arbitrariness of the camera angle and to the edge of the photograph but, precisely because of this, to the world outside of the picture's limits.

Fourth of July – Jay, New York is an image which, through all the nuances of its representation, displays and evokes an immensely complex view of American society. The purposefulness with which he incorporates this statement in the tattered and transparent flag is convincingly profound. So are the spatial planes and layers of meaning within the photograph, such that the picture exists simultaneously on multiple levels – the first is the photographic object proper, the second and third are the successively intertwined intellectual and physical layers of the participants in the celebration, of the flag and the ambiguous space in which it exists, and finally the space through it and that which is implied beyond. So subtle is this combination that our immediate experience is first of the simple and picturesque whole and only later of the total symbolic drama.

This is a photograph about ritual and ritual attitudes. Like all of Frank's work of this period it is tempered with the sharp nonobjective eye of a foreign observer. In every instance where Frank has used the American flag motif he is commenting on the literal fabric of American society. He is picturing the fundamental politicalization of this society through the image of its social emblem – the flag – suggesting with this symbol everything from individual sentiment to collective conduct. Frank is critical of his American subject, and he knew he was not an innocent abroad, as only one reading of his book *The Americans* shows. In this picture we perceive his attitude with regard to American tradition and values as uniquely represented by this particular flag. Consider, for instance, its transparency, its torn and patched com-

position, and the fact that he has not shown the whole flag
– omitting several of the stars or states. It is in Frank's act of
selection that one has an expression of purposeful intent so
rarely felt in photography. Knowing that experience is indeed
a matter of tradition, in collective existence as well as private
life, Frank is the heir of certain 19th-century photographers
who scrupulously depicted everyday life without idealizing
it. This particular photograph comes very close to being a
masterwork of photography, assuming that one feels, as I
do, that this concept is applicable to works in this medium.

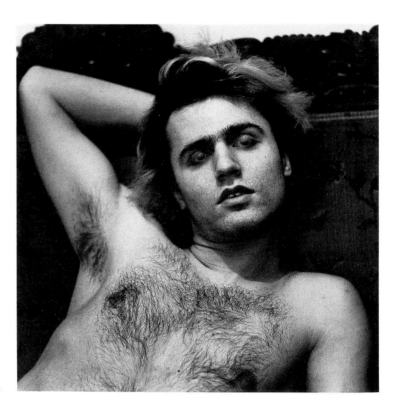

Diane Arbus, *Gerard Malanga, New York*, 1966

THE CAREERS OF artists do not always end with their lives. The posthumous fate of Diane Arbus exemplifies the way in which posterity can transform the artist's stature and the significance of his work. Prior to her suicide in the summer of 1971, Arbus was not what could be termed a well-known photographer. She had a certain reputation, which, in terms of the profession of photography, was based in part on her commercial work. In the late sixties, she had published pictures, sometimes representative of her best and most serious work, in such publications as *Esquire, New York Magazine, Harper's Bazaar, Show,* and *The New York Times Magazine.* However, she was reluctant to contribute to photography journals or to participate in exhibitions; most people, including even her friends and colleagues, knew only a fraction of her total output. She was also loath to become a professional talker (teacher) about photography. Since her death, her work has been included in the 1972 Venice Biennale – the first

"Diane Arbus," *Print Collector's Newsletter* 3 (Jan./Feb. 1973): 128–130.

American photographer to be so honored – she has been given a retrospective exhibition at the Museum of Modern Art, and a stunning monograph has been devoted to her photographs. It is questionable whether she would have participated in any of these endeavors had she lived.

Diane Arbus was a photographer of great originality and even greater purity who steadfastly refused to make any concessions whatsoever to her public. Clearly, she must be considered among the two or three major photographers of the last decade, and it may be said that the character of photography has been changed by her photographs. The influence of her work though most likely not the understanding of it, will increase each year hence. The young photographer of the future will find in her work the sources of a new modernism as well as the portents of a personality cult. But as with the photographs of Alfred Stieglitz and Edward Weston, her photographs can withstand such markings.

When her photographs were first exhibited in New York in 1967, Diane Arbus was forty-four. She was not born into the world she photographed. She came from a comfortable New York Jewish family headed by David Nemerov, who owned a once successful Fifth Avenue store. Her brother is the poet and critic Howard Nemerov. She was educated at the Ethical Culture and Fieldston schools. At eighteen, she married Allan Arbus, and together they became successful fashion photographers. In 1958 Diane abandoned this sort of photography and a year later studied with Lisette Model, that remarkable photographer and teacher whose work remains much less known than it should be. It was Model, whose own photographs show the inspired vision of an artist of fundamental human concern, who imparted to Diane the understanding that in the isolation of the human figure one could mirror the most essential aspects of society – the understanding that in a photograph the most specific details are the source of the most general conclusions. Out of this experience, Arbus moved from the unreal world of high fashion to a world composed of people who may seem unreal, or tragic, but whose culture is unfortunately interpreted through the mores of another. It is this – the configuration and imposition of a society's values – that is the root subject of Arbus' photographs.

Since her first major exhibition at the Museum of Modern Art in 1967, which was directed by John Szarkowski and titled by him "New Documents," the work of Diane Arbus has been considered in the context of documentary photog-

raphy. In that exhibition, she showed with two others: Lee Friedlander, whose precisely structured street views were seen to depict a new social landscape, and Garry Winogrand, whose seemingly unstructured pictures were nonetheless based on the strict logic of environmental circumstance. Many observers of this exhibition mistakenly compared the work of these three to that of men and women of the Depression era who, according to the narrow definition of documentary photography, attempted in their photographs to show actuality and subsequently, through their photographs, to alter the course of events. Or to put it another way, to improve and suggest social change. Materialism was perhaps the identifying concern expressed in this photography of the thirties. In contrast, the 1967 exhibition sought to show that these new documentarians, if indeed that is what they should be called, were interested in the redefinition of the freedom of contemporary life and focused on human concerns more complex than material station alone. They portrayed the nature of anyone's daily life, and the subjects of many of their pictures had not been considered meaningful for photography before. These photographers stated the distinguishing characteristics of that quality we call modernity. Their work was often ephemeral, violent, weird, excessive with that acrid bouquet of urban life which, since the 19th century, has been associated with the beauty of circumstance and the sketch of manners.

From the point of view of style, Arbus continued the prewar tradition insofar as Walker Evans may be considered to have been a part of it. For Arbus, like Evans, was a portraitist. Her approach was to devalue a person's outer garments and facts and to concentrate on the individuality of the human being with his combined material *and* mental presence. In so doing, she was no longer a fashion photographer, nor was she a documentary photographer. She had entered into the realm of larger truths – of art. One can understand how clear her approach was, even at the start of her career, from this statement she wrote to accompany a portfolio of her photographs in 1962: "These are six singular people who appear like metaphors somewhere further out than we do, beckoned, not driven, invented by belief, author and hero of a real dream by which our own courage and cunning are tested and tried; so that we may wonder all over again what is veritable and inevitable and possible and what it is to become whoever we may be."

In considering Arbus as a portraitist we are allowed many

interpretations, and these were also the opinions she consciously manipulated. The popular conception of portraits is they are ostensibly intended to show what someone looks like and they are truthful. We know they also tell about people and impart a sensibility of what the person's inner being, or character, is like. But we must not fail to realize that this is a multiple interpretation; the subject's own, the portraitist's, and the viewer's. The portrait exists simultaneously for all three but differently in each case. The individual participants are required to interpret each other by actually asking what they know of themselves. One of the things that disturbed Diane Arbus at the time of her death had to do with how misunderstood her work seemed to be, in the sense that it was thought of mainly in terms of the crudest subject identification with no self-reflection. In terms of the imitators of her photographs, these followers simply felt obliged to seek the bizarre in subject and secure a likeness on film. In so doing, they become even less than documentarians, and their work, because it totally lacks the psychological honesty of Arbus', is not portraiture. Her suicide will have to rest with our consciousness for a very long time, and even then one wonders if its meaning will be understood. It is clear she was not a voyeur. Rather she was a partner of the individuals whose true test was in living with themselves. Her pictures are about control, discipline in life, and controlled accidents in living it. In each case, the people she photographed had made the gesture of life their own affirmation of truth, and they were victorious. Her pictures are not of failures, and immorality is not the well from which these people, or Arbus, found nourishment.

Diane reminds us of Dorothea Lange, because here was another woman who was uncommonly tough. Each of these women could enter a situation that might destroy many people, and photograph, and then withdraw from the edge. We can sense this in their finest work. In this way, one can also understand something of what Arbus found in certain of her visual mentors: August Sander, Brassaï, and Bill Brandt. In the photographer Weegee, Arbus found not only formal aspects of his work to her liking, but a sense of that rude honesty which marked his relation to subject or situation. The violence he showed was often more physical, but the consequences of the situations in which both Arbus and Weegee found themselves, were alike.

Her stylistic development seemed to follow a progression from complexity through simplification to highly complex

pictures that seemed, however, deceptively simple. From photographs of people taken from a distance and in an environmental context, to a gradual close-up isolation of the figure or head and an accompanying monumentality through the physical scale of her prints, her last pictures revert again to that security of figures in an inhabitable space that exists apart from the photograph itself. It was perhaps as if, in challenging herself to move away from the type of picture that, since about 1967, she had been identified with, she chose the less dramatic, the less capable of imitation.

Arbus' photographs are superb accomplishments reflecting total control of the medium. Her concentrated work spanned a relatively short time, only ten years, but she seems to have sensed the primary hallmark of her work from the beginning. The intense, calculated frontality of her subjects affects us immediately. In this sense, her pictures are almost clinical, like Vesalius' anatomical drawings, and their heroic scale, many almost 16 × 20 inches in size, cause them to embrace us. It is literally true that when we read a photograph we are in it. We may be drawn in swiftly or slowly, but once we are there we are enclosed. It is the power of the photograph, and its success, to interest us in this way. As any viewing of the original prints will prove, Arbus' pictures are very difficult to stay out of. In fact, it seems to me, what disturbs people more than the subjects of these pictures, is the intensity of their power to dominate us, to literally stop us in mid-life and demand we ask ourselves who we are.

For the collector of original photographic prints, Arbus' work represents a fascinating illustration of aspects of the photographic medium. Save for the pictures she had casually given to friends and colleagues, and the relatively few in museum collections, her estate constitutes the bulk of her life's work. But as is so frequently the case in photography, Arbus rarely printed more images than she felt she required at any one time. For exhibition, for a purchase, or for reproduction, she made the required prints. So while the photographic medium is, in principle, capable of unlimited duplication, it is, in fact, the medium in which there are sometimes the fewest prints of any one image. It is hardly worth while for a photographer to print an edition, because the possibility of a sale of ten, twenty-five, or fifty is simply not yet a reality. Thus, when one places significant value on the personal interpretation of the photographer's own vision as carried through in the printing process, the few prints that may remain at a photographer's death become extraordinarily

valuable. Such is the case with Arbus. Judging from the information given by the Museum of Modern Art at the time of its exhibition, of the 112 photographs shown 39 were printed posthumously. Thus, at the time of her death, many of Arbus' most significant pictures were unprinted, or at least not represented with prints in her own files.

In 1971, she issued a boxed portfolio of ten photographs in a limited edition of fifty. It sold for $1,000, and it received wide publicity. It is understood that only two portfolios were sold. The subsequent value of this work is unimaginable, because it now appears that she prepared not the complete edition of fifty, but only printed each set after the sale had been secured. Such is the complexity of establishing editions in photography. The estate then offered prints from the negatives printed by Neil Selkirk, who prepared the posthumous prints for the museum exhibition. This procedure of posthumous printing is not uncommon in photography, and this practice could be the subject of a more extensive study than space here allows. One can, however, call attention to the practice of Cole Weston, the son of Edward Weston, to make from his father's negatives quality prints, clearly identified as posthumous printings, and sell them at a fraction of the price brought for one by Edward Weston's own hand. From the collector's point of view, the existence of such prints only serves to raise the value of those prints made by the photographer himself. For others, such a practice will provide, albeit too late, the only opportunity to support, in material terms, Arbus' work.

The photographic negative is what might be described as plastic, so that even though the extreme subtlety of the artist's own interpretations cannot be duplicated, a sympathetic and expert printer can render in posthumous prints much of the sensitivity of the artist's own vision. Arbus herself stated that she did not covet the role of printmaker, but this is not to say that she did not exercise exceptional care and judgment in making her prints. Her prints were indeed unique. Their tone, scale, surface, and composition reflected her vision of perfection and her sense of making of the print an object so photographic that the viewer effortlessly penetrated beyond its borders into the very environment of the subject. Her use of supplementary lighting when taking the picture – that is, not relying on simple available light to render a situation satisfactorily – allowed her when printing to have full control over tonal renderings and more convincingly create that picture space in which the subject may exist.

It should not be considered unfortunate that Diane Arbus' work is colored by the circumstance of her death. Not surprisingly, Arbus' work is now surrounded by a great deal of commentary; the personality of its creator will remain as pertinent as her photographs. Diane Arbus expressed her vision with a unique power. She pushed all the way through to the end logically, emotionally, artistically. One does not need to have seen every photograph she made to admire the courage and purity of her effort, to identify with it, and to recognize the cost. Diane Arbus, and the photographers who constitute that community of serious artists to which she belonged, all affirm Thoreau's declaration, "Be it life or death, we crave only reality."

LISETTE MODEL

Lisette Model, *Woman at Coney Island,* 1940

FOR THE PAST 25 years the photographs of Lisette Model have been more talked about than seen. Represented in few public collections – most notably that of the Museum of Modern Art – her large, commanding prints have been dear to those lucky enough to have them or even to have seen them. This fact reflects circumstances that are as much a mark of Model's personal idiosyncrasies as they are of her unorthodox and penetrating vision. She was recognized exceptionally early in her career, and some feel perhaps her acceptance was acquired too suddenly and too forcefully, diluting the poignancy of her statement and reducing her desire to more fully enact her historical fate.[1]

"Lisette Model," *Print Collector's Newsletter* 11 (July/Aug. 1980): 108–109.

1 Between 1940 and 1955 Model's photographs were included in nine exhibitions at the Museum of Modern Art.

Model first began to photograph in Europe in 1937 and she immigrated to this country the following year. She was not only encouraged but quickly promoted by numerous members of the New York photographic community – among them Ralph Steiner, Steichen, Ansel Adams, Beaumont Newhall, Berenice Abbott, Paul Strand. It was Alexy Brodovitch who, grasping the emotional precision of her work, hired her as a freelance contributor to *Harper's Bazaar*. From 1951 Model taught at the New School for Social Research in New York where she became something of a legend for the passionate character of her teaching.

What links all of Model's activities, and what her students have been drawn to in her work, is not so much a comprehensive theory about photography as an inspired approach to its problems and aims. For many her most notable student was Diane Arbus, but hundreds have attended her classes, and she is one of the few teachers of photography to be described as exemplary. While not a prolific worker, Model has a very deep understanding of the medium and this apparently has sustained her. "Only the teacher who has himself been fulfilled through his medium," she has said, "is capable of putting another student in contact with himself."[2]

This book, *Lisette Model* (1979), is an exceptional achievement in publishing. Its very existence attests to the patience and perseverance of the publisher in dealing with this sometimes recalcitrant artist. By respecting her work in its large format (generally 20 × 16 in.) and by mirroring this fundamental stylistic quality in a folio-size book, the publisher has given us a rare opportunity to truly feel the impact of these photographs – their gritty and gutsy quality. The physicality of Model's work has always been one of its most distinctive hallmarks. Had this not been echoed in the publication, much of what this emotional artist stands for would have remained a mystery to newly attracted viewers. The quality of the reproductions suitably reflects the originals and – apart from a niggling feeling that the few pictures that the designer, Marvin Israel, spread across the gutter might better have been printed singly on a page – the whole book is alive. The work literally vibrates with Model's near clinical vision. The anonymous portraits, especially, remind one of full-scale x-rays unceremoniously exposed and clipped to a light box awaiting the surgeon's diagnosis.

2 Mary Alice McAlpin, "Lisette Model," *Popular Photography*, November 1961, pp. 52–53, 134.

These photographs will probably be considered by many unfamiliar with them and their origins to be rather contemporary, but this is only because certain characteristics of her style – some notably grasped and expanded by Arbus – have given us a generation or more of photographers whose work reflects back to Model and even her predecessors. The landscape today is littered with knockoffs of their work. Model's selection of subjects and her articulation of the formal aspects of her pictures derive from the work of the decade immediately preceding the date of her first attempts: the German and Russian work of the '20s, with its belief in naked fact, its belligerence toward class and status, and its defiance of the gentility and obfuscation of art. Her large, coarse prints reflect that spirit of the '20s, in which straight photography was espoused to challenge the prevailing notions of what constituted art, especially those criteria of the aesthetically oriented pictorial photograph.

Most of Model's best photography further reflects an earlier period because it deals with the human condition – the prevailing motif of today's work might be described as one of image structure that deals primarily with itself. The human-condition photograph can be read and to varying degrees appreciated. A syllabus is not required. The other style cannot be read in the same context. The image-structure photograph intends to teach, but through another mode of explication.

Model's photographs hit her prewar American audience hard and elicited strong opinions from the very beginning. She was, for instance, notably linked with but contrasted to Lewis Hine. Commenting on the work exhibited at New York's Photo League in 1941, Elizabeth McCausland wrote, "the scorn and hatred of the photographer are directed not against the human victims but against the social forces which victimize them. . . . Lisette Model has gone . . . beyond the stage of those who can merely scorn; she hates with an active lens. The purpose of this hate is to purify and scourge. Beyond this stage, of course, there is a further philosophical position, where an intelligent love of humanity is possible. One may say that in ages of crisis, hate is love turned inside out."[3] This remarkable observation pinpoints Model's philosophy precisely. McCausland clearly articulates the attitude about aims and goals that Model as a teacher later surely gave

3 Elizabeth McCausland, "Lisette Model's Photographs," *Photo Notes,* June 1941, pp. 3–4.

to Diane Arbus. Arbus' photographs, made during the tumultuous decade of the '60s, were based on the same perception of love and hate.

The large format of Model's pictures and the fact that most were made from a 2-¼-in. square negative were aspects of their uniqueness perceived when first shown. Today it is hard for us to recall the spirited debate conducted before World War II concerning the technicality and aloofness of candid photography and the controversy between the use of the larger format camera and what was called the minicam. Model's images were praised for their capacity to reveal more, to express a sense of confrontation, and to embody a space or environment in which the subject existed; in short, these were pictures. Pictures with an unfragmented viewpoint and a holistic composition. But belief in this sort of work was limited and declined further in the late '40s and in the '50s when the miniature camera and the journalistic approach became dominant. However, interest in a larger format approach to a kind of photography vérité revived in the early '60s with photographers such as Arbus. She turned from the 35mm camera to the reflex camera in her courageous attempt to make images of a more self-conscious sort rather than simply to capture on film a vignette of the observed features of those whose lives she had entered and whose humanity had become her own. One recalls the frequently heard comment made after Arbus' work became widely known in the late '60s that she "had taken the camera away from the sneaks." Implicit in this observation is the quality of her work, like Model's, the expression of a realized moment of truth between the photographer and the photographed.

TAKEN FROM LIFE / PHOTOGRAPHIC PORTRAITURE

Your face my thane, is as a book
where men may read strange matters.
Shakespeare, *Macbeth*

Minor White, *Thomas Murphy*, from the sequence *The Temptation of St. Anthony Is Mirrors*, 1948

THE PORTRAIT IS similar to other photographs in that the subject is taken from the commonplace and presented as a focal point for our attention. The portrait also has a unique reality because its subject is catholic; that is, another one of us. The engagement which these two factors cultivate transcends other kinds of picture experiences, and its parallelism to theater is not unreasonable. It is literally true that when

"Taken from Life / Some Thoughts on the Portrait in Photography," in *Photographic Portraits* (Philadelphia: Moore College of Art, 1972).

87

we read a photograph we are in it. We may be drawn in swiftly or slowly but once we are there we are enclosed. It is the power of the photograph, and its success, to interest us in this way. The actor Nicol Williamson has observed that "acting is nothing but reminding people. It's reminding people of things. Sometimes, if it's very good, it can even remind them of themselves." The essence of portraiture lies, as I see it, in what the picture demands from us as viewers.

The popular conception of portraits is that they are ostensibly intended to show what someone looks like and that they are truthful. We know that they also tell about people and that they impart a sensibility of what the person's inner being, or character, is like. But we must not fail to realize that this is a multiple interpretation: the subject's own, the portraitist's, and the viewer's. The portrait exists simultaneously for all three but differently in each case. The individual participants are required to interpret each other by actually asking what they know of themselves. The self-portrait is extraordinary because it is a more abbreviated form of the duality between appearance and subjectivity. It is private theater in which both the creator and actor are one. Frequently it is psychologically richer, but as in literature, if we compare biographies with autobiographies we do not find that the autobiographies are in any way more truthful.

The degree of complexity in portraiture did not become apparent to all concerned until after the appearance of the photograph a hundred and thirty years ago. This was particularly true in matters of aesthetics and purpose. As for the latter aspect, commissioned portraits since the beginning of the traditional arts had a definite purpose and an interpretative bias, and by and large a rather solid record of accomplishment. With photography the reality of existence became an end beyond which such painterly considerations could only rarely project. It is true that in photography there were arguments about retouching, foreshortening, and the like, but at the root of it all there was the essential fact that the photograph was a picture of someone. The extent to which the emergent photographic process was considered nearly miraculous may be seen in how the creation of the image was vested in nature herself. Such observations as "the objects themselves are their own delineators, and perfect accuracy and truth (are) the result" were commonplace. It is no surprise that once photography appeared a new psychology of portraiture was understood. Nineteenth century photographic

portraits were frequently described as being "taken from life." This is another way of saying that as opposed to a conceptualized likeness, which had been and to some measure is still the basis of the painted portrait, here is the actual picture of someone and this is reality as we see it. While many early photographers copied the academic stylizations of their artistic colleagues, the vast majority of photographers simply made pictures in which the immediacy, mood, and physical treatment of the sitter reflected nothing so much as the individual himself and the traditionless medium.

As far as the auxiliary aspect of interpretation of character is concerned, it is clear that contrary to the view of the art historian, photography did not bring an end to portraiture. Photography truly made it possible. As a drama between people, photographic portraiture is one in which details of surface are lifted and brought to a significance of the subjective will that only a machine like the camera can capture and sustain. We can no longer hold the view that the more prolonged the work in its execution the more penetrating or complete the picture. Nor should its corollary be unwarily accepted, that the candid moment of instantaneous revelation is the more insightful approach; however, if photographs were not easy to make they would be impossible.

Each of these considerations does raise the point of the degree to which the subject can reveal himself. In the phrase "taken from life," there is the remarkable echo of what actually happens in making a photograph. Through the life process of human interaction; whether it be talk, suggestion, demonstration, or the sheer momentum of a personal relationship in which no actual contact is made, the person photographed is brought to a state where he does reveal himself. It is the moment when the actor becomes lost in his part. It is when contact between the eyes of the beholder and the subject creates a generative force. Such an occurrence clearly relates to the ancient conception that the eye is both a transmitter and receiver. The receptivity of the participants must be acute; something on the order of that state which Arthur Koestler termed "ripeness." Such a condition is also a requirement for looking at portrait photographs.

Perhaps the most fascinating of all the aspects of portraiture is that which concerns the rapport between the subject photographed and the photographer. In this context a consideration of the snapshot is illuminating. All too naively the amateur snapshot is admired by serious photographers and

artists for its formal and stylistic aspects alone. From a position of sophistication these pictures are viewed as a kind of primitivism, not unlike children's drawings. But this is only one aspect which should interest us. For while the facile way in which such pictures are made eludes considered thought, the majority of them represent a pictorial record of the most private of human relations between people. It is a curious fact, but it seems that serious photographers make very few conventional snapshots.

Because snapshot photographs represent pure picture making, where the configuration of things matters little and the content is obvious and unrestricted, their meaning is considered minimal by those not actually involved in the process. But for the individual who wished to take the picture, or for the person who wished to retain it, there is no more intimate and ultimately successful portrait in existence. The adequacy of meaning in the snapshot rests singularly on the psychology of privacy and the intensity of human reasoning. Stieglitz once remarked that when he photographed he made love. Such a statement refers not only to the generosity of human emotions but to the aspect of mutual vulnerability. Such pictures, including Stieglitz', frequently may be forms of wish fulfillment. A few photographers have aspired to incorporate both the experiential and formal aspects of the amateur snapshot in their serious work. Understandably, when we look at their photographs we find that this achievement usually occurs in maturity when the artistry of the photographer is dominated by a confidence that combines the common aspects of camera vision with the intimacy of understanding such that the photographs appear effortless and very youthful.

From the distance of a generation or less amateur photographs become human documents and take on the quality of the artifact. Frequently the identity of the subject is lost. The intensity of the personal emotion literally dissipates and the formal configuration which remains is transformed into a sentimentality not for individuals, but for the society as a whole and its objects.

There is no single form or style of portraiture. Portraiture means individualism and as such it means diversity, self-expression, private point of view. The most successful images seem to be those which exist on several planes at once and which reflect the fantasy and understanding of many. These observations on the portrait in photography in no way cover the multiplicity of the subject, but in relation to the pictures

in this exhibition, I believe they represent a starting point for self-discovery.

> He knew but so little of what he saw he
> saw only what was there.
> Wright Morris, *Fire Sermon*

BRASSAÏ / THE SECRET PARIS OF THE 30'S

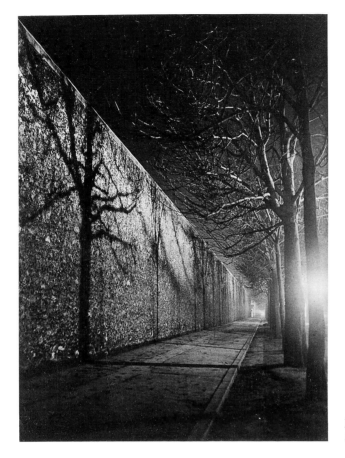

Brassaï, *Prison Wall of La Santé, Paris,* 1932

THE EASE AND relative safety with which photography allows us to examine our values and, more important, the values of others is an essential aspect of the medium's appeal. Since its inception photography has provided the viewer with an insight into the structure of culture through the selection and depiction of its outward manifestations in the real world. During its first years, photography was criticized as being too literal, meaning simply that it went against the dominating tradition in the visual arts to revere the artist's imagination and encourage his alteration of observable reality. In a short time photography undermined this tradition, and

"The Secret Paris of the 30's by Brassaï," *New Republic* 175 (November 6, 1976): 24–25.

whole new conceptions of responsibility and approach emerged in art and literature. The photographer could work anywhere and approach anything, and when it was placed in the service of the enormously curious mind of 19th century man, photography simply submerged all other media by the sheer number of its images. What began with the daguerreotype reached a peak with the stereo view. It was not, however, until the small hand camera and a sensitive functional film system were developed that the candid photograph emerged as a particular form. A photographic document based on the assumption that the camera image, made in an instant, could reveal more than the mind knows or the eye sees. This form fully emerged in the public consciousness in 1888 when George Eastman marketed his first Kodak camera and the realization that everyone, and at any time, could be the subject of a photograph became commonplace. Since that time the intensity of this concept has increased in proportion to the sophistication of the technical system and the allied emergence of pictorial journalism as a prime communicative form. Today, however, it is clear that this approach has reached a point of intellectual challenge, if not emotional weariness, such that the candid image is now held somewhat suspect. Today a more self-conscious partnership between photographer and subject has become the trademark of the cultural documentarian as, for instance, may be seen in the approach of Arbus or Avedon. It now seems more difficult to appreciate even a masterful Cartier-Bresson.

This introduction may seem at first inappropriate for a commentary on Brassaï, a photographer whose reputation is widespread following the publication of his book of Paris photographs, *The Secret Paris of the 30's*. It may be seen, however, that in Brassaï's photography we have a textbook example of candid photography being used as a tool for cultural investigation at the beginning of its golden age. The Parisian life he photographed was, in the '30s, at once both foreign and familiar, and as time has passed it has become increasingly tinged with nostalgia and fantasy. In his book, Brassaï shows the nocturnal Paris of brothels, whores, pimps, opium dens, lesbians and beaux-arts students – what is called the underworld life by everyone but those who lived it. This is his second major book on the same subject. His *Paris de nuit* (1933) has long been considered a classic of the genre.

The challenge which confronted Brassaï in the early '30s was how to photograph under difficult circumstances and without unduly calling attention to himself. It called for a

suitable craft and a good deal of cunning. Brassaï admirably solved the first problem, but his success should not obscure the interpretation of the pictures. Do his pictures reveal their subjects or only show them? In many instances I am afraid I conclude the latter, especially when they are compared, for instance, to Bill Brandt's penetrating studies of his fellow Londoners or the various photographs by Brassaï's close friend André Kertesz. This judgment may be tempered somewhat when one considers that Brassaï has never devoted his full creative energies to photography as have the other two; nor do I believe he sees himself as a social commentator. Brassaï has also achieved some note as a sculptor and artist. In his later photography he has rejected the documentary style, and he has approached other subjects and more formal issues through close-ups of graffiti (published in 1960) and highly manipulated images in the *cliché-verre* technique of Picassoesque nudes (issued in portfolio in 1967). Brassaï, in this sense, is much more the artist using photography, like Man Ray.

One aspect which, in part, strengthens our feelings about Brassaï's Paris pictures is the feeling of familiarity and true delight which he projects through them. This is what might be seen to separate him from the average journalist-photographer working on assignment; although it should be noted that Brassaï did take photographs for the illustrated picture magazines of the period and selections from this same group of Parisian night photographs appeared in the London *Weekly Illustrated* in 1934. His pictures lie somewhere between illustration and truly substantive work. Illustration shows us what we already know, reinforces attitudes already held, while a work of art challenges assumptions and, even in photography, with its omniscient realism, can change our realization of things; in short, alter our values. At his best, Brassaï's work does this, and this quality becomes most evident in his photographs when he seems less preoccupied with making finished compositions. In the instances when he suppresses his sense of pictorial order in his desire (or need) to photograph quickly and candidly, he is at his best. The portrait of Bijou, the café personality, is a case in point. The well-known picture is only the subject whereas the full figure variant is a brilliant photograph. When Brassaï chooses to exploit that most fundamental property of the medium – the fragmentary view – his vision is integrated with the medium itself and its esthetic corollary, the candid photograph.

One unique aspect of Brassaï's photographs is the quality

of his prints. They are almost crude in their physical presence – glossy enlargements, borderless, grainy, with a tonal scale which can perhaps only be described as purely photographic, or purely Parisian atmosphere, or both. There are no crisp highlights and shadows, only varying shades from a deep rich gray to a lighter gray. This is a quality which the re-production in the book cannot convey and why, in spite of the sensitive treatment the photographs receive in the book, one must see the originals. The best comparision to these prints are those by the American photographer Weegee, whose prints were meant for the newspaper engraver, but in a larger sense their physical properties were a reflection of their maker and his subjects.

An engaging writer, Brassaï published numerous books. His earlier *Picasso and Company* (1966) reflects a similar sense of enjoyable reading, particularly now with the vogue for the life of the Paris expatriate. The narrative text is divided into chapters focused on a particular subject or theme, or instance: The Street Fair, A Night With the Cesspool Cleaners, The Underworld Police, House of Illusion, and Kiki of Mont-parnasse. The pictures are reproduced without captions (these follow at the end of the book) and with the combination of black borders, white borders and full page bleeds one has the feeling that the designer was trying to bridge the same split in Brassaï's work described previously; that is, between the illustrative and the revealable.

WRIGHT MORRIS

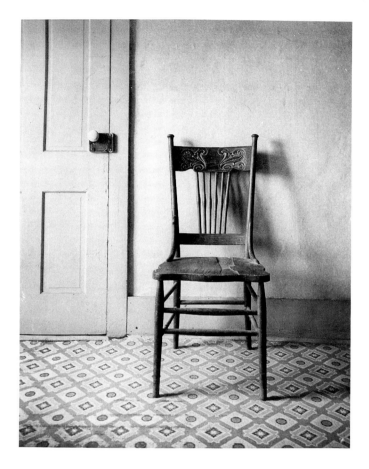

Wright Morris, *Straightback Chair, Home Place*, 1947

THE PHOTOGRAPHY OF WRIGHT MORRIS: A PORTFOLIO

PHOTOGRAPHS HOLD A curious fascination for us that is not unlike the fascination of concise, descriptive prose. Although some photographs reflect their creator's aspiration to poetry, by and large it is the actuality of things as they are that is remarkably reflected in photographs. In a sense, photographs are highly literary; and the photographer, like the writer, has to be both a master of craft and a visionary. Patient accumulation of facts and then speculation about their meaning

"The Photography of Wright Morris: A Portfolio" and "Photography and Reality / A Conversation Between Peter C. Bunnell and Wright Morris," *Conversations with Wright Morris: Critical Views and Responses* (Lincoln: University of Nebraska Press, 1977).

is the nature of authorship in both mediums. The speculation is often fictive – it may be untruthful. Perhaps untruthful is not quite the exact word. It might rather be said that the specificity of facts can give rise to heightened awareness which can evolve into heightened imagination. When considering the artist Wright Morris, we have in a single figure an exponent of the unity of word and picture. He seemingly found photography ready-made for his vision; and, importantly, he turned to it at a point in photography's evolution which found it ready-made to influence his vision.

Morris's most active photographic period spanned the decade ending in 1948. His work began out of his desire to master one kind of descriptive analysis – he wanted to treat objectifiable data so that man's artifacts could be presented as clues to the nature of existence. While it is generally assumed that the photographer is confined to reporting, Morris explores under the surface to reveal the significance beneath outer appearances. In his pictures Morris is interested in man's work – he has never been very much interested in nature. Not an anthropologist or a cultural historian, he is an exegete of action and values. Photography provided him with an objective sustained reality which enabled him to pose and solve problems of literal description. From this, as Morris has put it, the notion evolved, "that an accurate rendering of what was 'real' fulfilled the possibilities of fiction." He saw photography, in other words, as a synthesis – a drama combining the apparent duality of fact and fiction.

As a photographer Morris was more akin to the documentarians of photography's earliest period than to the contemporaneous social propagandists of America in the 1930s. Throughout much of the nineteenth century, photography was viewed as a kind of "self-operation" art in which the photographed object and the object itself were identical. Most photographers still act as though their pictures make factual statements: "This is a wall"; "This is a stove"; "This is a chair." Once one has recognized that photographs have their own meaning, however, they become open to several not mutually exclusive interpretations.

Morris reveals his approach to photography, and indeed to fiction, in the recent novel *Fire Sermon* (1971). In it he focuses on a young boy, who, after observing the household of a relative, is eloquently described by Morris, "He brought so little to what he saw, he saw what was there." This is an identification of what exists with what is seen and is characteristic of the demanding approach of the documentary. It

requires a balance between the contextual environment of the photograph and the photographed image so that the picture projects its content directly and can be read simply, even by the inexperienced. Morris aligns himself with a few photographers of his generation: Walker Evans, Russell Lee, and perhaps to a lesser extent Paul Strand. A similar approach can be seen in the earlier work of Atget and, more recently, in Diane Arbus and Robert Adams. These photographers do not abandon or deny artifice, but they aspire to suggest absolutes beyond it.

Early in his work, Morris was not far removed from certain straightforward pictorial documentarians, like Minor White, who with Morris and others were shown in a revealing thematic exhibition at the Museum of Modern Art in 1941 entitled, "The Image of Freedom." These photographers of the late 1930s rejected both the social realism of the Farm Security Administration school and the Stieglitz–Weston aesthetic. They had moved toward a pictorialism devoid of the tricks or charms often associated with the 1920s formalist style and concentrated more explicitly on human values. After about 1941 Morris turned to photographic problems even further removed from pictorialism; that is, he found his true métier in the specificity of things themselves. His photographs of this later period were taken at close range, unemotionally; they were almost gritty in their texture, insistently factual, and they reflected Morris's increasing concern with the vernacular artifact.

A photographer can minimize the pictorial by stressing the subject of his picture, its factual presence, and its identity with a social environment. The finest documentary photography offers us a picture which is organically unified around a subject. This controlled unity is the key to Morris's work. His images are not tempered with sentimentality but restrict themselves to recording the qualities of the subjects. By examining Walker Evans, who had published *American Photographs* (1938) during the time Morris was working, one can compare varying states of passivity and activism. In their quest for realism, both men take a static, frontal approach to their subjects; but the self-conscious frontality and framing of a Morris image exploits the fragmenting properties of photography. By calling attention not only to the arbitrariness of angle but to the edge of the picture, Morris refers to the world outside the limits of the picture. One is made forcefully aware that the rooms of the Home Place extend beyond what is pictorially presented, that a world exists be-

yond the world of the image. It is not the naturalism of the image that provokes this awareness but the degree of stylization in the picture. Morris does not glimpse reality, but he stares at it and, when at his best, lets it reveal itself.

Although Morris's photographs are part of his artistic development as well as part of the history of American photography, their intrinsic values remain. His two photograph-text novels, *The Inhabitants* (1946) and *The Home Place* (1948), are landmarks of their genre, brilliantly exploring a most complex form. In these books, pictures and fiction confront one another on opposite pages. They are described by some as "novels-cum-photographs" – most readers have found that the photographs "crush" the prose. But Morris never intended to harmonize the fiction and the pictures as Nancy Newhall and Paul Strand harmonized them in *Time in New England* (1950). Rather, he forged a kind of counterpoint out of the instrinsic characteristics of each medium in order to go for a larger statement. By juxtaposing picture and text, he set out to make each more, not less, than it was alone. He wanted to capitalize on the uniquenesses in each. A comparison may be made to the James Agee–Walker Evans volume, *Let Us Now Praise Famous Men* (1941). In combining pictures and text Agee and Evans used a classic, separatist format. The pictures here are separated into two "books" – all pictures together, then all text. In Morris's books, we do not read the photographs as illustrations nor the text as elaborated captioning. Morris uses words to describe the world that the photographs allude to, a world omitted in the pictures. The prose and the pictures are designed to function as a single unit.

Recently in *God's Country and My People* (1968) Morris has again used his photographs in conjunction with his prose. While highly autobiographical and refined in form, this book strives to provide examples of what might be salvaged for another generation. Morris exhibits his confidence in the timelessness of his approach to photography and to the photographic object. Nostalgia is not an issue. Instead, in this latest volume the photographs provide a checklist of the significant values which comprise the continuing American experience.

MORRIS: Peter, let's work around your idea of the photo-graph as a mirror and some of the modifications you made in playing with it. The mirror is one of the durable and inexhaustible metaphors we use in the interpretation of what we think constitutes reality.

BUNNELL: The nineteenth-century way of looking at the photograph was as a mirror for the memory, and at that time the photographs almost looked like mirrors, with their pol-ished, metallic surfaces. But really the photograph presents a kind of reality that isn't a mirror. It reflects yourself. You see in the photograph what you are. You recognize content only as you have ability to identify and then to interpret.

MORRIS: To what extent do you feel that might have been a reasonably common impression in the nineteenth century? Weren't most people overwhelmed just by the seeing of the self? Didn't they see the standard daguerreotype image as an object reflecting reality?

BUNNELL: Yes, they saw it as presenting the facts. Talbot's book, published in 1844, was the first to be illustrated entirely with photographs and it was called *The Pencil of Nature*. The image seemed to engrave itself without intervention. In ef-fect, I think they didn't interpret at all. I think they saw in the photograph what they would look at in some of yours: the artifact, the thing itself. Only later, after the daguerreo-type process was superseded by more manipulative processes and the potentiality of altering the picture was known, did the idea of the photograph as a new object really come into general understanding.

MORRIS: Was there anyone preceding Atget who seemed to be aware of the possibilities of transposing what is commonly accepted as the actual over into a possessed object separate from a mirror reflection? What about the French photogra-pher, Niépce?

BUNNELL: There were hundreds of photographers who saw, as you did, possibilities of transposing reality, but most of them are anonymous today. I think we must look for schools or bodies of photographic works rather than individuals. I've always felt, for instance, that in American daguerreotypes –

specifically in the portraits but in photographs of objects as well – the clarity and precision indicate that the photographers sensed a joining of process and object. There is always this sense of moving toward a more pictorial sensibility, where the photographic object supersedes in effect the fundamental integrity of the subject photographed.

MORRIS: The inclination is always to supersede.

BUNNELL: A lot of daguerreotypists didn't know that they were doing this. Their early manuals are fascinating because they told you everything. They are cookbooks. They told you how to get to the point of making one of those pictures but never what to make. In a way, they really had no other option than to respect the integrity of what they took the picture of. It really was only later that they began to see for itself what they had made.

When did you first know of Atget, Wright?

MORRIS: I think I saw my first Atget photographs in 1939 or 1940. An art editor from the *New York Times* gave me a group of them. I had had this little show at the New School for Social Research which he had seen, and he asked if I would be interested. There were hardly any prints of those photographs available at that time, and I had no sophistication whatsoever. But I did know of Atget, and yes, I wanted the photographs. It happened to be a marvelous group, just a marvelous group. It absolutely startled me that anybody should be seeing in such a manner at that time. That sense of being plagiarized before you are born is very tiresome!

BUNNELL: But were you conscious after that time that Atget influenced what you were seeing and doing?

MORRIS: He gave me reassurance and a sense of persistence. Now I think maybe five of those first pictures may have been portraits of women, his whore series, you know, which were extraordinary because they were so absolutely, beautifully detached and yet so good. The person is there, the situation is there, and they provided an effect of extraordinary bleakness by their sepia tone in contrast to the Paris atmosphere: it's bloodchilling. And then there were a couple taken out in the woods. There was one of a tree. I also had a picture of a tree and roots; and I felt, given the same circumstances, Atget's was a picture I would have taken. That simultaneous existence at different times of the same sensibility has always fascinated me. What I later came to was a kind of metaphysical

conviction that we really don't possess anything – we are merely the inheritors of a sensibility that moves among us. This awareness of a common sensibility gives the reassurance that I think we seek in immortality.

BUNNELL: The photograph has a strong sense of that, of immortality. In the introduction to your Venice book, *Love Affair: A Venetian Journal* (1972), you talk about salvaging the experiences of the city. This suggests the transitory nature of the thing itself and that the photograph serves to salvage, to monumentalize, to make permanent.

MORRIS: The word *salvage* is quite misleading and needs to be taken out and honed and broken down and reconsidered. Like any writer, I fall into a period when a word seems fresh and I grab onto it and it's gratifying, and then I wear the word out, and I come back to it, and I say, this word is bearing the burden of half a dozen other words and I don't like it so much any more. I'm beginning to have that feeling about *salvage*. I am just about prepared to turn it in for a retread. I am about to fall under the persuasion of my own rhetoric, so to speak; but it has an origin in an impulse that is authentic.

As an American of a certain period, I have built into me a certain sensitivity to "the arrears of our culture." I have an instinctive rejection of the fact that we constantly replace. We can speak of this habit as destroying or we can speak of it as progressive replacement, but I don't like it. There is operative in me an effort to put back the sand pile after the water has come in and washed it away. But that tendency does not serve as a real point of motivation. It is merely one of a variety of responses. When I use the word *salvage* in too general a way, I allow myself to oversimplify and turn what is a very complex relationship with an artifact into something that is quite misleading. If somebody says: Really, man, you're just trying to hang onto things that naturally have to be replaced; a kind of nostalgic mania and, basically, although this has a certain attraction and will keep you preoccupied when you're not suffering from migraine, it really leads no-where; and furthermore it does not constitute what your photographs really seem to be concerned with – I would have to say, Correct. Nostalgia is merely one ingredient.

Only at a certain point am I concerned with a holding action. You remember the Beckett quotation in the front of *God's Country and My People:* "From things about to disappear I turn away in time. To watch them out of sight, no, I can't

do it." That speaks deeply to me. Very deeply. We're dealing here with the *zeitgeist*. Perhaps everyone in this century is insecure about the persistence of the past. But there is something different too. In all artists there is something operating deliberately which is ordinarily concealed. I think there is present in any construction an effort to replace what is disappearing. I think it is like the replanting of crops.

BUNNELL: Is the photograph the replacement?

MORRIS: No, I'm thinking simply of any act that is imaginative or creative. That act appears simply to emerge, out of our nature. I am myself convinced that the imaginative activity is organic and that the mind thinks just as a plant gives off buds, and that the depression of the faculty inhibits man and destroys something basic in him. It is an absolute necessity for the mind, like the hands, to replace what is wearing out, to replace the cost of living. We can think and talk about art, talk about all its infinite labyrinthine experimentation, and forget that it comes out of this need to hold on to what is passing. The artist says, "Don't give up! Keep ahold!" Now the photograph cuts through the aesthetic of some of the more inwardly turned and inwardly developed crafts – like, let us say, contemporary painting. Just as writing resists some of the worst forms of erosion, I think photography resists them too. With both photography and writing, beyond a certain point what you do just isn't comprehensible, and you have to come back to the point of departure.

BUNNELL: You mean that the photo and writings are alike in that both are things in themselves and also refer to a reality aside from themselves?

MORRIS: These two sides of photography are something of a mania with me, and I've repeatedly talked about it. There's even a passage in *Love Affair*, if you remember, about giving up one picture to get another. That was as tactful a way as I could find to say that the camera is the first obstruction between us and experience. I think this is both subtle and almost inevitable. When you begin to be lens-oriented, the object itself is secondary and you wait to see later what it is you've done. On repeated occasions I have been very vague about what I have done, knowing that I'd see later, or I wouldn't see at all, why I had taken the picture. I waited. I *had* had a shock of recognition, but what it was, I would learn later.

And sometimes I have learned from the photograph – that

is, in the photograph I frequently learn the possibilities of the photograph. This is what happened, precisely, with the intrusion of my shadow in the picture of the Model T Ford. In the foreground you can see the shadow of the photographer and his camera between the edge of the picture and the car itself. At first I wanted to eliminate that shadow. It was a distraction toward which I had no ambivalence at all. I just wanted to get it out of there, and unable to get it out satisfactorily, I put the picture aside as one that I was not going to try to get into the book I was writing. It became a kind of secondary picture. Then coming back, about three years later, I saw that picture for the first time, and I said, Well! and I looked at it and I attempted to make an adjustment to the variety of impressions I was having from it. Gradually it began to win me over.

BUNNELL: In the farm house picture there is exactly the same kind of intrusion. The photographer's hand and his box get between us and the haystack and house which are the subject of the picture. That was made in 1940.

MORRIS: I'm in sympathy with what I learn from the scene itself, and I do not reject what I found in that picture, saying, My God, there's another intrusion! We'll just cut it off up here.

Under different circumstances something like this could have led me into a very different area of photographic experiment. But obsessed as I was with my material, I thought of it only as an incident. The possibilities and the limitations of photography can be almost summed up in this type of encountered reflection. If you are a photographer, you are obsessed with some concept of actuality. You do not want to diminish the essence of your statement, and then gradually it comes upon you that you are working as a picture maker. And so you have to reconsider and become a little less inflexible about what the medium really should be doing. At first you think you have rather clear ideas about this; it is the so-called straight photography approach. Getting away from that would have taken me considerable time, although it was inevitable – if I hadn't been diverted by the demands of writing. I did not at that point have to make the next step photographically because I was completely preoccupied as a writer.

BUNNELL: Does anything analogous occur in the writing? Do you face that shadow image when you are writing fiction?

MORRIS: Yes, the problems of the craft of fiction are not necessarily concerned with the intrusion of the writer, but they are similar in that the writer must move from one level of dealing with his experience to another level. I've never had to deal with the craft of photography as with writing, however, because by the time I reached the end of that first photographic statement, I was faced with a do-or-die challenge to simplify and make my way as a writer independent of my photography.

BUNNELL: You began your career in the thirties, and anybody who had to live through the thirties unfortunately acquired a kind of social-realist tag. You got it, but I don't think it is applicable, even though you must have been aware of the realistic photographic activity of agencies like the Farm Security Administration. Did you meet Roy Stryker of the FSA and offer to go out on tour, taking pictures of the country as they hired photographers to do in those days?

MORRIS: I was prepared to lay my hands on money if I could. I went to see Stryker, though I had at that time begun to be reasonably suspicious of his eye. He looked through a portfolio I had brought in – flipped through the pages the way a man does who has looked at too many photographs – and commented that the sort of thing I was doing was not at all what they were doing in the Department. I said I knew that but I simply wanted to show him my stuff.

BUNNELL: Were you ever in fact primarily concerned with the social implications of your pictures?

MORRIS: I still have this problem. The similarity of my subjects – abandoned farms, discarded objects – to those that were taken during the depression, and were specifically taken to make a social comment, distracts many observers from the *concealed* life of these objects. This other nature is there, but the cliché of hard times, of social unrest, of depression, ruin, and alienation, is the image the observer first receives. Perhaps it can't be helped. All, or most, photographs have many faces. The face desired is revealed by the caption. I do not have captions, but the facing text reveals the nature of the object that interests me: the life of the inhabitants whose shells they are, as Thoreau said. The social comment may well be intense, but it is indirect, and not my central purpose. These objects, these artifacts, are saturated with emotion, with implications, toward which I am peculiarly responsive. I see many of them as secular icons. They have for me a holy

meaning they seek to give out. Only a few, of course, speak out with this assurance, but if the observer is attentive he will be attuned to my pictures and how it is they differ from most others. Once that is clear, they do not need captions. He is open to the same responses I am.

Although that problem is always present, the photo-text confronted me with many others. Chief among them is that some people are readers, some are lookers. The reader becomes a more and more refined reader, with less and less tolerance for distractions. In my own case, I cannot abide illustrations in a good novel. They interfere with my own impressions. The pictures I need are on my mind's eye. Now the relatively pure *looker* will subtly resent what he is urged to read. He wants all *that* in the picture. Each of these sophisticated specialists resents the parallel, competing attraction. As you have pointed out, Peter, the photograph requires a "reading," as well as a looking – its details scrutinized in a knowledgeable manner. In my case, this was a crisis. If the photograph overpowered the text, or if the reader treated the text lightly, I had defeated my original purpose. It was also crucial for my publisher, who considered me a novelist. *The Home Place* was well received, but pointed up this dilemma. I was losing readers, picking up lookers. Several reviewers asked why this ex-photographer was writing fiction. There was only one way to clear this up. Stop the photo-books. And so I did.

BUNNELL: What was your present publisher's motivation in coming back to the photo-text book?

MORRIS: Me, I was on the verge of changing publishers, along with my editor, and I used the occasion to slip in *God's Country and My People,* a reconsideration and reappraisal of my photographs.

BUNNELL: In *God's Country* you use the same photographs that are in *The Home Place* plus obviously more. This is a different, explicitly autobiographical kind of text. Could the photographer's shadows in some of the photographs be a kind of self-portrait presence like the autobiographical text of *God's Country*?

MORRIS: You are getting very close to why I felt it necessary to do that book, and why I did it in that manner, It's a reconsideration of material from a later point in time, using essentially the same techniques and the same body of photographs. It was the quality of the repetition that was nec-

essary to this book. Both the writing and the photographs undergo a sea change in the overview taken by the writer. I didn't know what problems I would have with readers who understandably might take offense and say, What is he doing in repeating himself! But I couldn't go out and make a new world for myself to photograph, and it wasn't advisable. This is a revisitation. In fact, a repossession. But there weren't enough such readers to make any difference. Nobody raised this problem at all.

BUNNELL: Now that you are back in Nebraska, in a real revisitation, you must be challenged to deal again with things that you dealt with before, after, or through another point in time. One might ask, Why doesn't he try to find if the values which he tried to exemplify in the barber pole of 1940, say, are really of value now. What is Nebraska now? In other words, what does a writer and an artist who has this time span, do? It's something that a person my age can't answer.

MORRIS: I think this is not only a number one problem for me, I think it's also a number one problem for people of your generation. There is a diminishment of value in the artifact itself, and there is a limited way in which a photographer can deal with the diminished values of the contemporary artifact. There is a statement to be made about them, but it will be relatively shallow, soon exhausted. Young photographers, of course, orient themselves toward this problem much more positively, but I think aesthetically they face the same problem that I am aware of, the poverty of significance in the artifacts themselves. And when I come back into this old environment, I am startled by the relative richness of the old and the lack of it in the new. We call it progress. We make it new, but we do not love what we make.

BUNNELL: Judging from a photograph of your own house, you are not yourself much of a collector. I mean your house doesn't seem to be filled with artifacts, with objects. You don't seem to need things, however much you describe and photograph them.

MORRIS: What photograph did you see? Our house is bulging, but it's not a museum. Our friends get a contrary impression – or is it the difference between the actual room and a photograph of it?

BUNNELL: Here is a reinforcement of a kind of parallelism and divergence that I was setting up between yourself and Walker Evans. Evans collected like a maniac. When he pho-

tographed the soda pop sign in Alabama, he brought it back home with him. The photograph transformed it and he knew that he dominated it. Though he loved the subject, it wasn't of interest to him in his art. The picture was important, not the subject of the picture. So he brought the sign home. Look at a photograph of his place and of other photographers', and you find more than just lived-in clutter. They're surrounded by collectable artifacts, actual things. You are not.

MORRIS: I'd say it works in reverse with me. If I have the photograph, I can dispense with the artifact. The mobility of my life has made it impractical to hold onto more than books. But not showing in the photograph of our living room is an entrance and a hallway which has a group of my photographs. These constitute artifacts. In a sense they hang there by accident, not design. They were framed and put up for a Guggenheim exhibition; and when the show was over, they were sent back to me. Now it fascinates me that Evans would have had a need to latch onto actual artifacts. It's idle for me to speculate, but I wonder if there's a difference in our backgrounds. Was he mostly a city man?

BUNNELL: Yes.

MORRIS: I think that would make a big difference.

BUNNELL: I don't mean to say that what he collected was necessarily remnants of Alabama tenant farmers' houses. He was a great Victoriana collector – paperweights, and white marble – bric-à-brac I guess you'd call it. Coming back to Nebraska now, have you gone or have you any inclination to go back to these places that you lived in and photographed?

MORRIS: My God, yes. But our car was banged up soon after our arrival, during the period we had both the time and the weather. We did get over to Central City, my home place, with the local television people; incidentally, they are doing a piece called *Repossession* – we will see if it works. The Home Place, lock, stock, and barrel, was bulldozed out of existence in the late fifties. Nothing remains but what we have in the book, which does speak up for salvage. For a few days I did take a few pictures to see if there was a change in my way of looking at similar artifacts. But it was not noticeable. Much that speaks personally to me is still around, but I see little that is new that attracts me. I assume that younger photographers see it differently, but local work that I have seen is past-oriented, reflecting the vogue in nostalgia and "antiques." I sense there is a quandary in what they should

"take." And if they take *that* today, what will they do to-morrow? The vast number of photographers, feeding on any-thing visible, overgraze the landscape the way cattle overgraze their pasture. As in the novel, there is overprod-uction and underconsumption. You would know about this, and I wouldn't. In the way of *artifacts,* which is close to my experience, what is it that the young photographer loves? – or that he hates to the point of revelation? Revealing what that *is* is the one thing that still doesn't come with the camera. Or will that be next?

ELLIOTT ERWITT

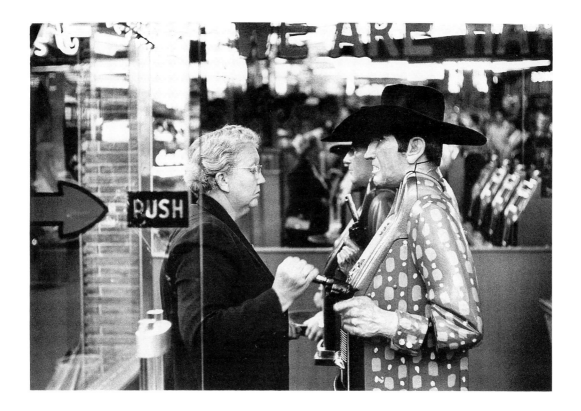

ELLIOTT ERWITT'S PHOTOGRAPHS are very straightforward. Comedy, one might say. The recognition of his subjects is swift – dogs, women, trees, birds, buildings, cannons, chairs, gourds. The recognition of juxtapositioning is equally swift, and this is crucial. The viewer who places himself into one of Erwitt's pictures will not be protected from experience, but he will be safe from outrage. He will recognize that the expression of this artist is nothing less than our humanness.

The things one chooses to photograph are rather the same, (with a similar heirarchy of tradition), as the subjects selected by any artist in any medium. Animate and inanimate objects make their appearance in photographs, but it is the way in which the photographer treats these subjects that gives rise to their meaning. Iconography, considered on its most basic level, has to do with recognition rather than treatment, and, unfortunately, in photography the tendency is to focus on

Elliott Erwitt, *Las Vegas,* 1957

"Introduction," *A Portfolio of Ten Photographs by Elliott Erwitt* (Roslyn Heights: Witkin-Berley, 1974).

111

iconographic recognition rather than treatment and meaning. In the work of a photographer like Elliott Erwitt, this problem may be clearly seen: it is hard to take his work seriously because his subjects are so ordinary. This is nonsense. Their ordinariness is only a feature of their recognition. Even the formal aspects of his picture-making seem deficient to those of limited comprehension. These functions are not important to Erwitt; that is, they are concerns which do not dominate his thinking. He skillfully centers the interest in his subjects and firmly – critically – determines the edges of his pictures. The edges are all-important, because they circumscribe the juxtapositioning of objects so that interpretation naturally follows. In this sense Erwitt may be seen as a present-day equivalent to those photographers of stereo views whose work was admired a century or more ago for similar compositional techniques, and for the capturing of the sketch of manners, the beauty of circumstance, and the bouquet of modern life.

In the study of a photograph, one of the qualities that is always felt is the degree to which the intellectual operations have been effortlessly and expertly performed. Erwitt's pictures are so charming a comedy that in order to enjoy it we need not think about how it was accomplished. Indeed, if his photographs had not been easy to make, they would have been impossible. Photographers are not often considered intellectuals, though sometimes they are praised for their curiosity, but in addition to whatever else it took to make these pictures, it took things mental, a sensibility expertly controlled, the exact like of which is not often seen in photography.

Reinhold Niebuhr has said, "Humor is the prelude to faith and laughter is the beginning of prayer." Given that humor has to do with the incongruities of life which at first seem ephemeral, while faith approaches the ultimate reality that life must end, the photographer is particularly adept at expressing humor. Photography verifies everything, from the most meaningfully wrought to the most contingent. But in so doing, it provides us with a changed measure because everything is recorded with the same accuracy, the same particularity, and with the same intensity on a sheet of paper where picture size becomes life size. The photograph itself thus becomes experience. It exists in our time even though all of the action recorded is past. Throughout Erwitt's long career he has consistently viewed the goings and comings of his fellow men with a sharp intelligence as well as a sharp

eye. His bearing is such that it allows him to be ever ready to know when a significant gesture might transcend its own circumstances to enter ours. In this way he is not unlike his fellow huntsman Henri Cartier-Bresson; however, Cartier-Bresson is less interested in the situation that will excite our intelligence than in one which will alter our physical equilibrium. Neither man is a reporter or journalist. For in his pictures each sacrifices locale for the consideration of values. The fact that Erwitt's photographs were taken in Nicaragua, Venice, New York, or Miami only identifies them; that they were made between the years 1946 and 1968 does this as well. The comprehension required to understand the meanings in them will come through having lived the phenomena Erwitt examines.

Finally, Elliott Erwitt's work is not satire. His expression is conducted without prejudice. He is humbled by his own presence in the larger whole of what he photographs. His pictures are a statement of contemporary life; an examination of certain ideas concerning life on a simple human level, but with a very clear eye to our punctilious conduct. Erwitt characterizes the world he lives in and the only world he knows. He loves the world as it is and that is why he understands it so well; that in turn is why, being the artist he is, he can make it over again into something so rich and clear. His comic touch, like the magic touch of any photographer, is one that helps us through our realities and our illusions.

EDWARD WESTON ON PHOTOGRAPHY

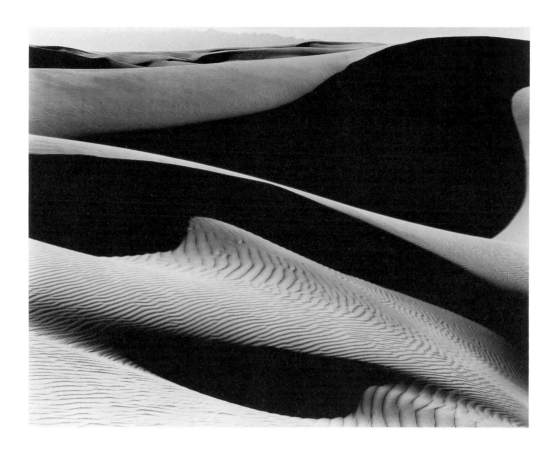

Edward Weston, *Dunes, Oceano,* 1936

THE NOTION THAT photographers have not significantly contributed to the literature of their medium is not true. Granted photographers have not generally been disposed to group activity or to what may be termed the manifesto form, but a review of any anthology of writing on photography will reveal intelligent and deeply felt statements by photographers. The one photographer who has given to the contemporary literature the most complete record of the self is Edward Weston, who, through his *Daybooks,* chronicled his life in photography as few others have. Through this compelling journal we can chart his evolution as an artist, his thinking about the medium, and find the all important documentation of and reaction to his personal and psychological

"Introduction," *Edward Weston on Photography / A Critical Anthology* (Salt Lake City: Gibbs M. Smith, 1983). © by Peter C. Bunnell.

life which manifests itself in his creative work. But Weston's *Daybooks* in their present form are not the whole story; indeed, they were revised and edited by him during his lifetime and they represent only a partial self-portrait. Weston intended that his diary be published in one form or another and he even prepared it for publication himself.[1] While much of his editing reflected second thoughts on revealing the identity of certain persons, more serious was his constant reappraisal of his career as an artist and his one-sided musings on his success or failure. In the end, at the conclusion of his life, he had prepared with the *Daybooks* a document which was to be a prism of himself both as a man and as a recognized photographic artist.

This is an understandable act for any person who keeps a journal as the basis of an authorized biography. Literary figures and some painters are familiar with the form, and in a few cases we have a similar effort by other photographic artists, notably Minor White's "Memorable Fancies." But for the art historian as well as the biographer, the trace of the artist in a less self-conscious, immediate, and untouchable form such as correspondence or published pieces sometimes proves of greater value as an insight into the progressive and evolving chronicle of the artist's perceptions and values. This, of course, is in addition to what is revealed by the works of art themselves which are always the primary source. It is a measure of Weston's stature as a photographic artist that we are as interested in him as we are. This is an anthology that presents for the first time the majority of his writings on photography which were meant for general consumption and which were unalterably fixed at particular points in time. In these articles, lectures, letters to the editor, and exhibition statements we find revealed the most fundamental of his thoughts with regard to photography, devoid of intimate biographical connections or personal meditations on aims and achievements. Here Weston speaks with self-directed authority, a quality he felt about himself and his work from his earliest years. These articles render in print what his photographs do in platinum or silver, and with a similar precision they identify where he placed his beliefs with regard to his chosen medium. Further, they show clearly, and in some cases uniquely, the progressive mark of influence on his think-

1 Three lengthy excerpts from the *Daybooks* were published during Weston's lifetime. The first, in 1928, was published in *Creative Art;* a second was published in 1947 in the *Stieglitz Memorial Portfolio,* edited by Dorothy Norman; and a third was published in 1950 as the text for *My Camera on Point Lobos.*

ing, and they reveal the models – both role models as well as stylistic models – for his life in photography.

Because Weston became a ruthless editor of his work as the years progressed, discarding the major part of his photographic work from about 1906 to 1921 as well as pages from the *Daybooks* prior to 1923, the analysis of his early interests, first in portrait photography and then in pictorialism, is now made possible with greater substance through these texts. With the exception of a few prints in various collections, very little is known of his work prior to his significant change in approach and style in the early 1920s. Frequently the only records of this early work are the reproductions in published sources. The texts contained in this anthology span a period from 1911 with his first published article, "Artistic Interiors," written for *American Photography,* to the 1950s, at which time he comments on color photography, and, nearing the end of his life, he publishes a reaffirmation of his enduring belief in the uniqueness of photography with a re-edited version of an earlier article, "What Is Photographic Beauty?"

Edward Weston began professional photography in California in 1906 working as an itinerant photographer specializing in children's portraits. He had been introduced to the medium in 1902 by his father who gave him an amateur's camera. He was essentially self-taught, although he did attend the Illinois College of Photography for six months in 1908. In the context of the observations above about the reappraising of his career, it is interesting to compare his two views of this experience. In 1939 Weston wrote, "I learned a lot about what not to do when making portraits," but earlier, in 1912, he wrote about his experience at such a school that he "had a short course in one and have never been sorry." His real training came during a two-year apprenticeship in the studio of a working photographer, but throughout his life he insisted in his writing that one's education must be self-directed, and he cautioned those who did not carefully and selectively seek advice and direction elsewhere – especially in areas outside of photography. One of his basic attitudes with regard to education was that "photography has become so simple an affair that a child can Kodak and even learn to finish well." When he had a rare retrospective showing in 1933 he exhibited pictures taken in 1903 from his youth in Chicago as if to demonstrate this point. At that time he referred to this work as immature but related both in technique and conception to his current imagery. He carefully

omitted from this same exhibition pictures from 1906 to 1912
which by this time he had expunged from his body of work.
He did show work dating from 1913 to 1920, but he described
it as reflective of the period in which he was "trying to be
artistic."

It is evident from the articles written throughout his life
that Weston was an avid reader of photographic periodicals
and that in spite of what he sometimes said, he used such
publications as sources of information and a standard against
which to measure his own accomplishments. While we have
only a few direct statements documenting his reading, the
sources of his own writings between 1911 and 1920 reveal
the following titles: *Photo Era, American Photography, British
Journal of Photography, Photo-Miniature,* and *Camera Craft.* We
also know he was familiar with *Camera Work.* The bibliog-
raphy of his published photographs reveals many other pub-
lications, including the popular annuals, with which we can
be certain he had familiarity during these years: *American
Annual of Photography, Photography, Photograms of the Year,
The Camera, Photography and Focus, Bulletin of Photography,
Photo-Graphic Art, Pictorial Photography in America,* among
others.

What this information provides is a depiction of how tech-
nical information and style were transmitted from one gen-
eration to another as well as the standards of photographic
work to be achieved. It must be remembered that few people
saw exhibitions of original prints, or at least exhibitions other
than those of the professional associations. This latter point
is very significant in understanding the young Weston, for
during these early years he was very conscious of his repu-
tation and he worked hard to assure for himself a place in
the arena of professional photography and later in that of
artistic photography. And while from the start he was critical
of popular taste, he wrote in 1913, "I am a great believer in
the value of competitions and exhibitions, both as an edu-
cation and as a business getter. By giving support you aid
the magazines, salons, and exhibits, and in return receive
splendid advertising upon winning a prize; and where, oh
where would we who believe in pictorial photography be, if
'twere not for such magazines as *American Photography?* Not
all of us are blessed with the opportunity of seeing salons,
and we must derive our inspirations from the splendid half-
tone illustrations of works by the masters of our art published
monthly in leading photographic periodicals. Those who do
not read and subscribe to these magazines and patronize their

advertisers unwittingly deal a blow at the advancement of pictorial photography; those who do, reap the benefit of knowledge imparted by those who know, and also avoid the necessity of digging out perplexing elementary problems in both art and technique." In reading this statement one gains not only confirmation as to Weston's sources at this formative time of his career, but also something of the tone of his very business-like attitude about professionalism and his standards as a working photographer. Further, it helps explain something of his later motivation to contribute to the literature himself, in part even through his journal, for the benefit of others. The mode of Weston's writings throughout his life was to establish himself as a kind of model, suggesting that his methods and successes would aid those coming after him. He was never afraid of competition and he understood that only through the challenge of comparative appraisal would real growth be possible.

One of the most significant facts to be uncovered in Weston's published writings throughout his career is his deep-seated interest in portraiture. Readers today will probably find this surprising because so much has been made of his later aversion to professional portraiture and because Weston is so largely perceived as a landscapist in light of his later work. The fact is, however, that from the beginning of his professional work and through his entire career he continued to address himself to questions of the photographic portrait and the figure. In articles between 1912 and 1917, and again all through the 1920s, there are repeated references to portraiture and these culminate in two lengthy discussions of the subject in 1939 and 1942. To know and understand his views on this genre is to understand Weston's basic involvement with the photographic medium. It is as if his concern for what he termed the "quintessence of the object" was most revealed in the rendering of the human face or the figure through photography. It echoes his most profound and deeply felt interest in the "poetry of being," which is in constant transition revealing the person himself and seemingly captured only through photography. It is of the essence in understanding Weston that he believed that photography was unique when used to record this fleeting quality.

Another early concept held by Weston and retained throughout his life was the belief that photographs are made and not taken, and he believed that "art is outward expression of inner attainment." His concern for being an artist in the medium was not simply the reference to practices and man-

118

ners derived from other media, but the knowledge that "as great a picture can be made as one's own mental capacity – no greater. Art cannot be taught; it must be self-inspiration, though the imagination may be fired and the ambition and work directed by the advice and example of others." He believed that "the picture must be the product of one's intellect. . . . Any individuality in my work is entirely due to the selection, arrangement, and lighting of the subject – the picture is conceived in the mind."

Weston's belief in the importance of the basic chemical and technical approach to photography is revealed exceptionally early in his career. His formulation of what was to become his famous dictum, "previsualization," rests on this early admonition of 1916 to "get your lighting and exposure correct at the start and both developing and printing can be practically automatic." This deep-seated interest in the control and perfection of technique as a component of visualization was forcefully expressed by Weston from the very start. What was to separate the quality of one photograph from another was the expressive realization of photographic craft. In his early articles on studio operation, he consistently demanded that the photographer demonstrate high-quality technique and appropriately charge his customers for it. In 1916 he already refers to straight photographs, and this naturally leads to the consideration of Weston's aesthetics of pure photography.

Weston held that there were qualities of photography which were unique to the medium and throughout his life he urged – even insisted – that photographers appreciate them as the keystones of photographic appreciation. It is interesting to note how early in his thinking these attitudes appear. Certainly by the mid-teens he was fully aware of the controversy raging throughout the photographic world concerning the manipulated, poetically pictorial photograph versus the straightforward and more realist approach. It is doubtful that he saw examples of this latter work other than in reproduction, but even via these secondary sources such imagery was clearly having its effect. By the time of his 1916 lecture he had firmly adopted the attitude that photography "aping another medium" would only spell its failure, and he used the term "photopainting" to label the work executed in this manner. Much has been written by way of trying to understand Weston's turning from the pictorialist mode to the straightforward, literalist approach represented by the work of Stieglitz, Strand, and others. We know now that he was aware

of the developing currents in modern art and much like his counterparts in New York, he recognized that abstraction was not simply a matter of representation but that it also spelled the deathblow to impressionist and literary depiction. If he did not find confirmation of this notion in any other publication (and the popular photographic magazines were conservative in this regard), *Camera Work* gave him ample documentation of developments since Stieglitz's first publication of Matisse and Rodin in 1910 and 1911 and of Picasso in 1911. By the time of the Strand issues in 1916 and 1917 Weston had abundant evidence of the new aesthetic and how it would affect photography. His firsthand exposure to modern art came at the Panama Pacific International Exposition in San Francisco in 1915, and some influence of that exhibition is already evident in his comments in the 1916 lecture, "Photography as a Means of Artistic Expression," delivered before the College Women's Club in Los Angeles.[2]

A careful reading of his June 1922 text, "Random Notes on Photography," again prepared as a lecture and given before the Southern California Camera Club, identifies what may well have been the most influential article of any in the development of his maturing thought. This was a piece entitled "Stieglitz," written by the well known critic Paul Rosenfeld. It was published in the April 1921 issue of *The Dial,* and it is significant that Weston had access to this article before leaving California for his important visit East during October and November of the next year.[3] From this single article Weston appears to have found the phraseology with which to articulate his entire aesthetic understanding of the medium and the confirmation of his developing aesthetic. In the article Rosenfeld writes, "the photographs of Stieglitz affirm life not only because they declare the wonder and significance of myriad objects never before felt to be lovely. They affirm it because they declare each of them the majesty of the moment, the augustness of the here, the now." He continues, "Never, indeed, has there been such another affirmation of the majesty of the moment. No doubt, such witness to the wonder of the here, the now, was what the impressionist painters were striving to bear. But their instrument was not sufficiently

2 Nathan Lyons, "Weston on Photography," *Afterimage,* 3:½ (May/June 1975), pp. 8–12. Peter C. Bunnell, "Weston in 1915," *Afterimage,* 3:6 (December 1975), p. 16.

3 Paul Rosenfeld, "Stieglitz," *The Dial,* 70:4 (April 1921), pp. 397–409. Reprinted in full in Beaumont Newhall, ed., *Photography: Essays and Images* (New York: Museum of Modern Art, 1980), pp. 209–218.

swift, sufficiently pliable; the momentary effects of light they wished to record escaped them while they were busy analysing it. For such immediate response, a machine of the nature of the camera was required."

In the first of the above passages Rosenfeld was speaking about Stieglitz's portraiture, and in the second he suggests Stieglitz's landscape work, although it must be noted that the great series of landscape and cloud studies was still a year to two years away. Weston was to quote the phrase "majesty of the moment" in successive articles written during 1922 and obliquely refer to it for years afterward. He uses it first in "Random Notes," where he quotes extensively from the Rosenfeld piece. It appears again in the August 1922 letter to *American Photography,* where he pointedly affirms his belief in straight photography and makes reference to the work of Frederick H. Evans, and finally, in his letter to John Wallace Gillies for publication in his 1923 book *Principles of Pictorial Photography.*

From this latter text, written in late 1922 or early 1923, one gains confirmation that by the time Weston visited the East he had read most of the significant literature of the new American photography in such publications as *The Dial, The Broom, The New Republic, The Nation,* and also John Tennant's perceptive reviews in the long-standing journal of the pictorial movement, *Photo-Miniature.* Through all of these sources Weston was making contact, really for the first time, with the eastern photographic workers. This was especially the case with Stieglitz, who had never before been singled out or even noted in a Weston article. In none of his writings prior to 1922 had Weston even referred to members of the Stieglitz circle, with the exception of Clarence H. White, Karl Struss, and Anne Brigman, but all of them were, by the teens, outside of the Stieglitz group and participants in the organization known as the Pictorial Photographers of America.

A series of pertinent quotations from the text of "Random Notes" indicates how strongly Weston was attuned to the new aesthetics in the medium and how influential Stieglitz had become via the articles by Rosenfeld and others. It is in this lecture that Weston precisely states the essential point of previsualization: "I see my finished platinum print on the ground glass in all its desired qualities, before my exposure – and the only excuse I make for after manipulation . . . is the possibility of losing a difficult position or expression by the delay in correcting some minor fault." And he establishes as a rationale for his technique the "continued search for the

very quintessence of life – the poetry of being." Significantly, Weston is still concentrating on portraiture and figure composition, the major component of his work, so he states further that his aim is to grasp "the very essence of man," and he concludes, "there have been those whose work showed fine perception of rhythm and balance and values – but considered as portraits, as likenesses – were sterile. So to combine pictorial qualities and likenesses is the real achievement. Few, only a handful, even less than that, are doing this."

Weston's trip East in October of 1922 has been described as one primarily to visit his sister and brother-in-law in Ohio, with a hoped-for journey on to New York. From the evidence in his June lecture, and with an understanding of his personal drive for achievement in photography, it would be more accurate to suggest now that the visit to New York was of the utmost importance; indeed that it was the essential motivation for the trip. Weston understood it was necessary for him to make personal contact with these photographers and writers at the center of the new photography. He recognized that their direction was that of the future, and everything we know about his past behavior in such matters indicates he realized that he had to be a participant in this movement at its source. In 1922 there was no other way for him to meaningfully enter this sphere of action. This meant he had to see the work of these leaders in the original; for instance, all of the major articles on Stieglitz cited above contained not a single reproduction. He also realized that they had to see *his* work, which he knew was changing significantly. Challenge and affirmation were needed now as at no time earlier in his life. He had not abandoned his pictorialist leanings, as his work shows, and the fact that he spoke warmly of seeing Clarence H. White and Gertrude Käsebier indicates that he was tolerant of their aesthetic and that he was still poised at the point of change. Stieglitz, Sheeler, Strand, and, notably, Georgia O'Keeffe, who was then living with Stieglitz, provided him with the challenge he needed, criticizing his pictures and drawing comparisons to works by themselves. O'Keeffe's paintings made a strong impression on Weston with their reductiveness and a sharp linearity that rendered forms with the precision of a lens. These were the qualities he also saw in Stieglitz's work, and he records Stieglitz as summarizing his aesthetic as "a maximum (amount) of detail with a maximum of simplification." Importantly, Weston also saw John Tennant, who praised his work but who also drew the inevitable comparison to Stieglitz's. The

visit with Stieglitz did not go entirely smoothly, as the *Day-books* and other documents show, but it was the confrontation and confirming participation that was essential. Stieglitz was probably the first such photographer that Weston had really come up against in such a personal, one-on-one forum and too much praise might have shaken Weston's sense of self-directedness and self-assuredness. Stieglitz's exhibition the year before, in 1921, his first since 1913 and the focus of the numerous articles mentioned above, including that by Paul Rosenfeld, was a masterful triumph presenting 145 photographs dating from 1886 to 1921. And even though Weston did not see the exhibition itself, we can suppose that he found it meaningful, in the context of his own work, that of the total number of prints Stieglitz exhibited, 113 were portraits or figure compositions. If nothing else it must have represented for the young Weston the profound authority of an *oeuvre* of total artistry in photography. Weston left New York with a vision of his own future.

The most important feature of Weston's published writing after this time, that is during the decade into the early thirties, is the refinement and articulation of his aesthetic of straight photography. The very brief and reductive statements begin to appear and these describe the boundaries of his pictorial theories and approach. He has also expanded his framework of sources, reflecting his experiences in Mexico and his broadening critical awareness.[4] The following is a sampling of statements from this period: "Photography is of today. It is a marvellous extension of our own vision; it sees more than the eye sees" (1926); "I herewith express my feeling for Life with Photographic Beauty" (1927); "Photography can take its place as a creative expression only through sincerity of purpose" (1927); quoting Van Gogh's letters, "A feeling for things in themselves is much more important than a sense of the pictorial," or from William Blake, "Man is led to believe a lie, when he sees with, not through the eye" (1930); "The lens reveals more than the eye sees. Then why not use this potentiality to advantage" (1928); and "Since it has the validity of a new expression, without tradition or conventions, the freshness of an experimental epoch, the strength of pioneering, photography has a significant status in the life of today" (1928).

This latter quote suggests that Weston, like so many others

4 From the *Daybooks* and other manuscript material we know that Weston was a conscientious reader who kept folders of quoted statements by various writers and artists on art, politics, and what he termed "life."

of the period, had adopted the fashionable but naive concept that photography was a traditionless medium, that straight photography was somehow unique to their time. This attitude mostly reflected the desire to pull away from the pictorialist tendency to relate to other, older media of visual expression and to certain photographic works from the nineteenth century, but it was also an attempt to make of photography an American art. The new photography was seen as a pioneering effort because of its technological authenticity, which in turn was viewed in opposition to everything European and everything before the Great War. Weston honestly believed that photography was fresh and without rules, presumably those kinds of rules laid down by authorities in other media, and on the subject of the manipulative practices used to suppress the photographic quality of a work, he was anything but impassive. This single issue becomes an obsession with him to the end of his life and his outrage over it appears in almost all of his writing, even after it was no longer a credible topic for concern. In 1929, for the catalogue of the Film und Foto Exhibition in Stuttgart, Germany, he wrote, "Those who feel nothing, or not completely at the *time of exposure,* relying upon subsequent manipulation to reach an unpremeditated end, are predestined to failure." By the mid-forties this idea became, "A photograph has no value unless it looks exactly like a photograph and nothing else." Earlier, in 1930, in one of his most important articles of that decade, "Photography – Not Pictorial," Weston writes, "No photographer can equal emotionally nor aesthetically, the work of a fine painter, *both having the same end in view* – that is, the painter's viewpoint. Nor can the painter hope to equal the photographer *in his particular field.*" In 1930 he defined what the photographer could do best: "To photograph a rock, have it look like a rock, but be more than a rock. Significant representation – not interpretation." Or again, from the 1932 piece, "A Contemporary Means of Artistic Expression," photography is the "fusion of an inner and outer reality derived from the wholeness of life – sublimating things seen into things known."

A major component of Weston's conceptualization was his belief in the control of technique and how pure photographic technique was the sole basis of significant photography. In 1934 he wrote, "In the discipline of camera-technique, the artist can become identified with the whole of life and so realize a more complete expression." In every piece for the general audience he describes and analyzes his working pro-

cedures, thus suggesting that the strict premeditation and morality of his method will provide the basis for meaningful imagery through straight photography. Allied to this belief was his constant need to declare himself an artist in the medium, and in 1934 he wrote that "a photographer who could not affirm his intention, who could not correlate his technique and his idea . . . was not an artist." Clearly the point here, as in all the writing of this period, was the search for a precision of intent and the presentation of a unique reality. As was pointed out above, beginning as early as his articles on how to manage a portrait studio, we find that he advised one to make good work and charge accordingly for it; that the quality of craftsmanship would be recognized and appreciated as integral to the artistry of the total work.

Weston's career as a photographer evolved through a series of distinct periods: his professional and pictorialist period from 1906 to about 1918; a transitional period representing his work prior to going to Mexico, or roughly 1918 to 1923; the Mexican period from 1923 to 1927, which preceded a post-Mexican period dating to about 1934. The remainder of the 1930s through the Guggenheim years represents another period, and, finally, the years 1939 to 1948 represent yet another distinct phase in his professional career. It is worth noting that his published writing appears strongest and more numerous in the most significant of these periods, that from about 1927 to 1934. As we have seen, however, Weston had developed his essential ideas early, and throughout the whole of his career he changed little, and he tended only to refashion his ideas with new terms and with greater assuredness. Certain of his writings were republished by other publications than those that commissioned them or to which he had first submitted them, and he was in the habit of repeating essential phrases in a variety of articles. What characterizes the writing, nonetheless, is a strong self-confidence and a confirmed belief in the acceptance of the responsibility for one's work. He assumes that he can offer a larger community insight into the medium through his own example, and while he denies being able to offer concrete advice, presumably reflecting his aversion to the establishment of rules, he repeatedly describes his working method with the clear implication that while simple, it is the true path to success in photography as he defined it. With the exception of Ansel Adams, no other photographer has given his public such insight into just how he creates his work. If we agree that the crucial tenet of expressive photography in its broadest sense is the acceptance of one's work

as a public art, then Weston was truly an artist in the medium.[5]

Following his award of a Guggenheim Foundation Fellowship in 1937, the first ever made to a photographer, Weston clearly assumes a new position in the hierarchy of photographers. From that date forward he is always identified in the media as a Guggenheim Fellow. It was an accolade no other photographer was to share until 1940 when Walker Evans received the Fellowship. The status that this award granted Weston cannot be overstated. In 1939, after completion of his Guggenheim project, he undertook the preparation of a panoramic series of five major articles for *Camera Craft* magazine, an old west coast publication which through the thirties was represented by an editorial policy that was still at considerable variance with Weston's aesthetic. The five unified articles, two of which were of such length they required publication in successive issues, were written with Charis Wilson, a young woman Weston met in 1934 and whom he was to marry in 1938. She was the daughter of the then popular writer Harry Leon Wilson, author of *The Ruggles of Red Gap, Merton of the Movies,* and with Booth Tarkington, the play *The Man From Home.* Though only nineteen when she first met Weston, she soon became more than his model for a series of alluring nudes begun in 1935. Important for our concerns here, she became the chronicler of Weston's ideas between 1936 and 1946, the year of their divorce.[6] Considerable speculation has been voiced as to the role Charis Wilson played in the preparation of Weston's writings during the period. Although she wrote almost all of his published works during this time and authored the report of their Guggenheim project, *California and the West,* a careful reading of the pieces reveals that the essential ideas, indeed even specific phrases, belong to Weston's earlier bibliography. The concern with the pictorialist legacy is repeatedly represented, as is the notion of good craft and the purity of photographic seeing and previsualized control. Weston's concern for the "living quality," as he put it, continues, and he still passes himself off as something of a rebel to be serving as a model for others. For example, one can read what has happened to the concept of the photographic moment as taken from Rosenfeld's Stieglitz article of 1921. The Westons now write, "For photography is a way to capture the moment – not just

5 Peter C. Bunnell, "Introduction," in *A Photographic Vision* (Salt Lake City: Peregrine Smith, Inc., 1980), pp. 1–7.
6 Letter from Charis Wilson to Peter C. Bunnell, 8 April 1981.

any moment, but the important one, this one moment out of all time when your subject is revealed to the fullest – that moment of perfection which comes once and is not repeated."

The five articles in order of publication are a summation of Weston's thinking on the medium: "What Is a Purist?"; "Photographing California"; "Light vs. Lighting"; "What is Photographic Beauty?"; and "Thirty-five Years of Portraiture." Some of the more significant phrases to appear in these articles are: "My work is never intellectual. I never make a negative unless emotionally moved by my subject. And certainly I have no interest in technique for its own sake. Technique is only a means to an end"; "I have tried to sublimate my subject matter, to reveal its significance and to reveal Life through it"; "It cannot be too strongly emphasized that *reflected light is the photographer's subject matter*"; "Photographic beauty as a term is only applicable to a finished print. But the photographer who would achieve it must remember that it is his seeing that creates his picture; exposure records it, developing and printing execute it – but its origin, in his way of seeing, determines its final value. His seeing must discover, before his technique can record"; "Our own vision is automatically selective; we see what we want to see. It is a long job for the photographer to train his eye to lens-sight, and then learn to use that undiscriminating lens-sight selectively to suit his purpose."

In a letter to this editor Charis Wilson describes how she and Weston worked together: "From the onset of the *Camera Craft* articles I began to accumulate notes and quotes on all likely subjects in a loose-leaf binder. The subject dividers made adding and retrieving easy, and I could see at a glance if enough material had accumulated for an article. The original notes consisted of things Edward had written and things other people had written. These were supplemented by material derived from 'interviewing' Edward on specific subjects.

"The interviews were extended discussions on particular aspects of photography. The trick was to pry him loose from a well-worn phrase that he felt 'covered everything' and, by asking all kinds of peripheral questions, encourage him to cover more ground and give more specifics. Edward was a confirmed reductionist, apt to prune and snip and condense ideas until nothing remained but a bit of branchless stalk, so it was my job to reverse the process by expanding the condensations and retrieving a sufficient number of snippings and prunings to give some shape and interest to the product.

"We had no fixed routine. We might discuss a possible article at the outline stage, or I might turn out a draft first. Then either of us might see changes needed or possible additions or improvements. Sometimes material needed deletion because it was sufficiently complicated to need an article of its own. We both went over final drafts carefully before sending them off.

"I never tried to change Edward's views or add to them – only to express them as clearly and convincingly as possible. One thing that made it easy was that Edward was the least ambiguous man where the basics of photography were concerned. His views were as sharp and clear as his photographs, and I had heard what he had to say on most of these subjects so often that to write in his words was never a problem."[7]

In 1941 the Encyclopedia Britannica published Weston's lengthy essay entitled, "Photographic Art." This edition of the Britannica was of considerable importance because it represented a major revision of past editions and the need to update the understanding of photography was essential. It is significant that the editor, Walter Yust, decided to ask a practicing artist to write it. And once this decision was made Weston was the obvious choice. Yust had first suggested in the late thirties that Weston merely revise the old article authored by Frank Roy Fraprie, a pictorialist, amateur popularizer, author of such works as *Photographic Amusements,* but the bias reflected in Fraprie's article was totally unacceptable to Weston and he refused, stating that he could only start all over again. By November of 1939 the text and reproduction photographs were sent off to Chicago, and in April of the following year the proofs came back to the Westons for correction.[8] In the article Weston draws on his own significant piece, "Photography," written in 1934 for the Esto Publishing Company. He briefly describes a limited history of the medium which has as its basis the split between pure and derivative photography. He summarizes the whole of the nineteenth century as a massive search for painterly effect, and he cites only one historical figure of the period as being worthy of continued consideration, David Octavius Hill. In his review of the modern period he describes the continued dialectic between the purist and pictorial approaches and he attributes to the Photo-Secession responsibility for the change in the medium's mainstream direction. He perceptively

7 Letter from Charis Wilson to Peter C. Bunnell, 25 April 1981.
8 Letter from Charis Wilson to Peter C. Bunnell, 12 February 1982.

points out that while numerous of its members continued to follow the painterly tradition, they used only photographic means to achieve their effects. The source for the historical information was surely Beaumont Newhall's *The History of Photography,* but the general historical treatment was shallow. The lack of such historical insight is, however, not surprising when one recalls Weston's earlier suggestion that the medium was traditionless and that the work by members of his generation was "pioneering." In summation Weston declares that "photography must always deal with things – it cannot record abstract ideas – but far from being restricted to copying nature, as many suppose, the photographer has ample facilities for presenting his subject matter in any manner he chooses," and he illustrates the piece with photographs by Stieglitz, Sheeler, Strand, Steichen, Adams, his son Brett, and his own work – notably two portraits.

One quality of this article, and with another written in 1942 on portrait photography, is a sense that the audience is thought to be more literate about photography than before and that his concepts require a more ingenious articulation. This would suggest the influence of Charis Wilson, an accomplished writer, who certainly saw the complexity of the issues before them and understood that by this time in Weston's career the public could match allusion with allusion. Indeed, the 1943 article, "Seeing Photographically," is a precise and well-reasoned statement of Weston's mature ideas even though it derived from the Britannica piece of three or four years earlier.

By this time Weston had become the most publicized American photographer of the new aesthetic. Stieglitz, and to some extent Strand, were less influential. They were representative of an older generation while Weston represented a kind of middle generation, and Ansel Adams and Walker Evans were of the new generation. By the time of his death in 1946 Stieglitz felt very much alone and neglected. On the other hand, Weston's place was assured when, in the same year as Stieglitz's death, he had his first major New York exhibition at the Museum of Modern Art.

Perhaps the most forward looking of Weston's writing in his last years, because of its implication for his unfinished work, were his comments on color photography. Clearly he was fascinated with it and he executed some stunning images. Characteristic of his life-long approach, he observed of the newly perfected technique, "Any predictions that color will supplant black and white are ridiculous; drawings, dry points,

etchings, lithographs are not negated by painting. The aesthetic possibilities of color will be determined by the creative ability of the individual."

The final points which are revealed in his writings in the 1950s were his deepened interest in the revelation of a unique beauty through photography and the concept of personal growth. Progressively Weston came to realize how his work had evolved and how it represented a much more detailed account of his life than any written diary he had kept. His photography ended in 1948 with his illness and it must be noted also that the last chronological entry in the *Daybooks* is 1934, with only a single entry ten years later. So it is that when he writes the introduction for his *Fiftieth Anniversary Portfolio* in 1952, he begins the brief statement, "When I was very young – say in my early forties – I defined art as 'outer expression of inner growth'. . . . I can't define art any better today, but my work has changed. Art is not something apart to be learned from books of rules; it is a living thing which depends on full participation. As we grow in life, so we grow in art, each of us in his unique way."

This sense of maturing growth and deepening insight was further evidenced in the publication of his last major essay, which was essentially the republication of the 1939 piece, "What is Photographic Beauty?" It was revised slightly in 1951 and it may contain the most enduring statement of Weston's philosophy. About the photographer and his audience he writes, "If his seeing enables him to reveal his subject in such terms that the observer will experience a heightened awareness of it and so inevitably share in some measure the photographer's original experience – and if his technique is adequate to present his seeing – then he will be able to achieve photographic beauty." This realization that the significant and fundamental tenet of pure photography is not a technique or an instinct for the visible, but revelation through heightened awareness, is Weston's own masterful summary of his thinking. Here at the conclusion of his career, like Stieglitz with his theory of Equivalence before him, Weston calmly sets this truth before his colleagues as his legacy to challenge the next generation.

BARBARA MORGAN

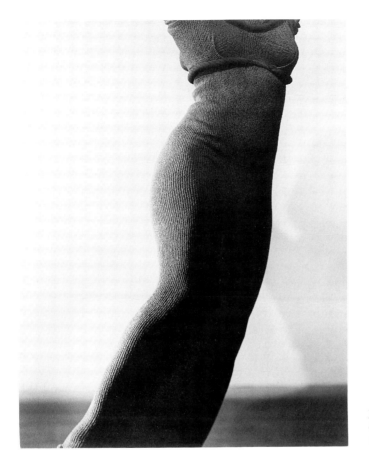

Barbara Morgan, *Martha Graham, "Extasis" (Torso)*, 1935

SO HIGHLY DOES Barbara Morgan regard the ineffable, so profound has been her commitment to the dance, an expressive form which she describes as "the life force in action," and so sure is her sense of the intuitive, it is curious that she has found so complete a life in photography. For this medium, which generally is esteemed for its actuality, would seem not appropriate for her at all. But it is through the work of such an artist as Barbara Morgan that we may gain the understanding that above all else photography is a medium of interpretative expression and not of depiction, that photographs may be seen to represent imagination limited only by truth, and material facts raised to the power of revelation.

"Introduction," *Barbara Morgan* (Hastings-on-Hudson: Morgan and Morgan, 1972). © by Peter C. Bunnell.

131

To see Barbara Morgan's photographs is to experience the work of a versatile artist whose creative life spans five decades. Her photographs display an energy of both physical and psychic dimensions which clearly echo every aspect of her spirit and insight. The richness and physical scale of her photographs compel us to delve into their every recess and to become a participant in their vitality. For Barbara Morgan it is the gesture of largesse which speaks.

The subjects and techniques used in her work are varied: nature, man-made objects, people, the dance, light drawings, and photomontage. The dance photographs, begun in 1935 with Martha Graham and her company, are justifiably celebrated. They were made with a deep understanding of the cross-cultural sources and the dramatic or ritual schema of the dances, of kinetics, and with an assuredness in the technical complexities of the photographic medium. Working alone with her subjects, not in performance but in studios, and fundamentally out of her own creative needs, she recorded not so much the literal dance as the essential gestural aspect of life which the dance symbolized. Each dance was reconceived for the camera and its actions were condensed to those movements which were the most eloquent, the most complete. The connective movements of the overall rhythmic structure were omitted and the thematic movements, those which contain the essence of the dance, isolated, generally at the point of their climactic clarity.

It is interesting that these images should be referred to as *still* photographs. They are, of course, not cinematic in the usual sense of the term, and Barbara Morgan has made no attempt to structure her work in a linear sequence. The photographs, each of which is expressive of an aspect of a particular dance, primarily reflect the beauty of themselves as pictures. But these images are expressions of states of being relative to time, and while she respects the work of the dancers and choreographers, Morgan's aim has been to evoke the content of the dance without calling on the totality of the dance action. It was T. S. Eliot, I believe, who observed, that "at the still point, there the dance is," and it is clear that he understood more than most the nature of the concept, referred to, especially in photography, as the *decisive moment*.

Barbara Morgan understands this concept very well. Writing in 1940, she observed that "previsualization is the first essential of dance photography. The ecstatic gesture happens swiftly, and is gone. Unless the photographer previsions, in order to fuse dance action, light and space expression si-

multaneously, there can be no significant dance picture."[1]
Such an approach requires previous knowledge not only of
the dance content, or story, but of what is photogenic; that
is, what can be imparted through a picture which will result
in its having an existence beyond that of being the record of
an event. She has written elsewhere that, "When I am full of
the subject, picture ideas and treatment spring to mind spon-
taneously and are not concocted. The power of an image to
appear full-blown in my mind is proof of its vitality, and
those that persist, I work on. Sometimes I will carry a picture
idea in my mind for days and months, but when the moment
comes, I like to shoot at a high pitch and develop as quickly
as possible, to analyze errors or success while it is fresh. Of
course, every step in the making cycle is integral, but I feel
that the gestation in the beginning is 90% of the picture."

"In this *unforced* meditation," she continued, "I empty my
mind and allow the memorable gestures which inspired the
idea to replay themselves; then, while holding these forms
clear, I envision trials of lighting, spacing, framing, as a re-
hearsal – until it clicks. This is especially necessary for such
shooting as dance action, for there is not time for trials when
the dancers must be kept invigorated by confident direction,
together with camera and lighting control. Sometimes in ac-
tual shooting the imagined approach is found unworkable
and given up for a quite different setup. Nevertheless, this
imaginary rehearsal attunes one to essentials."[2]

Barbara Morgan often refers to the "rhythmic vitality" of
her work. By this she means the translation of literal inter-
pretation such as light and dark, love and hate, natural and
man-made, all polarities of sorts, into a kind of visual dy-
namic. The body of her work must be viewed with this sense
of parallels and perpendiculars; of children happy and sad, of
a tree's delicacy and strength, of man's ruins and nature's
fossils. In one sense, no single picture by her can express the
complexity of her thought, for the whole of her work, the
design of her books and exhibitions, the sense of her total
involvement, is one of a reciprocity between the themes and
forms of one image and those of another.

The essential readability of Barbara Morgan's photographs
is very straightforward. I do not mean this in any pejorative
sense, but rather as a way to characterize her approach to the

1 "Photographing the Dance," *Graphic Graflex Photography,* Hastings-on-Hudson,
 N.Y.: Morgan & Morgan, 1971, p. 217.
2 "Kinetic Design in Photography," *Aperture,* 1:23, Number 4, 1953.

expression of content. The Morgan photograph of an ecstatic, leaping man is exactly that, and a rusting automobile engulfed in a bed of weeds has to do with exactly what is shown – power, decay, growth, man, and nature. Likewise the luminous swirl of a light drawing may be seen to be the free-hand equivalent in pure electric energy of Martha Graham's bodily swirl which, by its schema, symbolizes the transcendence of the heroine's personal tragedy in the dance, "Letter to the World." Similarly her titles for photographs, such as, "Pure Energy and Neurotic Man," "Fossil in Formation," "Saeta," and for one of the images described above, "Resurrection in the Junkyard," indicate both the literalness of her thought and the purposefulness of her intent.

Nowhere in her work can this sense of the literary be seen as clearly as in the book *Summer's Children,* which in every respect was created by the artist. This book, prepared in the late forties and "conceived as an affirmation of the art and science of human relationships," is deceptively simple. At first viewing it appears to be about what children do at camp, but with reflection it may be seen that these are photographs of experiences, not of events. It could not be otherwise, because the author was not so much interested in what the children did, but in what effects each of their actions had. In other words, she was attempting to show the evolving, quiet, yet profoundly moving and sometimes difficult process of human growth. Rather than describe these photographs as universal, it seems to me that they should be regarded as fundamental. In this way, the psychological appreciation of life will be grasped through the evocation of parallel memories in everyone and the burden of interpretation will reside properly with the viewer. It is a mistake to assume that a universally recognizable photograph means the same thing to all.

As opposed to straight photography in which the literal continuum of observation and reaction is maintained, Barbara Morgan sees the photomontage as more nearly approximating imagination itself. The multiple-image system of montage allows her to combine discontinuous thoughts, observations, and ideas into a visual metaphor and also to spontaneously create designs and patterns which relate to her continued interest in painting and graphics. Writing about this form, she has said, "As the lifestyle of the Space Age grows more interdisciplinary, it will be harder for the 'one-track' mind to survive, and photomontage will be increasingly necessary. I see simultaneous-intake, multiple-

awareness and synthesized-comprehension as inevitable, long before the year 2000 A.D. It is a powerful means of creating relevant pictures. I feel that photomontage with its endless technological and esthetic possibilities can be not only an inspiring medium for the meditative artist, but that it will increasingly serve the general public as a coordinating visual language."[3]

Barbara Morgan is not widely known for her work in photomontage, and while she continues to use it today, her work from 1935 represents an exceptionally early articulation of this technique by an American. In general, her pictures reflect an urban lifestyle which lends itself to this fractured, layered structuring – strata of people, place, mood, and meaning. As designs, her earliest compositions are not unlike aerial photographs, or drawings for the constructivist sculpture or architecture which emerged in the decade of the twenties. The old solid order of things – once felt in the weight of objects – is now fragmented into components, and these are rearranged into shifting patterns in continuous movement through space.

Barbara Morgan's work in photomontage and dance is perhaps her most important photographically because it marked a change in the fabric of prewar American photography. It bridged the abstract and synthetic work developed in Germany and elsewhere in the twenties and the rigorous straightforward disciplines generally admired in this country and practiced by two of her close friends, Edward Weston and Charles Sheeler. It was also a connective between the natural, pictorial environment, which for her colleagues and predecessors was the landscape, and her interest in the human world and the urban architectonic. She has always viewed nature socially, as a macrocosm of details in which an intimate world of human experience and values may be found. In the end it is the question of human potential to which she has addressed herself throughout her work. Whether it be in the poetic aspiration to symbolize man's spirit or in the challenge to manipulate the physical craft of her medium, Barbara Morgan has exemplified, as only few others have, the true liberality of personal freedom.

3 "My Creative Experience With Photomontage," *Image*, 14:20, December, 1971.

AARON SISKIND / 75th ANNIVERSARY

Aaron Siskind, *Chicago*, 1949

AARON SISKIND'S PHOTOGRAPHY may be viewed as an ideal expression in art. Through it he has ordered the chaos of his experience, he has matured as a man, and with it he has altered our culture with genius. Siskind has always been a leader; he has circumscribed a style which he originated and he has done so displaying a level of excellence which has placed him in the company of only a few photographers. Looking back over Siskind's work the impression one receives is of his unabashed tempting of controversy, though without any hint of desparation; something we recognize was not unlike the approach undertaken earlier by the composers of atonal music

"Introduction," *Aaron Siskind / 75th Anniversary Portfolio* (New York: Light Gallery, 1979).

136

or at the same time by the artists of Abstract Expressionism. The mood of some of his work is darkly pessimistic, but always all of it has been boldly assertive reflecting his belief that a picture has relevance as a dislocated object in an ever increasing community of triteness and uniformity. Siskind is an artist who has recoiled from the simplistic facade of urban life and the routine of mechanical civilization believing that the arenas of technology and politics are not strangers to the poetic vision.

Admirers of Aaron Siskind often speak of the robust actuality of his life. At seventy-five he is the very epitome of the mature artist. Articulate yet unbridled, secure in his place, he now reflects on the emotions of his youth with the enlightenment of good humor. He gives off the passion of one who has been willing to grasp and grapple with the world. His work is never a retreat into self-indulgent pathos but always the projection of a belief that the pictures he makes will add substance to the meaning of everyone's life; in this he insists on the confrontation with vitality. To know him encourages one to see his pictures for the very discriminating pleasure they afforded him in making them and this acquaintanceship, in turn, also prepares one for the fullness his works will provide in reading them. Siskind is one of the select group of artists who moved from the dependency on illustrative rhetoric to the realm of imagination and abstraction in the early 1940's. Nevertheless his imagery is that of living forms rendered with the veracity of the experienced world; something which only photographs can manifest.

That Siskind has utilized different referents shows that he has not been afraid to abandon what had become inadequate for his vision. This is shown particularly by his disregard of the specifics of local or popular interest and by his acceptance of symbolic representation in order to exceed to a larger plane of significance. The maximum articulation of pure form became for him the means of rendering to the public an active and participatory vehicle for the consideration of values. In this sense, he was involved in the joint realization among his generation of artists that a greater authenticity should be given to images than reportage. In this way he could focus attention – his and ours – on the issues of picture making as symbolic of the choices and responsibilities in daily life. His work succeeds, in my view, not through any novelty but through the purity, order and pertinence of the values thus signaled and the degree of human satisfaction he stimulates.

The effect of Siskind's photographs on the field of pho-

tography is by now obvious. Their effect on the general field of artistic expression since the forties is only now coming to be understood. That this should be the case no doubt pleases the artist today, but the lack of recognition certainly caused him concern during the years of their formative articulation. However, what has made Siskind exceptional is his recognition of the individual mind as a function of social life and of his need to pursue his chosen direction with diligence and above all, excellence. He has found in the technology of photography and in the politics of aesthetic identification the expressive resource necessary to cast aside the notion of simplistic mass culture and to give the artist the ability to challenge what T. S. Eliot described as the "steady influence which operates silently . . . for the depression of standards." Early on Siskind recognized the richness of his inspiration and his ability to give that inspiration its appropriate form, often with elegance and beauty. The form came as if by instinct, not unforeseen even in his earliest work, but ready at hand like a worker's glove shaped by personal use; an idea graphically expressed as early as 1944 in the magnificent image he made in Gloucester that year.

One of the most satisfying expressions by an artist is the versatile reflection of maturity. The ease with which the artist projects his inner strength and extends his own consciousness through his creations is his mark of genius; the achievement of an effortless will is gratifying to us all. Such is the pleasure of seeing Siskind's work, especially the most recent, but it is the mark of his virtue that he will not rest on his laurels. Commenting some years ago Siskind said characteristically, "what is here is known and, indeed, well packaged and labeled. I must be on my way to where I can suppose, stumble, dream, conjecture, play and fondle like a voluptuary." Only in this sense does Aaron show he is still as young as the rest of us.

HARRY CALLAHAN

Harry Callahan, *Eleanor,
Port Huron*, 1954

THIS ESSAY IS about the work of an American artist who has
devoted himself to photography. Born in Detroit, Michigan,
in 1912, Harry Callahan began to photograph in 1938. He is
self-taught. In 1946 he joined the faculty of the Institute of
Design in Chicago, a school which had begun as Moholy-
Nagy's The New Bauhaus and which later, after 1950, be-
came a part of the Illinois Institute of Technology. In 1961
he left Chicago to direct the program in photographic studies
at the Rhode Island School of Design. A year ago he retired
from teaching in order to devote himself fully to his own
work. Through all of those earlier years he maintained an
exceptional discipline of personal photography and individual
expression, believing that the most substantive gift a teacher
can make to his students is the demonstration of his own

"Introduction," *Harry Callahan* (New York: International Exhibitions Committee
of the American Federation of Arts, 1978).

139

creativity. His students are now representative of successive generations of important photographic artists in the United States and, in a few instances, abroad. Callahan's personal style has become indelible as an identification of American photographic approach and thought since World War II. The recipient of several large exhibitions in the United States, the most recent being a retrospective at the Museum of Modern Art in New York, this is his first major exhibition in Europe (at the United States pavilion of the 38th Biennale di Venezia, Italy, in 1978).

Harry Callahan has a reputation for being a quiet man, and indeed he is, preferring, as he might say, "simply to do." His students have benefited from his gentle verbal guidance for years; however, the public has not been generally aware of his thoughts through the written word. He published only a few extended statements, notably in 1946 and 1964, but in recent years he has granted a number of interviews. The quoted remarks in this essay are drawn from some of these diverse published comments. Without the tone of his voice these comments are only a partial rendering of the man, but the phrasing and the choice of words does reveal Callahan and his manner, adding to what one might call the overall fabric of his being.

Few men have given to photography greater riches than Harry Callahan and fewer still, once their achievement has been recognized, have maintained such a humbleness of spirit. For nearly forty years Callahan has demonstrated that the most common of subjects, approached with the most straightforward of techniques, can be made beautifully new.

Callahan's subjects – his family, city streets, facades, and portions of the natural landscape – are photographed so as to appear objective and analogous to truth. But this analogy is deceptive, because Callahan's exact and cultivated vision pervades each work and proves that truth is never quite so true as invention. His vision is particularly subtle when a photograph is isolated, but it becomes unmistakably identifiable when the body of his work is seen as a whole. Callahan directs us toward a more insurgent taste for life and his pictures enrich us by showing an intimate world where time has stopped to reveal man's unconscious or archetypal values.

The effortless mastery of Callahan's pictures is encyclopedic. While many have discerned in his work the brilliance of formal manipulation, this deliberateness of compositional intent is not fully shared by him. Instead Callahan professes a strong sense of the uncontrolled in the mak-

ing of his pictures, something bordering on the religious; seeing himself, in part, as a kind of vehicle in the creation of these images:

I sort of believe that a picture is like a prayer; you're offering a prayer to get something, and in a sense it's like a gift of God because you have practically no control – at least I don't. But I wouldn't make a pronouncement out of it. I just don't know what makes a picture, really – the thing that makes it is something unique, as far as I can understand. Just like one guy can write a sentence and it's beautiful and another one can write it and it's dead. What that difference is, I don't know.[1]

Callahan's photographs are deceptively simple in their straightforwardness. Indeed, the current vogue for considering as art a photograph which is thought to resemble the "snapshot" may be traced to the influence of Callahan's work; in particular, the photographs of his wife Eleanor, of his wife and daughter Eleanor and Barbara, and most of the urban street images. In part, this genre of photography which is rooted in the nonart of personally familial images was a source for Callahan's own creative impulse early in his career. Callahan remains part of a close family and he has maintained an interest in their personal reveries. However, he has also written perceptively, and as long ago as 1946, that:

The photographs that excite me are photographs that say something in a new manner; not for the sake of being different, but ones that are different because the individual is different and the individual expresses himself. I realize that we all do express ourselves, but those who express that which is always being done are those whose thinking is almost in every way in accord with everyone else. Expression on this basis has become dull to those who wish to think for themselves.[2]

In this context it may be seen that he recognizes that the ordinary shapshot is an illustration; a picture which represents understood and accepted values. Callahan is more interested in public art, something which might be called a defamiliar-ized image which, while drawing on conventional or accustomed subjects, transforms their representation into something new and life giving. He transmutes and compresses his material in an effort to dramatize the subject incisively, to render rather than report it. In the above statement he continued:

1 Alan D Coleman, "Harry Callahan: An Interview," *Creative Camera International Year Book 1977* (London: Coo Press Ltd., 1976), p. 76.
2 Harry Callahan, "An Adventure in Photography," *Photographers on Photography* (Englewood Cliffs, New Jersey: Prentice Hall, Inc., 1966), p. 41.

Photography is an adventure just as life is an adventure. If man wishes to express himself photographically, he must understand, surely to a certain extent, his relationship to life. I am interested in relating the problems that affect me to some set of values that I am trying to discover and establish as being my life. I want to discover and establish them through photography. This is strictly my affair and does not explain these pictures by any means. Anyone else not having the desire to take them would realize that I must have felt this was purely personal. This reason, whether it be good or bad, is the only reason I can give for these photographs.[3]

His urban street images are representative of this transformation of a familiar subject. In recalling his approach to this commonplace environment, one in which we all participate and therefore have an image of, he has said, "how do you make anything out of it?" He thus reveals his concern not to simply show a place or action but to draft a correspondence between its forms and his artistic feeling. In discussing these images of people walking on the street, Callahan has made this statement:

It was so strange to me – just people walking on the street – how do you make anything out of it. So I started photographing people with their hands in certain positions or their arms around each other, talking to each other and all this kind of stuff and I found that anything I thought of that way, literally, I never really care much about the picture. I found that when they were walking by themselves they were lost in thought and they weren't "with it" any more, and so this is really, I guess, what I wanted.

I photographed those by setting the camera at 4 feet with a telephoto lens on a 35mm and just when they filled up the frame, I snapped it. I'm walking and they're walking. Well, that was an exciting bunch for me. I photographed for a long time doing that. To describe what I got. . . . I have no idea. I just know it was moving to me.[4]

This process of what I call defamiliarization has as a fundamental strategy the alteration of the viewer's expectation of what a picture looks like. The photographer recognizes the generally preconceived notion of what a still image is and he attempts to extend that concept and stylize it. It is an approach based on the fact that normally objects or situations are so familiar that one's perception of them is habitual, and therefore automatic. Thus in order to renew perception pictures must be unfamiliar. This is highly complex in photography because the medium has as its inherent basis the mimetic

3 Ibid., pp. 40–41.
4 Melissa Shook, "Callahan," *Photograph* (New York), vol. 1, no. 4, Summer, 1977, p. 4.

vision of the lens; however, once the objecthood of the photograph is recognized, then this approach to stylization can be readily grasped with all its potentialities. In the context of contemporary experience Callahan's photographs are a strong antidote to the simplistic description of modern urban life. The social sciences have provided us with all the necessary clichés – alienation, disassociation, depersonalization – and we have been educated to think in these descriptions which have the effect of generalizing problems that already seem unrelated to our personal lives because they seem so abstract and general. This then becomes the challenge for the photographer; to break down the generalized nature of experience by making images which, in their specificity and uniqueness, serve to engage us in the realities of our lives. The process is but another form of expressive abstraction.

Today, when the conceptual framework of photography is being defined more fundamentally, it is essential to identify the relationship between subject and technique. Callahan's interest in the techniques of photography are integral to his interest in the subject and they are intimately suited one to the other. His background in a respect for the medium and in the freedom of techniques, such as multiple exposure and controlled tonal scale, stem from the spirit of the European avant-gardists of the twenties, whose views represented a liberal purism of what was truly photographic. Callahan has said of the subject and its representation in photography:

It's the subject matter that counts. I'm interested in revealing the subject in a new way to intensify it. A photo is able to capture a moment that people can't always see. Wanting to see more makes you grow as a person and growing makes you want to show more of life around you. In each exploration or concern for the subject, I continue in the area for a great length of time, sometimes a couple of years. Working this way has been the result of my doing the photo series or groups. Many things I can't return to and many things I return to come out better.[5]

With regard to influences on his work, particularly that of Moholy-Nagy, Callahan has recalled:

He did (influence me), in an underground way. As far as whatever so-called inventiveness I have. I don't think that had to do with him particularly, but he liked it, and that was nourishing.

He hired me on the basis of my photography, and when he first hired me he asked me why I took a picture, and I couldn't tell him.

5 Harry Callahan, untitled statement, *Photographs: Harry Callahan* (Santa Barbara, California: Van Riper and Thompson, Inc., 1964), n.p.

He said, "well, I don't care if it's just for a wish." Which is something he represented – a playfulness, a childlike look at things, which attracted me. You can't be that way forever, but he did it for a long time.

I'm sure that there's lots of influences, but I can't be too conscious of them. Walker Evans must have influenced me somehow; I liked the directness of his photographs, and tried to shoot as directly as possible. But that doesn't work so well anymore, unless it's his – but I like that part of photography . . . his photographs probably struck me the strongest – but that's getting to be like too much Beethoven; I don't know how much more I can look at that, really.[6]

This seeming polarity of influences and interests – Moholy-Nagy and Walker Evans – is not contradictory. Each artist projected an individual stylization and their views about the medium are becoming more widely comprehended today as we come to recognize that photography is such that the direct, so-called straight approach is no less manipulative than the more synthetic approach which is erroneously associated with experimentation and exploitation. This attitude, however, has not always been widely held and in the past these have been mutually distrustful traditions. It is because of their fusion in Callahan's work that a more sensible contemporary attitude has been forged. The fact that Callahan vests his most dramatic manipulative work in the camera, and not in the darkroom, is to place the loci where it belongs – with the vision of the photographer. We must understand that for most other photographers it is necessary to experience vision but for Callahan, to see is vision. The essential aspect of Callahan's work is manifest in the stylistic device of precise images with the utmost degree of photographic clarity. Not all of his synthetic work rests on multiple exposure, in which there is a significant reliance on chance, but also through tonal stylization, a no less fanciful or purposeful synthetic side of his work is evident in his pure photography; for example, his wires against the sky or blades of grass against a neutral background. For while appearing graphic rather than photographic, they are literal representations of the subject.

In identifying for himself an understanding of how he derives his pictures and the extent to which his imagery is realized in the camera, he has remarked candidly about the practice that is commonly called previsualization. This is a concept derived from the working method of Ansel Adams, the first photographer whose work fundamentally impressed

6 Coleman, "Harry Callahan: An Interview," p. 76.

Callahan, and others, in which the goal is to visualize the finished photograph before exposure:

The only previsualization I ever do is – like with the weeds in the snow, I know the background's going to be white and there are going to be lines. No, I think previsualization is in pictures, but I don't think of it in the terms that Adams and the others do. I understand what it means to them, but it doesn't mean anything to me. In fact, I like those little accidents. . . . I sort of believe it's untrue. I mean, are they previsualizing a masterpiece, or a perfect print, or what? If I knew every picture I made was going to be a real picture, maybe I could go along with that, but I can't. . . . I imagine it's a good teaching tool, though, so students can learn the technique of seeing. I suppose that's just their bundle of rules. And Jerry Uelsmann, he doesn't believe in that, he does it all afterwards, and that's his bag of rules.[7]

Elsewhere he has said:

I have ideas. I always go out with an idea, but it isn't a very big deal, you know. It isn't as if I'm going to save the world. Maybe I want to get down low and tilt the front lens, maybe it's that much.[8]

Unlike the numerous photographers of his generation, Callahan has not been haunted by tragedy or negative speculation; rather his art is about a more lyrical positivist emotionalism. His art is devoid of the socioeconomic values reflected in the major currents in much of today's photography. His view of the antique in Rome, or of the walls and buildings of Peru or Bolivia, or of the earlier Chicago facades are alike in his respect for tradition and craftsmanship. His is an art which pays homage to human endeavor in its gesture of will, revealing the intensity of interaction between man and nature, man and time.

This romantic impulse in Callahan's work is one which coincided with strong developments in photography after World War II. Minor White's work is a conspicuous example; and like White and others, Callahan should be seen as a romantic artist who used the selective literalness of the camera as a stylizing vehicle for his emotional expression. Callahan's view of woman is the obvious case in point, and these pictures are the most poetic of his work. The feminine is a theme to which his artistic precursors similarly aspired and also thought to be the most poetic. The essential emphasis in romanticism is on the symbol, the intensive enigma, while formal structure is a secondary consideration. The difficulty

7 Ibid., p. 75.
8 Shook, "Callahan," p. 4.

of projecting a romantic ideal in photography is undeniably difficult; Stieglitz first proposed a solution with his photographs of clouds, and photographers such as Minor White and Aaron Siskind opted for similarly nonobjective imagery through the decontextualization of the subject. But Callahan, intent on preserving the essential ingredient of the photograph – the subject – places a premium on the continuum between recognition and the evocative qualities of the imagination as revealed in the illusionism of his photographic presentation. For Callahan, the interpretation of a photograph should be not only an act of the eye but also of the mind.

Callahan's world is one dominated by the image of nature. This includes those pictures in which the very things of nature are missing, but echoed and metamorphosized through the process of absence and comparison; patterns of grass remind him of building surfaces and layers of buildings, seen at angles or through alleyways, are the forests of man's creation. Certain of his great textural landscape pictures are like tapestries. Woman stands among the trees as a human presence as much as woman walks the streets of the city. All of Callahan's pictures are environments, landscapes into which he projects his romantic spirit. His pictures are all meant as a confession of deep interest and respect. He is truly in love with woman and he lives and breathes this admiration and reverence. In his romantic temperament, woman plays the crucial role. As Goethe said, "the eternal feminine impels us onwards," and no expression of this idea has achieved greater universality in photography than in the work of Harry Callahan. Apart from Stieglitz's obsession with Georgia O'Keeffe, it is doubtful if the woman's world has ever before been so fully revealed in photographs by a man. In Callahan's workroom he once had two images tacked up above his desk which disclose his aesthetic kinship and something of his historical perspective; each is a post card reproduction. One is of a nude by Thomas Eakins from the photography collection of the Metropolitan Museum of Art, and the other is of Goya's "The Naked Maja." These two widely differing artists represent woman as a gentle and lyric goddess, an interpretation Callahan shares. His images of the female form may be dematerialized and superimposed on the earth itself, but in none of his images is either a figure or even a leaf mutilated or assaulted.

Callahan's most recent work is in color. It is an aspect of the photographic medium not new to him, but one which he has not utilized for a decade or more with anything like the present intensity. These new pictures are a further ex-

position of his romantic temperament through their warm earth colors and their vigorous perspective. They are rich in the intensity of their color, a palette which he owes to the recent colorist vision of a younger generation of photographers, yet the pictures are devoid of anecdote and the transitory; a vision which, in black and white, he himself established early in the fifties. There are many details in these pictures which echo his earlier work: the colorist exploitation of black not only as shape but as color, precise shadows and deep planes, window reflections as a kind of interior/exterior duality, and the juxtaposition of bits of cultivated nature with the constructed world. There is less precise regularity here, however, and a greater sense of humor, which he refers to as "freedom" and the pleasure of being "less fussy." The fact that all of the recent images are taken in Providence, a city where he has photographed for more than a decade, does not concern him, nor does the observation that the subjects are analogous to his earlier architectural work. Callahan, like other mature artists, is fully aware of the compulsion to repeat, to go deeper into what he has seen. Like those before him he holds the poetic conviction that the emotional forces generated by a place or an object can be made more visible through constant and deeper probing. In addition, Callahan has a considerable interest in serialism and he views much of his work in this ensemble format, preferring to show groups of images all reflective of a similar involvement with the essence of a subject.

It may be with more experience you can photograph more freely, even though you may go back and do the same thing in a sense. You can put some life into it a little easier. But I guess there's certain subject matter that you look for everywhere, and you go back to the same places.[9]

Callahan thinks of little else other than his work. His life as a teacher of photography has been dedicated to the young, but likewise through them and their work, he has been led back into his own. His work has not radically changed in the forty years he has been making photographs but they have steadily risen to increased levels of grandeur. Perhaps a comparison with the painter Cézanne is not presumptuous, for like the last works by him, Callahan's latest photographs are also the ingenious creations of a master drawing upon a deep

9 Jacqueline Brody, "Harry Callahan: Questions," *Print Collector's Newsletter* (New York), vol. 7, no. 6, Jan./Feb. 1977, pp. 172–173.

repertoire of experience and skill. He has commented on his near obsessive approach to work:

I photograph continuously, often without a good idea or strong feelings. During this time the photos are nearly all poor but I believe they develop my seeing and help later on in other photos. I do believe strongly in photography and hope by following it intuitively that when the photographs are looked at they will touch the spirit in people.[10]

Callahan speaks little about other artists or photographers, but one knows he is always looking and that he is fully aware. The names Steichen, Stieglitz, Moholy, Adams, Evans, Siskind and those of his students appear in his conversations, usually in the context of his personal familiarity with these figures as mentors or colleagues. He comprehends his place in photography and he recognizes his own uniqueness:

I think in the end that's what it's all about. You are an individual and you are unique and when you make something that really comes out of you it's going to be unique.[11]

He is, nonetheless, a remarkably unpretentious, witty and kind man; a complimentary personality in this time of expanding and sometimes superficial interest in photography. He senses the temporality in some of this and he cautions himself even in his delight with his own success and with that of the medium. When asked, "do you believe you're consciously trying to make the world more interesting?" he replied:

I've had all kinds of attitudes. About the most I can guess I feel is that some of the great sculptors, the great painters, the great architects, and composers have left something real wonderful for me, and so I'd like to leave something for someone else. That's about the closest I can come. I thought at one time I should benefit humanity, but I don't even know what that means anymore, and then you think, well, you're doing it to satisfy yourself but there's more to yourself than just satisfying yourself too, and so I really think it's just that I want to leave something for somebody. I feel whatever I've got is a gift so I have to take care of it, like it was a plant or a child growing or anything else. That's about as close as I can figure it.[12]

10 Callahan, untitled statement, n.p.
11 Jim Alinder, "An Interview with Harry Callahan," *Exposure* (New York), vol. 14, no. 2, May, 1976, p. 13.
12 Brody, "Harry Callahan: Questions," pp. 175–176.

PHOTOGRAPHY AS PRINTMAKING

Naomi Savage, *Enmeshed Man*, 1966

THE PHOTOGRAPHER IS universally characterized as an observer who possesses a vision. It is less often realized that he is also a printmaker – whether working with paper, metal, or plastic, whether through the customary direct silver techniques, or electronics, inks, synthetics, or combined media, and whether in terms of the unique original print or editions. Not all photographers who possess a vision impart equal sensitivity to printmaking.

By calling attention to the photographic print, one in no way depreciates the importance of the optical image. Rather, this concern extends the image and in addition recognizes the

"Photography as Printmaking," *Artist's Proof IX* (New York: Pratt Graphics Institute, 1969).

149

photographer's creative objective in the execution of an artifact.

There are two attitudes most frequently embraced to clarify the nature of photography. One aesthetic states that the photograph mirrors or imitates a kind of exterior reality: a straightforward image is interpreted illusionistically through the picture plane. This approach, which the photographer Edward Weston pursued to the highest level in this century, is linked to the relationship between significant revelation and action, or what he termed previsualization. "The conception must be seen and felt . . . complete in every detail," he wrote, "for with the shutter's release the isolated image becomes unalterably fixed." This idea is the fundamental tenet of what is generally termed "straight" photography. But Weston and others further realized that no matter how straightforward one's disposition may be, nature cannot be copied exactly even by means of a camera. Thus there are still subjective mannerisms, in part directed by techniques and materials, which render each print unique and which, in the last analysis, place man as the actual medium of expression. Therefore, one must face the added complexity, as may be seen in Weston's "Shell and Rock," that the most descriptive image is also an abstraction elaborated with ambiguities of the imagination.

A second aesthetic, however, draws on the first concept and expands it. In this case, the print itself is emphasized. Now the goal of the artist, who often uses a partially manipulated or wholly cameraless image, is to make of the picture itself an object so distinct that it serves as an extension of the eye – an extension toward what is felt about the world rather than what is seen. This approach seeks to make the medium visible, whereas the former seeks to make it invisible.

Within the straightforward mode lies much of the 19th century work which later served as the basis for Weston's ideas. Often these earlier photographers translated the externals of life into pictorial form, almost as an act of preservation. Emphasis was on recording the salient points of an object, or its principal characteristics, making the photograph serve as an aid to memory or experience. This was the intention of the portraitist, or the landscape and architectural documentarian, for example Francis Frith. Essentially the 19th century was a period of the exploration of those characteristics of photography that had been so unexpectedly granted – mobility, instantaneousness, continuous tone, and

optical clarity – with a determination to utilize these qualities in whatever way seemed clear or expedient at the time.

Nevertheless, a survey of the processes used in the 19th century to produce the final pictorial form, the print, evidences a variety of perceptual qualities quite different than those which form the basis of our present-day conception of what a photograph is supposed to look like. This contemporary notion is that a photograph is a piece of paper on which there is a more or less recognizable image which is interpreted in terms of two dimensions standing for three, picture size representing life size, and a variety of greys representing colors. Some of the processes used in the last century were the calotype, silver chloride, Woodburytype, gravure, carbon, platinum, gum-bichromate and related pigment processes, Aristotype, Daguerreotype, and ferroprussiate, also called the cyanotype. These are all monochromatic picture making processes, or the opposite of today's direct color techniques. However, a view of these photographic images in the terms suggested above is limited, because in their monochrome the range of colors and surfaces resulting in these processes extend from a tawny brown of the calotype, to the soft, mellow, greyish white of platinum, the harsh metallic tones of the silver chloride papers, to the brittle tones of amber in the Aristotype, and cyan, green, yellow or sanguine in the gum-bichromate.

The desire for color images with the greater satisfaction for the evocation of mood than the shallow experiences derived from the hand colored *black and white* photograph is one of the important motivations for the use of these earlier processes. On its introduction in 1839, the photograph was invariably considered a form of art; not by the photographer necessarily, but by the critic. The rendition of color was found to be most wanting and it was a problem that did not find a solution until our own time. Even today direct color photography is inadequate to most of the demands placed upon it. Fundamentally, photography remains an intimate graphic medium which renders in a unique way the values of natural color other than by counterfeit.

In photography the most significant and vigorous undertaking in the area of synthetic printmaking has occurred in the last decade. The contemporary photographer is responsible for his imagery, is personally identified with his work, and boldly determines the content of his pictures. This attitude, of course, it not unknown in the arts in general.

Beginning at the turn of the century with Alfred Stieglitz

and his colleagues, both here and abroad, efforts toward equating variety in prints with greater individualism of statement began to be apparent. The advent of the cameraless image by Christian Schad and Man Ray, in 1918 and 1921 respectively, thoroughly challenged the illusionistic aesthetic and works in photographic manipulation became commonplace. Critics and scholars, unable to grasp the implications of this work, began to label techniques differing from the straightforward as "experimental." This designation allows an interpretative bias which assumes that in the creation of a photographic image other than the descriptive, a fully realized work is generally not obtained. Jerry N. Uelsmann, in his use of the photomontage technique in "Small Woods Where I Met Myself," is an experimenter only to the degree that Edward Weston was in his manipulation of the traditional silver chloride paper in his "Shell and Rock." Conversely, these same non-imitative, "experimental" methods have also been labeled as "creative," implying the equally narrow view that straight photography is not. Such concepts are restrictive, if not false, as clearly shown by the sophistication of photographic results in the last fifty years and by the increasing awareness that our concept of reality is not so much based on the veracity of retinal perception as on psychic vision. Today, the basis of criticism should not be the photographer's choice of technique but those greater complexities of his judgment which ultimately define the quality of the work.

Printmakers in the traditional graphic arts, who in the past have exclusively emphasized the hand drawn image and the subtleties of personal interpretation are today turning to photographically inspired optical images. While few persons are misled by the *truth* of the camera's image, the comparative literalness of its visual result is often seen as an inspirational complement, albeit with necessary tension, to the hand-created image or what Michael Rothenstein has termed the *gestural* image. In this form the photographic imagery, generally derived from such sources as advertising illustration, editorial journalism, and television, is utilized for its literalness and uninspired sensualness in opposition to the imagination. Some contemporary photographs, like those haunting documents from the last century, have a peculiar aspect of recollection; the record of a distant memory which is more sharply defined than the memory itself. Hamilton, Kitaj, Rauschenberg, and Rivers, among others, often use the photographic image in the way it was once described by Oliver Wendell Holmes, "as a mirror with a memory." These print-

makers would have us believe that the event depicted engenders in us a similar experience to actuality. In fact, an event, personality, or place, secure and instantly recognizable in the photograph as a kind of timeless icon, is the key to their meaning: the assassination of a public figure, the Manhattan skyline, Marilyn Monroe, the President, Che, or the titillation of nudity as, for example, in Kitaj's "Boys and Girls!".

It is not surprising that artists in recent years have been drawn to the photographic image. It is the image making system of the mass media and many artists today are endeavoring to speak in a less heroic fashion to more than the reflective few. Interestingly, the photographer, who always has produced this imagery, feels the need to make of it something more than charged documentation. He wants to assert his individuality which he feels is restricted by conventional photographic media as well as to broaden his potential in terms of publication, criticism, and patronage. Photographers of late believe less in the symbolic actuality of their imagery and more in their virtuosity as synthetic draftsmen. This is not to say, however, that the photographers who pursue an aesthetic other than the straightforward create less than valued work. But to understand it fully one must recognize how distinctly the photographer adheres to the underlying photo/optical basis of his imagery as opposed to the printmaker's synthesis of idea and image through drawing.

Douglas Wadden is an artist in whose work one can explore this contemporary manifestation. He utilizes the photoserigraph technique in a way that both conceals a photographic notion and elaborates it. In his untitled work showing a nude figure, the rich opaque ink does away with the variable tones, but the optically formed linear edge remains. As one attempts to construct the reality of the statement from the actuality of the composition, one invariably questions Wadden's motives. However, the sophistication of his approach and the archetypal symbolism of the work is apparent once the few details of the face are related to the supine torso. Naomi Savage, in a similar fashion, allows those vestiges of photographic clarity and objectivity to remain and come through in the subtle delineation of a facial highlight line enlarged out of focus from a photographic negative. In her inkless intaglio relief "Profile," what at first appears to be a supple hand drawn image becomes, on consideration, astonishingly surreal. This is no mere profile, it *is* someone. Savage has also extended the photographic medium by her presentation of the photoetched plate itself. A simple act, but in its generosity she

has brought to the medium a kind of topographic photograph, which modulates forms in three dimensions with a variety of metallic surfaces and tones. The existence of a negative enables her to duplicate these plates, which differentiates her attitude about them from that of the printmaker. Her work represents the first prints on metal in nearly a century.

Collage has been a familiar 20th century technique in all of the arts. But a remarkable example from an earlier period is a work by Sir Edward Blount of 1873 in which the illusionistic space of the interior is created in a perspective drawing into which are inserted the contour cut photographs. A metamorphosis of particular grace and romantic fascination results. Moholy-Nagy, Heartfield, Citroën, and Hannah Höch have been the leading figures in this approach for the last fifty years. They have drawn on the more advanced modes of vision and design originated by their immediate predecessors. Ray K. Metzker shifts the concept of the collage from illusionistic juxtapositioning to a homogeneity of surface and detail. With many original continuous tone photographic prints merged into a single non-objective pattern he magically presents literally hundreds of synoptic views of the figure.

James Fallon fuses a xerographic picture, derived from a photographic positive, on acetate and places it in a simple sandwich collage of paper to achieve a monochromatic color image. Other work in xerography, including direct camera photographing onto the selenium plate, makes this process the most challenging and provocative for the immediate future.

The composite photograph is a variant of the collage, in that the constructed image is photographed in its entirety to produce a print with a continuous surface. Photographically this technique is almost as old as the medium itself. The rich tradition begun by Robinson and Rejlander in the 1850's continues today. The aim of these two 19th century Englishmen was to create a picture through fabricating bits and pieces of various photographs together. Jerry N. Uelsmann elaborates the discipline to a more complicated and perfected form in what is called photomontage. It is so termed because a number of negatives are printed successively on a single sheet of paper. In Uelsmann's approach, the potential for print variation is increased although at a single printing he can duplicate nearly each visual effect provided he does not exceed the limits of accident within the photographic process in such things as blending, deliberate fogging, or image reversal.

Whereas Robinson and Rejlander used the composite photograph as a technique to construct a unified picture of a completed event or idea in conventional linear space/time, Uelsmann presents in his approach to photomontage simultaneously *varying* systems of idea/event as an analog for the inner and non-linear processes of thinking and feeling.

The dissolution of continuous tone, or the straight photograph, through processes natural to the medium itself has rendered many effective works. One instance is the deliberate tone reversal through the effect known as solarization. Given expressive substance by Stieglitz in his figure studies of 1918, and by Man Ray in his "Sleeping Woman" of 1929, it may be seen as the basis of Edmund Teské's work entitled "Woman of Flame." In addition to the reversal of linear highlights, from light to dark, Teské also has utilized the staining properties of the various chemicals used in development and fixation. The original, rich in colors of brown, chalky grey, and black, blends a variety of *normal* procedures but, here, thrown awry by a radical alteration of sequence. Another instance of the simple alteration of process is Arnold Doren's use of photographic paper in the camera to make a direct negative on it. The work "Elizabeth" has an incredible subtlety in tone and detail, giving a result unobtainable in the usual circumstances of printing from a negative on film to a positive on paper. Each picture is unique and demands great skill in execution.

Cliché-verre, or the making of a printing matrix by means other than the camera alone, is another approach available to the photographer. Corot, Millet, and the Barbizon painters were interested in this technique as early as 1853. It has only recently been revived by the delightfully imaginative artist Brassaï. Taking negatives of the figure made about 1934–35, he created a series of studies utilizing a partial cliché-verre on the original negative. In his portfolio *Transmutations* of 1968 he writes, "the photograph is now and then volatilized. At times some debris has survived: a piece of quivering breast, a foreshortened face, a leg, an arm. Enshrined in graphism this debris gives to our obsessions, to our dreams, the flesh of the instant, the breath of reality." Utilizing a somewhat similar printing device, in this case dye transfer matrix film, Caroline Durieux has produced in her "Frail Banner" a deeply personal non–objective image which could only be achieved by the transmission of light through such a rarefied gelatin membrane.

The photographic image, as discussed earlier in opposition

to the gestural, lends itself to the duality of realism and imagination. In other words, time can be juxtaposed and subjects can be brought together out of sequence. Robinson and Rejlander, in terms of their working technique, brought this revolutionary insight to the medium a century ago. Scott Hyde in the tondo "Fruit," extends this concept in his use of the once popular gum-bichromate technique where color pigments are introduced into the printing process almost in the manner that various colors are laid one atop another in additive processes, such as woodcut or serigraph. Here the multiple levels of color are compounded by layers of images, in this case figure, figure detail, and fruit, somewhat like multiple exposures in the camera. Similarly, Gary Metz in his portfolio *Song of the Shirt,* begins with a black and white photographic print, in some cases destructs the traditional image through the dissonant tonal rendering of a xerographic copy, only to reconstruct a picture through the use of synthetic color. Working with the printer John Moore and utilizing a small commercial offset press, he has been able to produce works of great variety and imagination where the color is wholly arbitrary to the original sources but integral to the interpretation of the picture. Of all the photographers discussed here Metz is perhaps the most painterly in his approach, but his poetic insight still has as its base the lucidity of the photographer who passionately documents his experience through records of his environment.

This piece is an explication of the idea that for photographers and printmakers alike there are aspects of photo/optical imagery that can and should be of interest. Certainly the immense variety of media and the vigor of their contemporary use is suggested. But in pointing out these frontiers caution should also be exercised. The art of true character eludes a simple label or description and in the end has little to do with techniques anyhow.

OBSERVATIONS ON
PHOTOGRAPHIC SENSITIVITY

Eugène Atget, *Saint-Cloud,* ca. 1921–22

VARIOUS OF THE visual arts are sometimes inflicted with a kind of intellectual and critical blight. No medium has been exempted but photography seems to have been more deeply impaired than others. Instead of assuming the fact of its existence and concentrating on those aspects which have so fundamentally altered our vision and understanding, the majority of serious critics tediously speculate on whether or not photography is authentic.

This situation reminds one of the drawing room dramas of the last century, or of current television soap-operas, in which the playwrights ponder whether an obviously pregnant woman can give birth to a child and, *if so,* who the father

"Observations on Photographic Sensitivity," *Arts in Virginia* 10 (Winter 1970): 44–45.

might be. Similarly, beneath the statements of the most earnest photographers lies a selfconsciousness and an almost apostolic fervor to establish the equality of photography among the arts. However, what is often being asked by these men is that photography be more equal. These two critical positions have been taken with such frequency since photography was invented, that one would think that even the most simple of minds could conclude its natural state or status. Because photography is based on the vision and intellect of man it has to do with the arts of expression, but as to its qualities and virtues photography is photography, neither more or less.

One of the reasons for this curious situation is that there have been few truly anarchist confrontations in photography with their allied radicalism, polarity, and examination of intrinsic values. True, there has been progress and change, and plenty of cultism, but revolution has been unheard of. One sometimes longs for that kind of mischievous nihilism, such as we are experiencing in the contemporary theater, which bewilders the establishment and stimulates the outsiders.

Photography has a genuine underground. One has only to tour the galleries of the Museum of Modern Art, the Art Institute of Chicago, or the San Francisco Museum of Art to see where the young in spirit are and where they remain the longest. In the photography galleries many viewers appear to be on a quiet, inward journey of appraisal. One reason for this devoted and individualist following is the paucity of insightful critics and publicists. Few persons know anything about serious photography and we all know that the seeds of revolution are not borne by the ignorant. There is only one scholarly history of the medium[1] and few critical monographs. Even the finest of our universities are of no help. One can attend a survey course in the history of art and never once hear the word photography mentioned, let alone the requirement that the students study the work of its masters: Hill, Gardner, Cameron, Atget, Stieglitz, Cartier-Bresson, or Edward Weston, to name a few. Graduate seminars in French painting still explore the question of whether or not Degas knew of photographs, or could have been influenced by them, all in spite of the fact that Degas himself was a photographer.

Periodical publications in the field remain few in quantity

1 Beaumont Newhall's *The History of Photography*, New York, The Museum of Modern Art, 1964.

but high in quality.[2] Only three of the many popular art periodicals and none of the scholarly art history journals, treat photography with regularity.[3] The young people of today understand photography in their own terms in spite of these deplorable educational oversights. Jerry Uelsmann, Diane Arbus, Robert Frank, W. Eugene Smith, and Minor White are the heroes of the underground. Even Stieglitz commands a following of greater intelligence and insight than he did during most of his life. How many museum directors or collectors have heard of these names? How many are responsive to the work of these artists either through exhibition or acquisition?[4] How well is the medium itself prepared for this insurgent demand for a greater taste of life? Personally I am optimistic about the former questions and rather more worried about the latter one.

When I directed for the Museum of Modern Art the exhibition *Photography as Printmaking* in 1967, I was astonished by the variety of opinions about the exhibition. As an historian, I had tried to maintain a certain over-view while introducing the most recent and vital work. I was accused in the press and privately of everything from the perversion of the photographic medium to the kidnapping of artists from the traditional printmaking disciplines of etching, lithography, and serigraphy. My aim had been nothing of the sort. I sought to exhibit what had been done and is being done by the creative and photographically-oriented community, in spite of a certain lack of critical acknowledgment by this same community. Apparently I partly succeeded, but only at the expense of my goal, which was to show how extraordinarily varied and rich the medium has been and how unsure we are of just what photography is today.

In a way, this lack of understanding is caused by the fact that photography is practiced by such a varied number of persons. All photographers are not artists and one must be cautious not to seek an art of true character in the sheer exuberance of execution or the virtuosity of technique. A work of art must change the viewer. He must be made different by his encounter with the work. In this context one is drawn to appraise the role of the hobbyist in photography. It is a position which is difficult to analyze. With serious artists, faith in the work of art as a vehicle of self-expression,

2 There are four: *Aperture, Camera, Contemporary Photographer,* and *Creative Camera.*
3 *Art Forum, Art in America, Studio International.*
4 Mr. Bunnell has discussed this topic in further detail in "Photographs for Collectors," *Art in America,* January/February 1968.

with the expectation that it clarify some moment of consciousness, is clear. These men respond to art in terms of ethical implications. One may interpret their work freely, but the basic artistic choices appear to us as do right and wrong actions and, therefore, affect many more areas of our life than the merely sensory. For the hobbyists, on the other hand, most of what one sees indicates that they consider photographs as things, decorative adjuncts to life, more or less technically inspired and generally related to a memorable event or place as opposed to revelation. Dealing in this realm of objects, the hobbyist has no choice but to attempt at giving direct pleasure which is frequently only ultrastabilizing. Morality rarely enters his conception. This is not to say that these men and women are less than honest or hardworking, but while honesty is virtuous, artistic creation by the truly committed is a responsibility. Thus, while many persons make photographs, few truly understand them, and fewer still contribute to the establishment of human values through the art of personal expression.

Photography has an illuminating history. The chief spirit which gave rise to the invention of the medium was a desire to reproduce the significant images and objects of the past. But the unexpected freedom of the camera and the magnificence of the photographic process caused the question of reproduction to be put aside, to be replaced by a more problematic one: Was the traditional concept of veracity as a criterion of excellence in certain of the visual arts open to challenge – and, if so, did this then make of photography some form of art? The nineteenth century photographer, not having sought so direct a confrontation with tradition, understood neither the enormity of the debate nor the complexity of the potential solutions.

From these early years came at least two developmental modes of approach which continue to this day: the first was based on the assumption of pictorial conventions from the other arts, both in terms of subject matter and treatment and, if necessary, at the sacrifice of the unique aspects of the photographic medium. The second was to exploit those qualities of photography which had been so unexpectedly granted: mobility, instantaneousness, continuous tone, and optical clarity. John Szarkowski has subtly characterized these motives as follows:

The history of the art of photography can be viewed as the result of a continuing interplay between two distinguishable motivations. The first can be called the pictorial motive. It begins with the desire

to produce an amalgam of forms which is in visual terms indivisible and sensuously rewarding. The second can be called the documentary motive. It begins with the desire to discover and state clearly the most relevant data. The first has been consciously concerned with the relationship of photography to the other visual arts; the second has produced work which exists as a kind of wordless literature. The first begins with sensation, and aspires to beauty; the second begins with meanings, and favors eloquence.

Perhaps the pairing of a few photographers would help illustrate this analysis, although it must be noted that photographers do not necessarily work throughout their career in one or the other of these modes: Edward Weston and Walker Evans, Hill and August Sander, Peter Henry Emerson and Timothy O'Sullivan, Stieglitz and Atget, Aaron Siskind and Lee Friedlander.

The clarity of these motives must not be too quickly assumed. This is because treatment is not necessarily all there is to a photograph. Nor is the obvious content the only other aspect to consider. One of the great problems in dealing with individual photographs is that as a medium, photography is not *felt* enough by the majority of persons to make it meaningful to them. The person who truly grasps the nature of the photographic medium today begins to know of a feature that the earliest photographers only sensed. This feature has to do with the concept of meaning outside of what is directly identified or recognized in the photograph. Alfred Stieglitz, who pioneered in the articulation of this aesthetic in the early 1920's, called it Equivalence. The basis of this aesthetic is the understanding that the individual frame of a photograph marks only a provisional limit, that its content points beyond that frame referring to a multitude of phenomena which cannot possibly be encompassed in their entirety. The exploitation of this aesthetic has been the dominant trend in the art of photography up to the first half of this decade. Its leading force since Stieglitz's death has been Minor White; others, such as Aaron Siskind, Harry Callahan, and Paul Caponigro also should be mentioned.

The two motives here discussed are by and large encompassing, but it would be a mistake to consider them closed or even so simply defined. To these motives I would like to add one which draws on them and from aspects of Stieglitz's aesthetic of Equivalence. I describe this third mode as psychogenic, or one which is dependent on psychic conditions and processes. In this approach the print is emphasized and media purity is de-emphasized. The goal of the artist, who

often uses a partially manipulated or wholly cameraless image, is to make of the picture itself an object so distinct that it serves as an extension of the eye – an extension toward what is felt about the world rather than what is seen. This approach seeks to make the medium visible, whereas the former two seek, in part, to make it invisible. This approach frequently consists of the artist working with one or more techniques – paper, metal, or plastic, the direct silver process, electronics, synthetics, or combined media – and almost always concluding with a unique work. A more recent direction, similarly stylized but more illusionistic in conception, has been that toward sculpture or the fully dimensional photographic object.[5] This latter development comes closer to true innovation than any that has been seen for decades. The persons who adhere to the straightforward or documentary approach to photographic reality are understandably repulsed by these penetrating directions, but their rancor has little effect. These new developments will continue and thus far it has been shown it will not be at the expense of former approaches, but with them, toward increased sensitivity and relevance.

Today it can be seen that in expressive photography new directions are becoming fertile in a degree equal to the artist's most personal imagination. However, the greater issue remains constant – how will the photographer's challenge for change be met by the critic, the public, and his fellow artists? In photography the measure of success is not always unanimity.

5 See "Photographs as Sculpture and Prints" by Mr. Bunnell, in the September/October 1969 issue of *Art in America*.

PHOTOGRAPHY INTO
SCULPTURE

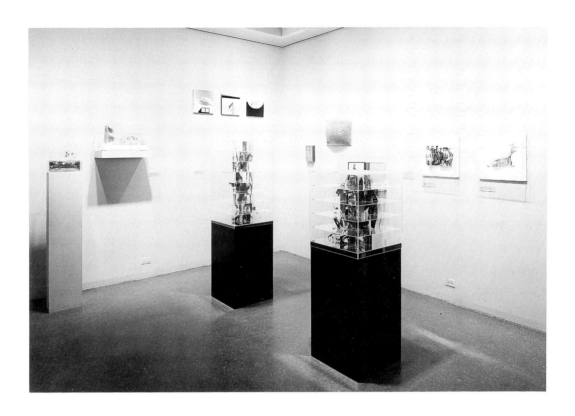

THE EXHIBITION *Photography Into Sculpture,* directed by the author, opened at the Museum of Modern Art on April 7, 1970. It contained fifty-two works by twenty-three American and Canadian artists. Not all of the work in the exhibition is discussed here. The participating artists are: Ellen Brooks, Robert Brown, Carl Cheng, Darryl Curran, Jack Dale, Michael deCourcy, Karl Folsom, Andre Haluska, Robert Heinecken, Richard Jackson, Jerry McMillan, Bea Nettles, Ed O'Connell, James Pennuto, Joe Pirone, Douglas Prince, Dale Quarterman, Charles Roitz, Leslie Snyder, Michael Stone, Theodosus Victoria, Robert Watts, and Lynton Wells.

Photography has always been extraordinarily rich and varied in its complexion, but at any single point in time it has been exceedingly difficult to state just what the medium is. The current notion of what a photograph looks like is that it is a piece of paper on which there is a more or less rec-

Installation view, "Photography into Sculpture" exhibition, 1970, The Museum of Modern Art, New York

"Photography into Sculpture," *Arts in Virginia* 11 (Spring 1971): 18–25.

ognizable image which is interpreted in terms of two dimensions standing for three, picture size representing life size, and a variety of greys representing colors. All of these conceptions are perfectly adequate as far as they go, but they do not exhaust the complications in contemporary photography.

In the last few years artists from a variety of disciplines have embraced a new kind of photography in which many of the imaginary qualities of the picture, particularly spatial complexity, have been transformed into actual space and dimension, thereby shifting photography into sculpture. This work has introduced into the medium many fresh illusionistic qualities as well as new techniques and materials which up to now have been only marginally important. Among these innovations are topographic structure, image participation, tactile materiality, procedural time, and the technology of plastics, liquid emulsions, fabrics, dyes, film transparencies, and emitted light.

Aside from the use of new materials, which are evident in the objects themselves, the single and most unifying element of this work is the artist's commitment to the physical object. Photographs have hitherto fallen into a most ambiguous space; that which exists somewhere between the wall and the hand. We are all accustomed to the framed presentation of pictures, but the result is not altogether satisfactory. The finite detail of the photograph, frequently obscured by reflections in the glass, as well as the prohibition of any kind of behavioral or participatory experience in the work, tends to cause one to seek a relationship with the medium more in terms of the hand-held object. These new sculptural works bridge this gap by means of exploiting the physical substance of photographs, or what may be called tactile materiality.

Developing out of this latter thought has also come a new concern for the process, or act, of structuring the pictorial components by the viewer. For instance, in Robert Heinecken's picture puzzles, which are composed of blocks of varying depths with photographs on the surfaces, the artist plays on our desire to make of picture fragments a representational image. However, in this case such a solution is actually impossible to achieve. Michael deCourcy's boxes are also fascinating examples of this approach in which the random stacking of some one hundred units is to be done without critical expertise in formal visual relationships. Michael Stone desires such participation by the viewer with his sculptures, which imitate the displays found in our variety stores and supermarkets and from which, in a practically unconscious

state, we select goods for ourselves and our homes. Here, however, the "goods" within the meticulously fabricated plastic bags are caustic photographs showing our fascination with war, the banality of television, and police oppression. Douglas Prince's intimate environments, much less topical in mood, also invite participation, even if only to lift and hold them in an attempt to become one with the pictorial space and thus provoke the resulting intellectual experience.

Prince and others have remarked of their interest in the ambrotype photographs of the last century where the viewer could figuratively hold within the palm of his hand the object photographed which was itself hermetically isolated in its velvet-lined case. A further extension of this interest in early photographs, for Prince in particular, was the discovery of the photograph on glass: of the multiple levels of transparency, of the simultaneity of negative and positive images, of the world of re-phrasing illusion and meaning. Jack Dale, a Canadian artist, relates a similar experience in his fascination with lantern slides of a more recent era.

Historically, the techniques of sculpture have reflected the technological character of the society in which the work was produced. These artists work in a way that is wholly modern, in that it closely parallels the pictographic and structural framework of our scientific culture. All of them are young, and the majority are from the West Coast – from Los Angeles to Vancouver. If this movement seems to be centered there, it is mainly because the commitment of these artists to technology has been more significantly gratified, if not fulfilled; as a regional expression, they have enthusiastically endorsed the notion that photography is a material medium.

For the artists closely identified with the photographic community, such as Heinecken, Stone, Snyder, Brown, Prince, Quarterman, and Pirone, the source of this technological commitment also lies in their frustration with the once dominating view of photography as a straightforward documentary medium. For the West Coast, the artist who most distinctly expounded this view was Edward Weston. "Straight photography," as it is called, is linked to the relationship between significant revelation and action, or what Weston termed previsualization. "The conception must be seen and felt . . . complete in every detail," he wrote, "for with the shutter's release the isolated image becomes unalterably fixed." After Weston's death in 1958 this approach, which is not without exceptional merit, gradually became identified with a particularly narrow regimentation of pho-

tographic style centered on the West Coast. So while most photographers confirm the traditional and continuous link between finding and making, these younger innovative photographers gradually have sought to emphasize the latter term.

For those not so intimately aware of their photographic heritage, such as Jackson, Nettles, Victoria, McMillan, and Cheng, the source of their work is a more broadly based spirit circumfused throughout the arts. For the most part their work is highly original, particularly in terms of new materials, although conceptually these artists have followed Dadaist and Constructivist theories, and the more recent pursuits of the three-dimensional assemblagists and illusionists. Rauschenberg's *Revolver* of 1967 and his earlier *Shades* (1964), in which photoserigraphed images are placed on layered Plexiglas, and Robert Watts' various Pop Art pieces such as *BLT Sandwich* (1966), are relevant; however, there is little evidence to suggest that any of the younger artists are particularly identified with these more well-known figures.

What has occurred in the photographic medium is that making and materiality have become more closely identified. In photography the term "make" is as common as "take" – to take a photograph. But the traditional interpretation of the latter term is an experiential one in the physical delight of capturing aspects of observable reality. These photographer/ sculptors have come to be more interested in the physical gesture of constructing the pictorial work from supple materials – of creating a new form which only embodies aspects of the original observation, if indeed there ever was any. One of these artists told me that "the Los Angeles environment is such that to take a picture has no meaning. What is left is to make a photograph and in so doing my hands have as much to do with photography as my eyes." Dale Quarterman, a Richmond artist, understands this position as well. His constructions, such as the untitled group of male figures or *Marvella,* are not simply multiple views of the same subject. He replaces the usual linear process of observation and interpretation, such as one would experience in a *series* of individual pictures, with a *single* object in which the viewer becomes involved with the simultaneously varying systems of idea/event as an analog for the inner and non-linear processes of thinking and feeling. In addition to Quarterman's work, *Negative Numbers* by Richard Jackson, *Succubus Three* by Joe Pirone, and *Torn Bag* by Jerry McMillan are contemporary pieces which reinforce the Constructivist philosophy

that art is concerned with technics, not experience observed.

To stress this new dimensionality in no way diminishes the nature of the inherent photographic image. In fact, to appreciate these sculptural artifacts in the sense of their complexity of involvement, one must recognize how distinctly the artist adheres to the underlying photo-optical basis of his work, and how he exploits the properties unique to photography itself. There is a feeling, when looking at much of this work, similar to that experienced in the nineteenth century when the first photographs appeared – a sense of delight in the magnificence of the photographic process with its perplexing optical clarity, continuous tone, and essential reality. Thus in Carl Cheng's *Sculpture for Stereo Viewers,* or Dale Quarterman's *Marvella,* or Ellen Brooks' *Flats,* human figures, whether printed on film, photographic paper, or sensitized cloth, have the substance of the things themselves – of skin, leather, rubber, or hair. Cheng, Quarterman, and Brooks each show us what photography is about.

The maker of any photograph takes subjects – things – as he finds them and, with the selectivity necessary to determine their significance, manipulates them into an expression of his sensibilities so that they may constitute a revelation. It is not what is nominally said that counts in a work of art, it is what the artist creates with such an intensity of perception that the work lives with an intrinsic truth of its own. Kenneth Clark has observed that, "the less an artifact interests our eye as imitation, the more it suggests that the intent of the artist was in interpretation." It is this metamorphosis that identifies the artist's creativity in the execution of a work which fuses the literal or symbolic component of the photographic image with a specific form. These photographer/sculptors are seeking a new intricacy of meaning analogous to the complexity of our senses. They are moving from internal meaning or iconography – of sex, the environment, war – to a visual duality in which materials are also incorporated as content and at the same time are used as a way of conceiving actual space. The sculptural ideas involved insist on volumetric properties that intellectually and physically correlate form, space, and light; the pictorial space is made to work in combination with an environment that is literally three-dimensional.

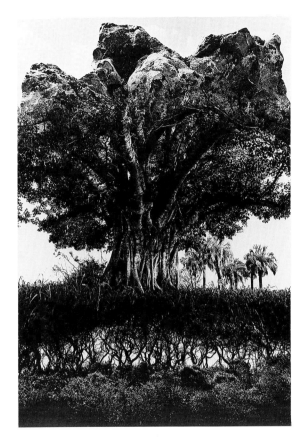

Jerry N. Uelsmann,
Rock Tree, 1969

Although I believe my work is basically optimistic, I would
like people to view my photographs with an open mind. I
am not looking for a specific reaction, but if my images
move people or excite them I am satisfied.

I have always felt I photographed the things I loved.

My images say far more than I could say in words. I
believe in photography as a way of exploring the
possibilities of man. I am committed to photography and
life . . . and the gods have been good to me. What can I say.
Treat my images kindly, they are my children.*

"Introduction," *Jerry N. Uelsmann* (New York: Aperture, Inc., 1970).
*These quoted statements are from Uelsmann's lectures, his letters, his conversations
with the author, and from his published remarks.

In his humanity Jerry Uelsmann is impressively real, yet his photographs, born of a fantast's vision, manipulate our deepest and most fundamental emotions, prompting us to suspect his person in art to be romantically independent of the real. He possesses a rare inspiration which effortlessly moves us. Like all true artists he is motivated by enthusiasm, and by the enjoyment of creation which drives him to share his dreams and experiences with us. Unconsciously, we are under his control and this control has been crucial to his success. His art is essentially direct rather than allusive, and his pictures appear analogous to that believable reality so fundamental to photography. But herein is the rub; Uelsmann's interpretative vision pervades each work and causes us to ponder whether reality is really quite so true as invention. Perhaps more consistently than any other photographer of his generation he has sought what Apollinaire called art's greatest potential – surprise.

Upon its introduction photography was understood in terms of a mystery related to its process alone. In recent years this mysterious or even mystical regard has been transferred to the photographer. Today he has become the pivotal figure in a creative metamorphosis which links sensory experience and physical process in such a way so as to reveal in a picture something much greater than the depiction of any subject or thing. What we have come to realize is that the frame of a photograph marks only a provisional limit; that its content points beyond that frame, referring to a multitude of phenomena which cannot possibly be encompassed in their entirety. Thus creativity in photography is the exposition not only of the photographer's receptivity in observation, or the skill of his craftsmanship, but the delineation of spiritual reality wherein the symbol transcends its model.

In the depths of any art must reside a personality, and like an instinctive animalistic struggle to recover from birth, the artist aspires to express his *self* in his work. How lacking in courage is an art in which the creator examines the collective ideal as opposed to the self-centered individualism of his own being. The key to a work of art lies not only in the work itself, but in the artist's outward labor to be someone. Uelsmann's life, his manners, his physical being, his work, all that forms the aggregate of his personality, imparts a final impression experienced at once as both dark and dazzling.

Basically I am dealing with the predicament and condition of man as it directly involves me as an individual.

I have gradually confused photography and life and as the result of
this I believe I am able to work out of my self at an almost pre-
cognitive level.

Life relates to attitudes. I have my own attitudes to work with, my
own ritual, my game of involvement. Images create other images.
I cannot be asked to be something other than what I am, but I
enjoy mind-prodding and mind-stretching.

Learn to use yourself as an instrument.

I first met Jerry Uelsmann at the Rochester Institute of
Technology fifteen years ago when we were both students.
I don't recall knowing him well – he wasn't making pho-
tographs then – but he was the kind of person one always
knew was around. He had a kind of flamboyance and vitality
which can only be described as humor.

Jerry's humor remains with him today and while it is no
less discerning than wit, it has much of the uninhibited ear-
thiness of vaudevillian comedy. It is reflected in his speech,
his mildly eccentric clothes, his mania for collecting bric-a-
brac, and in his phantasmagorical letters some of which in-
clude handwriting, photographs, Victorian valentine stickers,
Laurel and Hardy vignettes, peace symbols, and Florida gator
heads. It could never be thought that he conducted anything
like an old world salon in Gainesville, but a typical "at home"
with the Uelsmanns might begin with libations followed by
a superb lasagna prepared by his wife Marilynn for a dozen
or so people, include a visit to the University of Florida
campus for a screening of the complete Flash Gordon serials
run end to end, followed by dessert at Dipper Dan's, and
climaxed by a return to the house for a raucous songfest of
maudlin church hymns and nifty songs from the twenties
conducted, orchestrated, and played with consummate en-
durance on the grand pianola pedaled by Jerry himself. He
has frequently remarked that he prints his photographs best
to Beethoven and Bluegrass; and although Earl Scruggs
would make a perfect name for his extremely gentle watch-
dog, he chose instead to name her after a once famous animal
photographer. An addict for musicals of the largest, gaudiest,
Broadway variety, Jerry entertains a secret desire to be a tap
dancer and he would also admit to a love affair with Shirley
Temple; that is, before she became an ambassador to the
United Nations.

Social humor and amusing antics are significantly absent
in Uelsmann's photography, and it is in his photographs that
the darker facets of his being become apparent. For one can-

not escape the belief that his comedy conceals an intensity of concern for life and personal doubt which Jerry harbors about life's meaning. Indeed his interest in photography goes back to the time when, as a teenager, he discovered he could use the camera to divert attention from himself, or to have it function as a kind of buffer in personal encounters. He thought that in so using the camera – or photography – he could exist outside of himself, an idea he would realize in his later life to be naïve. Jerry is passionately in love with life but behind his exuberance is a coldly determined intention to seek the means of expressing the human condition in the most visible way. He understands perfectly well what he is doing. Although he publicly claims innocence in his creations, subtly redirecting inquiries about his approach to the concept of what he calls "in-process discovery," he assuredly possesses what a stranger to him described as "shadow wisdom." Such sagacity befits this double Gemini.

Let us not delude ourselves by the seemingly scientific nature of the darkroom ritual; it has been and always will be a form of alchemy. Our overly precious attitude toward that ritual has tended to conceal from us an innermost world of mystery, enigma, and insight. Once in the darkroom the venturesome mind and spirit should be set free – free to search and hopefully discover.

I can really be excommunicated from the world in the darkroom.

In the darkroom, a comfortable kind of situation is needed; for me the darkroom experience seems to relate to the cosmos outside – in fact, the experience seems to relate to an internal/external cosmology. There is the opportunity for an internal dialogue in the darkroom . . . a turning inwardly relative to what has been discovered outside . . . the two coming together. I develop an attitude toward something I am working on and can spend ten hours or more without becoming uncomfortable. I am creating something while I am working . . . not just technical orientation . . . really I am midwifing images and this is sort of what I am about. I see myself in terms of my self.

Today the artist, more than the priest, reveals the existence of an intangible extrasensory force which is constantly affective in our life. The artist is the surviving exponent of the mysteries, the last believer in the duality of our world, the last teacher of the method whereby we may establish contact with the mysterious and convert the mysterious into the credible. By so completely absorbing the real world Uelsmann is able to go beyond it. He is able to annihilate it and to create

in its absence visions and forms that man has hardly ever seen.

The excruciatingly complex techniques of photomontage are superbly suited to his effort. These techniques are Uelsmann's alchemy. His volatile photographic images, in which the dominant character is the dynamism of a psychic order, open to the world of magic. I do not believe he could ever satisfy himself with what is termed straight photography, because for him straight photography is not the resolution of a vision, but the beginning of a process. He takes pictures simply, rapidly, and straightforwardly, responding freely to the inspired revelation and recognition he achieves through the camera. With little or no preconceived notion of a finished photograph, he makes enormous numbers of negatives, stores them carefully, and in this way prepares his visual vocabulary for the next step.

In the darkroom he progressively and additively compiles the visual equivalent of his inner vision. He consciously follows the dictates of his insight in the construction of an image. His work would not be as convincing if it were not totally drawn from himself, and this means working with the negatives of no other photographer. It is the intimacy of the personal, half-forgotten image or event, recorded perhaps years previously, which is drawn from the negative file and brought into the light of a new consciousness. Every discrete step is the commencement of a new moment in his life, a fresh vision of reality, a rape of common sense.

One cannot look at the body of Uelsmann's work without recognizing in it the sustained effort, matched by few photographers of his time, to come to grips with all the problems of photography – to achieve in the end an unmitigated integrity of the whole. Nothing is left out. The failures are important; they matter profoundly. The struggle matters too; and in this age of easy images it probably matters most of all.

The contemporary artist in all other areas is no longer restricted to the traditional use of his materials . . . he is not bound to a fully conceived pre-visioned end. One of the major changes seen in modern art is the transition from what was basically an outer-directed art form in the 19th century to the inner-directed art of today. To date, photography has played a minor role in this liberation.

By post-visualization I refer to the willingness on the part of the photographer to revisualize the final image at any point in the entire photographic process.

The truth is that one is more frequently blessed with ideas while working.

An old Uelsmann negative gathers no moss.

I'm really very concerned with helping to create an attitude of freedom and daring toward the craft of photography.

Jerry is considered something of the *enfant terrible* of contemporary photography. Consciously drawing on the work of Robinson and Rejlander, two of the most misunderstood photographers of the last century, he sees himself as their successor. The aim of these men was to create a picture through the combining of photographic bits and pieces. Uelsmann elaborates the discipline to a more complicated and perfected form. Whereas Robinson and Rejlander used the composite photograph as a technique to fabricate a unified picture of a completed event or idea in conventional linear space and time, Uelsmann presents in his approach to photomontage simultaneously varying systems of idea and event as an analog for the inner and non-linear processes of thinking and feeling.

It is too soon to tell what Uelsmann's place will be in the history of photography. But we know even now that contemporary photography is not the same as it would have been without him. Many of us, perhaps all of us, feel richer in having experienced his work and this is something that happens infrequently in a lifetime. I feel confident that he will continue to provide for us the imaginative leap to a reality greater than anything we may otherwise observe.

JERRY N. UELSMANN /
SILVER MEDITATIONS

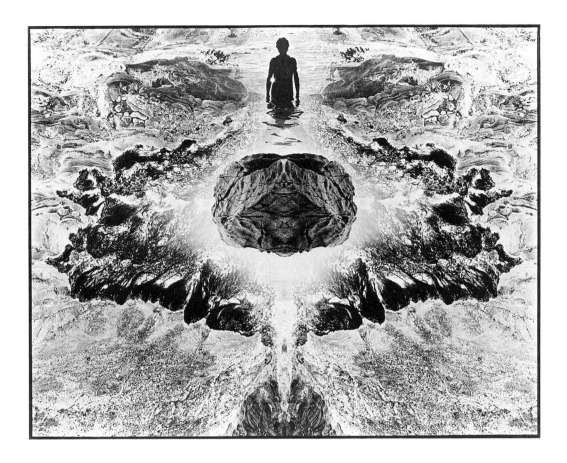

Jerry N. Uelsmann,
Untitled, 1972

CREATORS OF JERRY UELSMANN'S stature may be seen to have altered the language, the substance, and the direction of their art. He personally has been the recipient of considerable critical praise, though the general field of synthetic photography remains only cautiously embraced. Critics have been transfixed by the rational and the realistic in photography while the irrational and the imaginary have remained foreign to most. Present-day thinking about the medium is dominated by a naturalistic aesthetic and only a few individuals have encouraged the possibilities of separating and manipulating the syntactical structure of the *language* of photography. Most people still tend to think that when photographers make pic-

"Introduction," *Jerry N. Uelsmann / Silver Meditations* (Dobbs Ferry: Morgan and Morgan, 1975). © by Peter C. Bunnell.

175

tures they must depict objects and scenes that could, in principle, also be described in words. Photographs which appear to lack the assertive handiwork by which the artist has traditionally pointed to his invention are understood to be truly photographic, while artists in photography who employ varied and fundamental approaches to the synthesis of the medium are shunned. Uelsmann is, of course, of this latter rebellious breed and in his approach he strives for his senses to reveal, for his mind to re-create, a quintessential structure reflective of how he views the photographic process itself. In one sense his art may be considered conceptual; however, this is not wholly accurate for the otherness of the outside world is affirmed, not mitigated, by the intrusion of this artist's mind and hand.

The metamorphosis of ideas in photography is one of the most difficult aspects of the medium to understand. How a photographer such as Uelsmann searches for a significant image, first from the selection of the motif, then to the organization of forms, and finally to the combination of each in a picture in which the content is other than pure data is a kind of process magic-theatrical magic if the essence is the least bit irrational. This is no different from the process of creation in other media but it seems that photography has been dominated, in fact handicapped, by the failure of persons to recognize this conception of expression in the medium. So permeating has been the belief that photographs must be a form of vicarious experience of the subject itself that exceptions to this interpretation are rejected. A picture, properly appreciated, stands away from us as an object on its own – independent and complete. A division of the medium may be seen in which, on the one hand, images provide an imaginative and on the other a rational basis of experience.

Uelsmann's adherence to what he terms in-process discovery places him firmly in support of intuition. He affirms that there is no doubt that an important connection exists between his creative activity and dreaming. As the dream is an involuntary act of poetry, so the fortuitous selection and combination of negatives is the reflection of the imagination's independence of the will. In this sense Uelsmann's photographs, like dreams, have either no meaning or several meanings. Photographs freed from the scientific bias can, and indeed usually do, have double meanings, implied meanings, unintended meanings, can hint and insinuate, and may even mean the opposite of what they apparently mean.

Photographs have tended to be treated scientifically as a

factual statement: "this is a person," "this is a shell," "this is a building." Contemplation in the face of such concrete things demands a great deal of the mind and the senses. Once one has recognized that photographs have meaning, they become open to interpretation and characteristically several not mutually exclusive interpretations can be made of them. One has to add that most photographs are, usually, incomplete acts of visualization. Something still must be added to them before they can be transferred from the private sector of experience to the public, before they can acquire universality. This something-still-to-be-added must, I think, be more than just the translation of visual, nondiscursive imagery into coherent discursive photographic language; in other words, the transformation of a dream or unconscious fantasy into a work of visual imagination cannot be analogous to the process of interpretation as practiced, for instance, by psychoanalysts. It must rather comprise the casting of the central meaning in symbols which are part of the shared iconography of the culture of which the artist is a member, and which, therefore, carry a heavy charge of shared, public associations and resonances. It is not that the artist actively masters the iconography of his times in order to be able to universalize his private emotions, but that one aspect of his capability is an exceptional sensitivity and receptivity to the iconographical network that constitutes the culture of his time that makes it natural for him to express his private emotions in universal terms, or perhaps not to distinguish between the individual and the universal, between the microcosm and the macrocosm at all. In this vein many persons superficially acquainted with Jerry Uelsmann and with his work have difficulty recognizing in him the ability to articulate the complex symbolism, which a number of writers, especially William E. Parker, have identified in his photographs. What I am suggesting is that while Uelsmann does have an inquiring, searching, and aware mind he is moreover exceptionally sensitive to the iconography of public expression. It is a fact that in photography there is a strong anti-literate sentiment which is most generally brought to bear against any photographer who is the least bit learned in his work. Such is clearly the case with Uelsmann and in his public appearances he often does little to challenge this notion. He is one of the few photographers to talk about his work with commitment and to have articulated a stylistic analysis of his own photographs, but I believe he stops short of verbalizing his awareness of iconology because he fears this very sentiment among his

peers. No additional evidence of his ability to use his knowledge need be cited than the considerable body of photographs made over the last fifteen years which are indicative of his overall expressive achievement.

A necessary precondition of all imaginative activity seems to be what Keats called "negative capability," the ability to allow oneself to be "in uncertainties, mysteries, doubts, without any irritable reaching after fact and reason," in other words the ability to abandon the ideal of rational action and stop trying to master reality in favor of letting oneself happen. And, at least for such artists as Uelsmann, the execution as well as the conception of a work of art may also be largely independent of the will. In this it must be seen that all images reveal a psychic state.

In his approach Uelsmann has affinities to several artists in a variety of media. Like Joyce, for example, as he chooses to let his subjects dictate his methods rather than to impose a method upon his subjects. Uelsmann's description of his working procedures is similar to Jackson's Pollack's well known comment, "When I'm in my painting, I'm not aware of what I am doing." Like action painters Uelsmann sees the aim of art to be discovery, not the solving of formal problems. At work he proceeds until intuition informs him that a culmination has been reached which is the way abstract expressionist painters recognize that a painting is finished. One discovers what he has done afterwards. Art has to do with finding out something one did not know. This illustrates the fact that the imagination is autonomous of the will, of the self-conscious ego, and it is presumably the reason why poets and artists before the rise of psychology could believe literally in their inspiring Muse.

Uelsmann's process of self-revealment lies in the imaginative articulation of fragments. These fragments are the components of his existence experienced first, and partially, through the camera but it is as if he has not lived them until he sees them combined in pictorial form. Indeed he may also be seen to have now reached the state in his life where he projects these completed visions back on to reality itself. His self-confidence rests in his ability to synthesize knowledge outside of actual experience and his affirmation of in-process discovery is another way of saying that he values the revealment of autobiography. His pictures reflect a formal order, but their meaning is outside of the logic which confronts the rest of us in our everyday life. He is one of the very few to have depicted the Apocalypse. His work has been deter-

mined, in part, out of painful adolescent experience and tempered by the acceptance of the premise that the practice of art is rooted in life and that the felicity of art lies in its sustaining power. Humor, or perhaps more pointedly a kind of wit, has been one of Uelsmann's most characteristic qualities. On the surface it might be seen that this is reflective of his doing what he likes, but it is also reflective of a lingering suspicion that life is positioned by the potential of tragedy.

Minor White, whose aesthetic derives from Stieglitz's equivalent form, gave Uelsmann the realization of the poetric reality when he was a student at the Rochester Institute of Technology. Significantly, however, White by that time had extended Stieglitz's concept of equivalency through his own development of the corporate sequence of non-similar images. White draws freely from all fragments of his personal experience and recombines them into controlled autobiographical statements. This sense of control, through the combining of single photographs, and the interest in autobiographical expression, are key elements in White's contribution to the medium and in Uelsmann's subsequent extension of it through his own work. Autobiography is not necessarily in accord with fact and it may be seen to possess an immense potential for fiction and passion.

While Stieglitz organized his cloud photographs – images so photographic that they were true pictorial abstractions – into sequences or groups, the effect he sought was not so much to recreate experience as it was to allegorize his emotions. White, on the other hand, takes images which are more obvious or rational than abstract, and combines them into a kind of cinematic presentation heavily reliant on a varied repertoire of symbols which he believes can be "read" in photographs. The goal as White sees it is one of freeing the photographic experience from chronological time and making it into the totality of a life experience which has a cumulative meaning and identification greater than any individual picture. Because of this method his pictures are frequently fragmentary in themselves and incomplete as allegory.

Uelsmann grasped this concept and has significantly modified it by adopting manipulative techniques which allow him to construct a non-linear sequence of images within a single picture. White, it must be pointed out, has always adhered to the stylistic purity of the straight photograph and his images reflect his strong and continuing solidarity with the group of Stieglitz, Weston, and Adams. Uelsmann, who by

1959 was now building on the encouragement of Henry Holmes Smith who placed a liberal emphasis on subjective creativity within the photographic process itself, sought to re-invent the process of picture making in photography by considering each camera negative as only *part of* a single photograph. I use the word re-invent very particularly, because this is precisely the contribution made by Rejlander a hundred years before but which unfortunately has been lost today because of our inability to see his extraordinary invention beneath the sentiment or subject for which it was placed in service. Photographers like Uelsmann, Rejlander, White, and Stieglitz extended the concept of photographic time by replacing the finality of exposure time with a construct of conceptualized time as the basis for the experience of photographic reality.

The thought of incongruous juxtaposition was not, at first, an issue with Uelsmann and his early images are as pictorial in motif and motivation as are the photographs by the other three photographers mentioned above. Interestingly, Uelsmann's observation on Rejlander's "Two Ways of Life" is that it is "an amazing image in that it is so intricately complex yet so infinitely resolved." Only gradually has he developed the ambiguous and more psychologically related experience where the expression of the irrationality of thinking and feeling is seen in both content and form. In recent years Uelsmann has admitted to not knowing what some of his pictures are about. I believe this is due to the fact that he has used single images within these photographs that came about through unrealized experience as early as the time of photographing when the continuum of recognition and reaction was incomplete and when his subconscious did not absorb and categorize even the observable sensation. It is very much to the point in analyzing Uelsmann's working method that he does not consider using other person's negatives. He will not borrow from the consciousness of others their visual fragments which are vividly different from what I have described as his life fragments in visual form. This methodology also relates to, and I believe clarifies, the issue of the symbolic construct of his pictures as discussed earlier. His sensitivity to the iconography of culture is manifested in the gesture of identifying his fragments in the field when photographing, and not only in the selecting of parts for a picture once in the darkroom. It is in this respect that he, like Manet, a counterpart in painting, may be seen to create after nature and it is why, after all the arguments about synthetic pho-

tography are said and done, Uelsmann is a photographer dependent upon the real world of primary observation.

Nevertheless Uelsmann also loves fantasy, and he uses it to carry a distinct moral. Literary art for him does not mean the mere teaching of moral truths, because whatever is honestly worth seeing seems to him also capable of moral implication. His repetitions of various images and themes is an emotional rhythm of testing propositions by refutations, as with bringing witnesses forward and cross-examining them. Like artists everywhere it is his aim not to find wisdom but to put it to work. He believes that reality has room for such models.

In contrast to his earlier pictures, Uelsmann's work in recent years has become less graphically dominating in terms of what may be seen as the relatively simple and harmonious counterpoint of objects and forms. Since about 1972 the picture space in his images has been filled in a more total and stressing fashion reflecting his own more complex psychic nature. He has reached the point where the work has turned in upon itself, where the mastery of craft has moved outside of illusion and conscious showmanship to a more introspective state of affairs where one can no longer tell so easily what is going on. I do not believe this is a matter of his technique becoming simply virtuosic, but rather that a fundamental change has occurred in the work where the desire to exert any control over the artistic invention has been relinquished for the sake of creating images which exert control over his own life process in the hope of realizing something he feels is confused or incomprehensible. It is as if he is allowing the dream/image process to stabilize his own existence. Even today I do not believe we are at a point where this change has been concluded, though I sense a returning to his accustomed security which in the past has made his pictures more pictorial.

The dominating character and participant in Uelsmann's visual world is man. He is a humanist concerned with man's achievements and interests, with his actions and, as I have stated, with the moral implication of these actions. In many cases his pictures are singularly expressive of the sexuality of human interaction and he has mastered the presentation of erotic tension without yielding to pornography or resorting to non-objective symbolism. He uses the clothed or nude figure almost interchangeably. This is true not only with the female but we see it even more with his depiction of the male figure which does not appear naked but is almost always used

as an expression of the anxiety and the primitive power of male sexuality. His rendering of the human figure is analogous to how one contrasts masks with illusion in the theater and it is clear that Uelsmann prefers the mask because it is frank; the figure in the mask is clearly an actor, not someone who is half-persuading you with grease paint and a wig that he is Othello.

Many persons, including myself, have been photographed by him and it is difficult to characterize these pictures. Portraiture is an easy label to assign to a large number of them, but it is not wholly satisfactory because Uelsmann's own dominating presence is never far below the surface of our own projection. When viewing our likenesses our composure is shaken by the realization that he has exempted us from the crowd and that we now must contemplate ourselves in a landscape which was not of our own choosing. The interpretation of these pictures will be largely individual when it is most clear that the emotive image is very particular, and when it is not the tendency is to take comfort and reach out for more universal interpretations.

Uelsmann is one of the few photographers who is not afraid to place himself before the camera. I believe that this is to intervene in his fantasy life, thus to assure his physical presence there, as well as a gesture to record for posterity the life process of aging-cum-maturing. Technically, Uelsmann's self-portraits are no different from his other compositions, but in conception they are significantly different. His identification with his own being causes him to counter the independence of his will and to more fully conceptualize and control the image. In this way his self-portraits are extraordinarily reminiscent of the self-portraits of the pioneer Frenchman, Bayard, or not unlike Stieglitz's shadow images of 1916, or Friedlander's recent photographs. These images are all compelling and rich because they are so dominated by a controlled psychological intensity. In portraiture we are always concerned with revealment, a quality which is frequently associated with perceptual truth. Uelsmann has admonished photographers to get out in front of the camera. Under his terms yes, but when he is photographed by others he is noticeably reticent and inevitably a comic pose is assumed in gesture and expression. He is aware of what the camera can do. Not that any of us are not, but in his self-portraits, and likewise in his pictures of others, Uelsmann disarms us with the dark ambiguity between model and persona.

Uelsmann's photographs from the late sixties and early

seventies reinforce his position in the field, and as I said at the beginning of this essay, he clearly prefigured the contemporary direction of his medium. In so doing he has restored a tradition and acquired a position which relatively few of his generation can match. He has done this through a sustained endeavor and in measuring his work his failures must be seen to matter as much as the successes. It has only been in recent years that the public dedicated to photography has been able to map the continuous growth of its artists. Through many exhibitions and publications we have been in a position to follow this artist's work in depth as it has been created through incessant and thoughtful effort. In some respects this public awareness of him, which began at a very early point in his career, has had a profound effect on Uelsmann's own consciousness. There have been many public events, as his chronology shows, but the slow evolution and tempering of a maturing personality occurs more through private agonies and obsessions. All of these pictures do not have the instant appeal of certain of his earlier images which, both by quality and familiarity, are considered masterworks. These more recent images are less simple, more substantive, and in some cases dangerously close to contrivance or *voulu*. Certainly they are much less apt to amuse the viewer, but to be a master is to be a master. Uelsmann's innovation as an artist is in keeping with the multiplicity of his vision. There are pictures of his as perfect as anything in photography and emotions as clearly expressed as any in any medium. It is precisely in making the accommodation between self-confidence and humanity that makes his pictorial life so pleasurable for him and, ultimately, so challenging for us.

JOHN PFAHL /
ALTERED LANDSCAPES

John Pfahl, *Blue Right-
Angle, Buffalo, New York,*
1975 (Original in color)

A keystone in the arch of human understanding is the
recognition that man at certain critical points synthesizes
experience. Another way of stating this is that man learns
while he sees and what he learns influences what he sees.

Edward T. Hall, *The Hidden Dimension*

ONE of the concepts regarding photography and the making
of photographs that has taken the longest to be realized and
appreciated is that of intentional creation. Early in this century
the pictorialists began to articulate the inherent linkage be-
tween the act of photographing, the sense of responsibility

"Introduction," *Altered Landscapes / The Photographs of John Pfahl* (Carmel: The
Friends of Photography, 1981).

184

that falls on photographers because of their pictures and the sensuality of the pictures themselves. These are the principles that have become the fundamental bases of modern photography. Further, photographs that were once derided as illustrative are today not so disrespected because this term is no longer reserved to describe work reinforcing traditional regimes. It now refers to that providing an illustration or a kind of mechanical for the activity Edward Hall identifies above. The art of successful photography has once again come to be concerned with artifice and, like the best writers of literature, the goal of a contemporary photographer like John Pfahl is not to turn viewers into rereaders but into readers.

John Pfahl was born in New York in 1939 and grew up in rural New Jersey. He began his interest in photography at Syracuse University, where he was a student enrolled in a program of advertising and graphic design. Significantly, his earliest work was in color. Following two years in the Army he worked for commercial photographers in New York City and in California. In 1966 he returned to Syracuse and studied color photography, graduating two years later with a Master's Degree. He has been on the faculty of the Rochester Institute of Technology since 1968. From 1969 through 1974 he made three-dimensional screen-printed photographs on formed plastic. From 1974 through 1978 he worked on an extensive series of related unmanipulated color photographs on the theme of *The Altered Landscape*.

While working with the musician and composer David Gibson, Pfahl became interested in photographing elements placed in the actual landscape. Deciding to make collaborative photographic music scores, they went out into the forest south of Buffalo, New York, where Pfahl resides, applied tape to trees and executed two compositions together. The intention, though never realized, was that the visual configuration was to be recorded in notation form and played. The photographic image would serve as a visual backdrop to the musicians. While Pfahl now considers these two pieces to be largely unresolved, they mark the starting point for his later conceptions. *Music I* is one of these two initial efforts.

Pfahl rapidly became interested in the pictorial potential of these alterable acts and has now formed a body of some one hundred and fifty images in this series. The idea was not acted upon immediately, however. It was not until the summer of 1975, at the Penland School in North Carolina, that he executed ten works, including *Shed with Blue Dotted Lines*.

The photographer describes the notions of the pictures in

his series as follows: "The added elements suggest numerous mark-making devices associated with photographs, maps, plans and diagrams. On different occasions, they may point-edly repeat a strong formal element in the landscape (i.e. the outline of large rocks echoed in rope in *Outlined Boulders*); they may fill in information suggested by the scene (the red line in *Coconut Palm* or the yellow ropes in the meadow in *Haystack Cone*); they may depend upon information external to the photograph itself (the location of Bermuda in *Triangle*); or, finally, they may be only arbitrarily related to the scene (as in *Pink Rock Rectangle,* where the granite boulders simply form the substrate for an imposed figure)."[1]

In these pictures Pfahl creates, usually within twenty or thirty feet of his camera, a construction that is given order and perfection through the manipulation of the optics of the camera. These fabrications may be made with tape, string, rope or foil positioned on or amongst the objects in the picture or through the placement of objects, such as balls, in the foreground plane. Pfahl manipulates these illusions carefully and tediously, often making preparatory drawings on a black-and-white Polaroid of the scene or using clear plastic overlays on the ground glass itself. In all of this there is the critical notion that the arrangements are not done to mathematical perfection but are purely visual. He has pointed out that his working method demonstrates the fact that since we cannot see the flat picture plane through the ground glass of a view camera we must work with pictures, in this case the Polaroid, to adjust both the mind and the construction to the picture making problem. Utmost care is taken not to alter the actual subject in a way Pfahl would consider harmful to his positivist respect for nature. He has described his process as the "pos-session of the space and then its return to a pure state fol-lowing my own personal ritual"; he approaches the entire endeavor with a "strategy of affection."[2]

Much has been written about the *Altered Landscape* series. Pfahl himself has commented most informatively in a number of interviews on his background, techniques and intentions.[3]

1 John Pfahl, "Introduction," Focal Point Productions Slide Set, Rochester, New York, 1977.
2 Interview with the author, Princeton, New Jersey, November 24, 1980.
3 Anthony Bannon, "John Pfahl's Picturesque Paradoxes," *Afterimage,* February, 1979, pp. 10–13 (including transcript of interview); Van Deren Coke, *Fabricated to be Photographed* (San Francisco: San Francisco Museum of Modern Art, 1979), pp. 9–10; Ben Lifson, "You Can Fool Some of the Eyes Some of the Time," *The Village Voice,* March 6, 1978, p. 68; Stuart Rome, "Interview with John Pfahl, Sun Valley, Idaho, June, 1980," *Northlight,* Number 14, 1981.

The term *picturesque* frequently appears in these interviews. As a concept the picturesque is very much aligned to the illustrative. Were it not for the unfortunately bad name given to it during the late nineteenth century, we would realize that the picturesque was originally understood in the context of the striking picture. This interpretation has been overlooked and therefore much of the reason why John Pfahl's photographs are important has been missed. I believe Pfahl's photographs are important; they are very picturesque because they suggest to me his immense pleasure in making them and his ready, indeed, his eager acceptance of responsibility for them.

These pictures are a celebration of both the photographer's art and his deliberateness. Their quality lies in the demonstration of forcing nature to rival art. By addressing his camera to scenes that he feels, as some others do, are on the edge of cliché or novelty, he actually imposes more of himself than might otherwise be the case. Now Pfahl is not a passing entertainer, but a fervent artist who has worked hard at the detail and the mastery of his craft. He has lifted it from the drudgery that characterizes so much of what is termed concept art. In a recent lecture Isaac Bashevis Singer remarked, "In art, like in love, the act and the enjoyment must go together. If there is a redemption in literature, it must be imminent. In contrast to politics, art does not thrive on promises. If it does not impress you now, it never will."[4] Such is the case with the art of John Pfahl.

To be put off by these pictures is somewhat akin to rejecting the idea that we can never subtract from knowledge but only add to it. Pfahl's contribution comes to us through the true pleasure of his wit and his doctrine of spotless technique. In the sense that these pictures reflect the individual ego of their creator they are expressionistic. While the obviousness of the demonstrated acts – stringing rope, laying tape, wrapping foil – might be seen as only superficial, these gestures, like the gestures of contrivance in any medium, reveal the inner artist. As was suggested earlier, this revelation is particularly difficult for a photographer, considering the traditional inhibitions against methods which have, for too long, only served the basic banality of photographic representation.

Pfahl's imagery is a sure manifestation of the belief that

4 "I. B. Singer, at West Point, Meets Cadets of Another World," *New York Times,* September 25, 1980, p. B12.

society can produce an art suitable to its nature and, in this case, a specific kind of photographic presence that expresses current societal values. What can be seen in Pfahl's work is a certain and not so subtle anti-popularization that seeks to subdue the rude realities of the 1960s with a beauty more ideal and a morality rather more precious than what was then current. It is removed from contemporaneity and, by reinstituting values and conventions of the past within a mode of thinking about the present, Pfahl creates a revivalist photography. The photographs are scientific in nature in that they build their esteem on a mathematical system of perspective and illusion through a precise and unmoving point of view. This anti-emotionalism seeks to re-establish a more rigid self consciousness of photographic perspective than has been the case with the rash of modernist distortions found, for instance, in aerial photographs, street photographs and decontextualized details in the 1950s.

Pfahl's reasoning is rooted in an interest in the problems of spatial positioning current among contemporary anthropologists. Instead of finding fault with distortions, orthogonals that converge too quickly or grossly enlarged objects in the picture plane, these optical characteristics have become the topography of Pfahl's argument. What is new is the immensely sharp awareness of the effects the positioning of the camera might produce in nonpictorial terms, that is, for concerns outside the substrata of interest in the scene itself. This is why his photographs are so very different from the modernist notions revealed, for instance, by Alvin Langdon Coburn in his well-known photograph *Octopus* (1912) or in his writing:

why should not the camera also throw off the shackles of conventional representation? . . . Why not repeated successive exposures of an object in motion on the same plate? Why should not perspective be studied from angles hitherto neglected or unobserved? . . . Think of the joy of doing something which it would be impossible to classify, or to tell which was the top and which was the bottom![5]

It would seem that in Pfahl's photographs the entire question of the construction of pictorial space has been replaced, as if to prepare us for the last quarter of our century during which we must, as perhaps at no time in years, consider what is retinal and what is perceived. Our momentary, fragmented and captured vision of disorder and emotion has been replaced

5 Alvin Langdon Coburn, "The Future of Pictorial Photography" (1916), *A Photographic Vision* (Salt Lake City: Peregrine Smith, 1980), pp. 194–195.

by a cool rendering of purposefulness as if to accord another
dimension of positivism to the moving force of contemporary
human awareness. Pfahl's work is an attack on the problems
of space and, ultimately, existence from a rational point of
view. Whether Pfahl has read Leonardo's *Trattato* I do not
know, but it would not surprise me if he has. Pfahl's work
is hidden from us only in the sense that what he does before
the exposure is never revealed. We do not go through his
work step by step, incident by incident, to discern the way
it was constructed as if one were taking a timepiece apart,
because what Pfahl is doing is putting the watch together. If
we need to investigate these pictures it is only to address the
issue of three-dimensional realities subjected to two-
dimensional photographic surfaces.

Pfahl's work rests at a point in the latter part of the con-
tinuum of art's development in which has been reflected
man's growing awareness first of himself, second of his en-
vironment, then of himself scaled to his environment and,
finally, of the transaction between himself and his environ-
ment. Pfahl's photographs are but one more demonstration
of man's inhabitation of many different perceptual worlds;
they tell more about man than they provide simple data on
human perception. They are not shocking in the sense that
some photographs, and most modern paintings have been
shocking, because they do not conform to the popular notion
of perception in art. Rather, they ply the delicate balance
between understanding and expectation. This point of tra-
verse is the most contemporary aspect about Pfahl's work,
which I hesitate to describe with the now fashionable term
post-modern; it symbolizes the vastly changed world of today
where ridding the viewer of radical expectation has allowed
the artist to reveal himself through intellectual process.

His photographs are static in that they do not reflect the
traditional view of looking out of a large plate-glass window
because of the simple fact that the images allow no move-
ment. Not only is it improper to move one's body or head
to see more, there is simply no more to see. It is just the
reverse demand which Pfahl places upon us: to remain still,
focused and unmoving. The glorious color, sometimes
pushed to the extreme of decorativeness and verisimilitude,
only enhances the tension created by this forced inhibition of
movement, a restraint that fully recognizes our need to see
a picture and not recreate an experience. The picture is the
experience.

Will we ever reach the point where we might believe that

we dissect nature along lines laid down by our photographers? Although few accept this proposition, and Susan Sontag cautions us when she writes, "photography implies that we know about the world if we accept it as the camera records it,"[6] I do not find it a poor proposition at all. Much as we have come to understand nature through our native languages – a fact long held – I do not believe that photographs, let alone paintings, are unacceptable forms of instruction that might serve this understanding. In such a context one could move meaningfully to the apprehension not only of nature, but of subtle differences in cultural view by studying the photographs of Emerson, Atget, Moholy, Stieglitz, Adams and Pfahl, to suggest a list pertinent to this thought. Photographs such as these reflect a patience and a chore in teaching such that they are demanding, and give back to Pfahl the role of one who elucidates discovery through creativity.

John Pfahl has become an influential photographer. In a most straightforward way the fastidiousness of his color imagery together with its lush descriptiveness has fostered the development of the genre. Quite apart from this obvious impact, however, has been his influence as an educated and articulate artist. He has rejected the cult of naiveté, of working without preconceptions. His own purposefulness has given us a break in the rigidity of convention; his sense of history and his sense of learning have put photography back on track. He is a stylist. He has not been afraid to reveal what he knows, or to reveal his learning states; for him each picture had to have its own reason. "It had to be more than simply a new illusion – the illusion has never been the main point."[7] In this way John Pfahl is not a magician or an illusionist. He is an artist who favors the elegance of the mind that appreciates reality.

6 Susan Sontag, *On Photography* (New York: Farrar, Straus and Giroux, 1977), p. 23.
7 Op.cit., Interview.

LYNTON WELLS / PAINTINGS, 1971–1978

Lynton Wells, *AYYYY, 74*, 1974

A FAR-REACHING ACHIEVEMENT in the visual arts of the modern era has been the firm recognition of the object presence of the picture. This concept provides a beneficial way of looking at advances not only in painting but also in its counterpart, photography. In this context, the understanding of how we engage a picture, how we perceive its presence and interpret its construct is of fundamental importance. There is a good deal of contemporary painting specifically about these problems, but few artists have sought to explore those particular aspects of spatial structure that have interested Lynton Wells over the last decade.

"Introduction," *Lynton Wells: Paintings, 1971–1978* (Princeton: The Art Museum, Princeton University, 1979).

Lynton Wells, who was born in Baltimore in 1940, studied at the Rhode Island School of Design and the Cranbrook Academy of Art. He has worked in New York since the mid-sixties. His first interest was sculpture, but since 1971 he has devoted himself to making large-format works which are produced by drawing and painting over a photograph of his own making that has been printed on a sensitized linen material. This exhibition is a selection from his production since 1971, and the paintings in it may be seen to derive rather exactly from the analysis of the artist's problem as set down by Frank Stella in 1959 when he said: "There are two problems in painting. One is to find out what painting is and the other is to find out how to make a painting. The first is learning something and the second is making something."[1]

Wells has sought to determine for himself what it is about painting that is important to him. He has searched far and risked experimentation and invention in order to approach a greater notion of the possibilities of contemporary image-making than he believes is encouraged or even given cursory recognition by today's critics. In a letter written to a magazine editor in 1979, he reflected on his aims:

I am not asking for chaos or for a spatial depiction that substitutes description for aesthetic values, rather a freedom to redefine the correlatives of painting, to be able to ask what is possible, instead of a continued working in a circumscribed area where ideas and attitudes have been learned, digested and finally played out.[2]

Wells's unique contribution to contemporary painting has been to present the photographic image in a context which is rather more complex than an artist's use of the photograph for the statement of visual fact. Indebted to the earlier work of Robert Rauschenberg, who used photographs for their representational symbolic contribution to his more important painterly concerns, Wells adopts the elemental symbolism of the photographic medium itself. As opposed to other painters, and apart from artists in the photographic field, he has a specific interest in the medium that focuses on the concept of conjunctive illusion rather than on content. That this illusionism is surreal has been recognized by many, including Susan Sontag:

Surrealism lies at the heart of the photographic enterprise; in the very creation of a duplicate world, of a reality in the second degree,

1 Robert Rosenblum, *Frank Stella* (Baltimore: Penguin Books, 1971), p. 57.
2 Unpublished letter to Roberta Smith, January 3, 1979, in response to her article "The New Gustons," *Art in America,* 66 (January–February 1978), 100–105.

narrower but more dramatic than the one perceived by natural vision.[3]

No other art has this capacity to be entirely there, totally existent like a phenomenon of nature.

In sensing this property in photographs, Wells recognizes that the photographic image does not lie outside the current painterly concerns for objecthood and that, indeed, it may serve as the starting point for a painting which does not have nature as its first allegiance and one which reflects the artist's concern with issues of pictorial flatness. In this usage, the photograph takes on a quality of sophisticated fiction, where the viewer finds himself placed in the tension-filled area between image and experience and sees himself mirrored in the play between physical reality and the creative artifice of man, a position that Wells finds meaningful. Talking about his use of photographs, Wells has said:

It's really a kind of philosophical reason for doing it. It is based on the consideration of the nature of what is real, and what is not and if there is a dilemma in that, if one can't define what is real, how can one illustrate that particular dilemma?[4]

By 1973, two years after undertaking this body of work, Wells was recognized for the contribution his pictures were making. Paul Stitelman, writing in *Arts Magazine* about the painters involved in the use of photographic imagery, commented on the uniqueness of Wells's approach and at the same time his affinity with that good Duchampian trust in the mind of the artist:

Wells seems the most daring and the most inclined to experiment. Using technology to actually enlarge and transfer a photograph onto canvas is a most interesting inversion of the super realist technique of rendering a technological phenomenon, namely a photograph, in traditional media. Furthermore, making this image into a painting by the gratuitous act of applying paint to it (paint which, incidentally, is not at variance with the black to white tonalities of the works) implies elements of Dadaistic and Duchampian anti-aesthetics.[5]

Wells has had no career in photography per se, although his work has been especially appreciated by the photographic

3 Susan Sontag, *On Photography* (New York: Farrar, Straus and Giroux, 1977), p. 52.
4 Unpublished taped interview with Rosanne Livingston, January 1976, in conjunction with the exhibition "Photographic Process as Medium," Rutgers University Art Gallery, January 25–March 7, 1976.
5 Paul Stitelman, "Notes on the Absorption of the Avant-Garde into the Culture," *Arts Magazine,* 47 (May 1973), 54–59.

community and he has had a considerable influence on it. Being a sculptor by education, he first made life-size portrait figures out of painted photosensitized linen which, in at least one exhibition, formed a fruitful counterpoint to the work of George Segal.[6] In his sculptures, Wells was already exploring the precepts of illusionistic fiction through his use of photographic material as well as by his treatment of the edges of the pieces which were purposefully left unfinished and untrimmed. In 1970, I included Wells's sculpture in the exhibition "Photography into Sculpture" at the Museum of Modern Art. The exhibition sought to explore the increasingly persistent presence of works utilizing the photographic medium for its properties of spatiality, which could be enhanced or extended in the actuality of a three-dimensional work, rather than relying on the intellectual basis of customary two-dimensional perception. However, at this same time Wells was gradually modifying his aesthetic concerns to deal with images in ways that were akin more to the latter characterization than the former, which had been the basis of my exhibition. What came to concern Wells was the alteration of the conventional perspectival interpretation of the photograph in its pure state on a flat surface and the possibilities of what could be done to that surface to further mark this configuration. Nevertheless, all of his work from 1971 to 1978 reveals to a certain extent his beginnings in sculpture. First is the importance of the created object itself. Echoing his approach to the edges of his earlier sculpture, he has consistently taken to wrapping the pictorial surface around the stretcher and leaving it visible. Second is the manipulation of his subjects, which began first as events or a sort of mime play in front of the camera conducted in a space reminiscent of the environments in which he placed his sculpted figures, and until his most recent works, he has consistently photographed the arranged subject.

It was in the early 1970s that Wells undertook to more seriously learn about the photographic process, a technique that in itself fails to inspire him. He takes little delight in the subtle manipulations of the process, though his handling of the material is exemplary and his works display a lively inventiveness based on the properties of the material. He accepts surface abnormalities caused, in part, through handling the wet emulsified material, and he unites these felicitous effects with his erasing, smearing, and other hand operations.

6 Martin Friedman, *Figures/Environments,* exh. cat., Walker Art Center, Minneapolis, 1970.

That Wells would work in large format is understandable because of his background in sculpture and because of his intent to use the photograph as part of the construct of contemporary scaled paintings. He knows, of course, that only the environmentally scaled photograph fully extends the spatial potentiality of the optical image. That the architectural photomural is really the only photographic tradition or model for such work, and that this form has never really been explored beyond decoration, do not concern him. Wells has the perspective of an artist working in relation to the wall so that the photograph seems to be reality itself, only abstracted in the tones of black, white, and gray. At this scale the viewer is first made to feel he is in the space, a setting Wells seeks to make convenient. But the viewer recognizes quickly that something is wrong in this interpretation, and one literally loses one's balance before the best of these works and wants to reach out and touch the architectural elements to steady oneself. Describing how this sensation is achieved, Jeanne Siegel has written:

He dissolves the structured space so that it becomes difficult to tell what is real and what is illusory. To start with, a photograph is itself an illusion. But the introduction of a photograph of an environmental situation affords Wells the opportunity to manipulate the photographic space itself. For example, he dissolves space where the wall meets the floor through lighting. He stretches space by including a shadow of an object that makes one unable to determine whether an object is in real space or is just a reflection.[7]

It is not simply illusion, however, that interests Wells in these pictures, nor is it the provocation only of physical instability or anxiety. He is concerned with creating an imaginative manner of depicting visual space which, as a device, will have meaning in a contemporary context as the viewer seeks to cope with expectation and actuality. What Leo Steinberg has called "the flatbed picture plane" is another spatial device that has been used by contemporary artists for similar purposes.[8]

Wells's pictorial artistry comes into play in the arrangement of the material for photographing and in the act itself. It is of the utmost importance to recognize that the photograph serves as the ground for the entire work and that he has utilized the photograph in place of the collage technique, which, by 1971, had become the more customary method of

7 Jeanne Siegel, "Abstraction and Representation Made Visible," *Arts Magazine*, 51 (November 1976), 70–73.
8 Leo Steinberg, *Other Criteria* (New York: Oxford University Press, 1972), pp. 82–91.

establishing the tension field between the painted plane and the spatial referent. He views the finished, stretched photograph as a "setting for some kind of activity," a "setting for [his] response to that particular space," but what might be called his course of action begins with the making of the site photograph.[9] It is to the point to emphasize that Wells works only with his own photographs, a significant signal as to the nature of his art, which derives fully from concerns within the artist himself. Sometimes in the making of photographs in the field and more often in the appropriated use of them, this construct is not upheld. Sally Yard, who included Wells's work in an exhibition early in 1977, has described the integral relationship between the dynamics of the finished picture and the process of camerawork used in making his images:

In the work of Lynton Wells, the photographic image, which one expects to be the most "accurate" of illusions, is confounded not only by the manner in which he paints and draws over the photographic images, but by the very photographic means which have created them. Multiple exposures give Wells's images a dreamed, unclear presence. The pictures . . . are in a sense studio still lives set in motion. The elements have been carefully arranged and lit, and then rearranged before each of four or five subsequent slow exposures, creating an appearance of movement. . . . They are photographs of nothing in particular except the photographer's tools and the ambiance created in each arrangement of the setting. . . . Ordinary plants, lights and empty stretchers are arrayed with nondescript floors before hazy walls. But these neutral elements are used to create an illusion of place – and the moods and places evoked are quite varied. The rich textures, colors and materials which for centuries have filled studio images here defer to the studio apparatus transformed to function evocatively.[10]

Over the last decade, Wells has progressively enlarged his compositions in complexity and authority, particularly in the multiplicity of the description of space and objects within a single work. His pictures are thus related, in a very real way, to certain works by Matisse, an artist whose elegant paintings Wells has admired for many years. Another artist Wells frequently mentions in the context of planal and compositional sophistication is Velázquez, whose work he first encountered in his student days, when he spent part of 1961 in Rome.

Wells's use of color is very deliberate and it follows the evolutionary aspect of all his work. Color begins to appear first as subtle and discrete passages, almost as highlights re-

9 Unpublished taped interview with Rosanne Livingston.
10 From *Women's Eyes,* exh. cat., Rose Art Museum, Brandeis University, Waltham, 1977, pp. 21–25.

appears more richly across the whole surface as an integral
part of the drawing, and finally, by 1976 or 1977, it takes on
the character of a veil of colorist description. Once Wells
leaves the studio altogether and enters the outdoors, color
comes to dominate the photograph totally and manifest a
hermetic expressiveness.

Wells's work over the last decade fits within the devel-
opment of painting since the late 1950s, which may be char-
acterized as an attempt to return to some form of
representationalism after the dominance of abstraction. To
most, this return was achieved in two different ways: from
within the abstract painterly process itself, via Johns; and
from what was assumed to be the least respectable area of
image-making, photographs, in this case via Rauschenberg.
What Wells has attempted to do, however, is different from
either of these two artists although certainly related to the
guidelines set forth by each. In the photographic aspect, he
has removed the contemporaneity of those subjects and issues
of daily media experience to which Rauschenberg was at-
tracted and replaced it with a more neutral ground on which
to conduct his investigations. In his early choice of subjects,
there was something of the European attitude of a spare and
pure materialistic iconography, especially reminiscent of the
twenties, which suggested a professionalism of ideas and a
definite attitude toward the so-called art-life equilibrium.
Thus Wells's pictures are dissimilar in both the implication
and appearance of Rauschenberg's combine-works such as
Photograph of 1959, which is perhaps the artist's most self-
conscious statement on the photograph and its present-day
cultural context.

Marking an interest in the esoteric subject of the painter
himself, Wells first selected as his primary subject the artist's
studio, the scene of his own activity which, I believe, serves
as a metaphor for that painterly sensibility he is exploring in
his pictures and to which Johns addressed himself in his work:
why make paintings, where are they made, how is one to
position oneself between tradition and novelty? Being some-
thing of an explorer and historian, Wells has pondered the
question of how an artist could move if one traversed an
alternative course from the numerous directions already tried
in painting. Knowing, of course, the outcome of those routes
which, in particular, had been followed in the past twenty-
five years, there was a sense about his work of being anti-
vanguard. But more recently he seems to wish to be a part

of what today might be characterized as a romantic revolt similar to the Romanticists' assault on Neoclassicism years ago. Wells rejects a passive affirmation of the pure painterly operation and he gives to the politics of experimentalism a new vigor.

By 1978, in such a work as *Untitled (Oma Oma)*, he begins to reduce drastically the amount of photographic information presented and instead paints whole branches, flowers, and leaves directly on the linen surface in heavy impasto. This picture, which is more reticent than many of the same date, some of which are truly vulgar, leads directly into the most recent large-scale works in which the artist, for the first time, abandons the studio motif, with all its implications, in favor of landscape. This change, which had been developing for about two years, coincides with Wells's acquisition of a country pond in Connecticut and his new-found desire to modify his witty calligraphic painting to that of pictorial drawing. Like all changes in his work, it can be observed progressively. In *Six Wizards (Italian Bellflowers)* of 1976, the painting becomes much more expansive and it forms an organic shape in itself, which may be read as a field of grass covering the entire foreground as a second pictorial field in conflict with and well in front of the photographic field. The "horizon" has now moved up in the picture and the vantage point is higher; thus the stage is set for the later landscapes. The floral and plant motif varies in treatment in several more paintings, until 1977, in *Six Wizards (Oma Oma)*, where the first depiction of trunk, limb, and brush forms can be seen, signaling a new phase in Wells's work. At first these sketchy scenes will be placed in front of the interiors and be related to them, until the time Wells finally chooses to abandon the concept he has always held about his work, that they are landscapes of the mind, and to affiliate himself with the long tradition of representational landscape.

Through what is now a brutal confrontation between painting and photography, the pictures become more difficult and more contrived. The large imposing tree forms draw one's attention to an emphatic frontal plane, which suggests looking through a window at a distant landscape from some elevated position. The pictorial device is curiously similar to that used in cartoon overlays, and indeed one observer has suggested a feeling reminiscent of viewing Disney's *Fantasia*. Color is used no longer simply to create a mood or dictate a subtle adjustment of the plane or space but for its expressionistic dominance. A new plane appears, which results from

the raw color pigment that is rubbed into the surface, and as a presence it lies behind the tree but before the very simple, unaffected landscape photograph or ground. The optical precision of the photograph is reduced by this tinting and it now becomes a pentimento, truly an underimage, something it has not been in the past.

The radical breaking of the frame by the tree is reminiscent of the photographic properties of camera seeing that had such an effect on the avant-garde artists of the twenties, an influence that can be seen, for instance, in Georgia O'Keeffe's *The Chestnut Tree – Grey* of 1924. Certain screens by Japanese artists also come to mind. Indeed, the latter source of inspiration has become more and more a part of Wells's thinking, such that his most recent work takes from the example of the *Cherry and Maple Trees* screens by Sakai Hōitsu in the C. D. Carter Collection, which were shown at the Brooklyn Museum in 1975.

By 1976, Wells's titles or identifications of the pictures also begin to reflect further allusions to the Far East in such manifestations as wizards and dragons, plant and tree associations, and Japanese place names. At times in the midseventies, the draftsmanship had become less a kind of abstract drawing and more a calligraphy. It is the linear stylization of Oriental art that appeals to Wells, and he has sought to invest his works with this quality. An affinity with Oriental art has often been suggested in the criticism of his work because of his use of the paneled format that is determined by the widths in which his sensitized material is commercially available. The authority with which he has articulated the places where these panels are joined is one of his most original devices. Existing by necessity, the articulation of these panel divisions marks one of the key places where he seeks to show the photograph as both the space and the surface where the rival claims of illusion and truth are resolved. And in the most recent pictures it is where, through the drawing of the limbs at these points, the unsettling claims of abstract and pictorial representation are encountered.

These latest pictures are the furthest Wells has gone with his strategy to express the unlimited arena within which his thesis can function. These are consciously decorative pictures, and in them he tries to blend all the influences that have acted on him. He has become progressively more concerned with artifice, and the hierarchy of his interest has shifted from the simple, logical tension between spaces or planes to the expressive coloration of line and surface. Alfred Frankenstein,

in a review in 1977, understood this direction when he commented, "It is as though the shapes of ordinary things were lifted into a new sphere of value and meaning, dissolved into the dynamics of line."[11]

The move from the contrived world of the studio, which had been the locale for the exercise of his thinking imagination, to the natural world places Wells in a milieu where he must determine the apogee of his control anew. The critical response to these pictures has been less positive; sensing that he is perhaps drawing a too aggressive definition of painting as a distortion of the real and the photograph as more gentle and reflective, his detractors suggest that the results are ill conceived and disjointed in comparison to the harmony they perceive in the early works. That this is true and that Wells himself recognizes this is not in doubt. But it is also clear that he has been progressively driven toward a sense of greater release, which he does not view as being in the least self-indulgent. Another way to consider these newest works would be to suggest that it is not simply their resolution that may be disjointed but the very process of their creation; that is, that Wells may be now into an art of discovery while still maintaining the stance of an art previously conceived to solve set problems.

Wells is an artist young and vital enough not to want to repeat himself or others. I believe that the challenges he presents to us in all his pictures are sufficient to cause us to question what constitutes quality and originality in certain works and what are the parameters of contemporary painting. The issue finally comes down to whether or not we are willing to accept his invitation to consider proposals which may set us free to think for ourselves and experience the luxury of discovery.

11 Alfred Frankenstein, "A Unique Approach to Photography, and More," *San Francisco Chronicle,* November 12, 1977, p. 36.

RAY K. METZKER

THE RETROSPECTIVE EXHIBITION of Ray Metzker's photographs at the International Center of Photography in 1979 provided a rare opportunity to view the work of this innovative photographer. The exhibition, rather crowded and underilluminated in the less than satisfactory galleries of the center, was, nonetheless, an important gesture by the ICP to bring the work of this photographer to the attention of the public and especially to young photographers. Metzker has chosen to remain somewhat outside the customary gallery/publication interlace and, instead, pursues his career in photography with the elegance of quiet dedication. A consummate craftsman of the medium, his photographs should be more widely known and appreciated.

Throughout his work, Metzker has been an exponent of what he has termed "photographic form." Two decades ago, when he was already advanced in his investigations, this was the characterization of much work encouraged at the Institute

Ray K. Metzker,
Pictus Interruptus, 1977

"Ray Metzker," *Print Collector's Newsletter* 9 (Jan./Feb. 1979): 177–179.

of Design in Chicago where he was a student. Metzker's work, together with that of his colleagues there, Ken Josephson and Joseph Jachna, are major reflections of this sort of renaissance in the '50s. In a crucial publication (*Aperture,* Vol. 9, No. 2, 1961) these three photographers first showed the stunning originality of their work and the eloquence of their perception. In a lengthy statement accompanying his pictures, Metzker related how he came to find the exploration of the medium of greater importance to him than the exploration of a place, which had ostensibly been his first goal as a graduate-student photographer. While one finds intimations of his later pursuits in the work of this period, the modesty of these exercises was soon to be superseded.

Following graduate school Metzker began to investigate systematically the possibility that the medium could exist more purely for its own sake than as a conveyance of descriptive content. The goal was to move away from what he perceived as the stultifying domination of the poetic and reportorial views of the medium then current in photography circles, particularly in the educational institutions. Following the example of his mentors in Chicago, Harry Callahan and Aaron Siskind, Metzker did not abandon purest photographic concerns in his investigations nor an essentially urban orientation. The point, however, is to recognize the theoretical and progressive basis of his work; that is something William Ewing, who curated the present exhibition, attempted to deal with by placing small copy prints of earlier work near later work of a "similar" sort. The technique was not successful, because Metzker's work exceeds such a simple device and, most importantly, presumes a literate audience well enough acquainted with methodology to understand its development. The naïve simply saw repetitions of motif that, while present, are not the subjects of the pictures.

Until very recently Metzker has chosen not to abandon the representational subject, seeing it as a necessary component in his architectonic scheme. In his tightly controlled studies he has sought to re-explore the kind of photographic illusionism that was characteristic of post-pictorial work of the '20s. His approach was to stress an underdeveloped aspect of photographs – that is, to read them laterally as a patterning of forms on a flat surface, not only in a kind of recessional depth. In so doing he sought a dramatic presence for his pictures, with a graphic preponderance of stark black tonal areas and a framing configuration that could immediately be grasped as a construction internalizing forms and, in turn,

setting an emotional tone. Metzker was not afraid to define for himself what might prove to be a successful picture in his terms: one dealing with problems given in the medium and resolvable only in the making of convincing pictures. While it is generally understood in art that the work is the solution to problems the artist has posed, this approach to the making of photographs remains somewhat alien to the photographic community, which tends to remain aloof from intellectual concerns.

In the winter of 1959–60 the painter Frank Stella, who is five years younger than Metzker, lectured at the Pratt Institute. In the course of a concise and illuminating talk on his own work he said, "there are two problems in painting. One is to find out what painting is and the other is to find out how to make a painting. The first is learning something and the second is making something."[1] It is revealing that Stella should have spoken these words at the very time Metzker was trying to identify the nature of an alternative photographic option. The approaches of these two artists to their mutual problem are remarkably parallel, though I am not suggesting any personal awareness. Rather the point is that at the precise moment in painting when a younger generation represented by Stella, and of course, Jasper Johns, was seeking to free itself from a kind of bondage to an older generation, young photographers were attempting to do the same in their own medium. Both groups of artists were feeling the heavy burden of an emotionally charged abstraction that had developed out of the representational art of the '40s and early '50s. Metzker's problem was to find a way to explore the character of the medium in order to define photography and then to make a photograph conform to this definition. His fundamental interest was to isolate the unique formal aspects of the medium and to see if they could embody an expressive statement – a statement rather far removed from the psychological humanism of much of the work surrounding him. All of Metzker's work since has been a continuous step-by-step articulation of this desire. It has been a challenging of himself to make the picture be of something and simultaneously exist independently as a photograph. This sense of objecthood is the key to understanding the best work in painting since Johns and Stella, and it is the same for the photography of Metzker and others like him. In this sense Metzker may also be seen to trace his heritage back to Stieglitz, who

1 Robert Rosenblum, *Frank Stella* (Baltimore: Penguin Books, 1971), p. 57.

realized that abstraction in photography was not to be found by distorting the subject, but by establishing the independence of the photograph as an object.

The intensity with which Metzker explored this activity was challenging to all who knew of his work during the past two decades. His sense of finish and deliberateness of purpose clearly set him apart from others, and his work must be seen to predate a great many contemporary images and image-making concerns. Concerns such as those he has approached for nearly 20 years are only now coming to be dominant; and not without reason, because the work of certain structuralist artists has vitalized interest in these issues on the part of young photographers. Some pictures by these artists shock photographers with their minimalism and complex formalism, aspects separate, in part, from the artist's documentary concerns in such images. Behind these photographs is work in which the conceptual emphasis is placed on the process through which one creates or visualizes so that when this idea is transferred to self-conscious photography, descriptive analysis is placed in the service of exploring not the subject but the medium itself. The unsettled state of contemporary photography would suggest that the example of Metzker's work is not understood and that it has not been as influential as it should be.

The most resolved demonstration of Metzker's exploration into the photograph as object was his work with the very large format of constructed photographs. He became one of the first, long in advance even of large photographlike works of art, to make truly big pictures that identify themselves with the wall. Unfortunately a selection of these works was not included in the ICP exhibition. Perhaps they were not available; two, however, were included in the Museum of Modern Art's exhibition *Mirrors and Windows,* and several were in the most stunning presentation of Metzker's work in recent years, Aaron Siskind's exhibition *Spaces,* which he directed for the Rhode Island School of Design early in 1978. These large pictures are constructions of multiple photographs that deal with the photograph in every variety of interpretation – time, motion, tonal variation, serial repetition, sequence, scale, and, most importantly for all his work, the frame. Metzker has indicated the enormous effort that went into their conception and fabrication and the very meager return he received on his investment of time and funds – a frustrating reality that apparently caused him to return to the smaller single-print image. This is unfortunate, because

I believe these large works were achievements of an extraordinarily high level for all art of the '60s. If these images are unfamiliar, make an effort to see them at the Museum of Modern Art or the Philadelphia Museum of Art; the latter has recently purchased one of the finest, *PCA* (1965, 39-¼ × 35-¾ in. on 50-½ × 45-½-in. mount).

Metzker's most recent pictures are seemingly disfigured in relation to the past work, but they emerge directly from the earlier images that demanded a single-image reading. However, these new pictures represent a more expressionist phase in his work. A seeming release from the rigors of an unalterable commitment to sharp focus and a pictorial order based on pattern in form, a discrete screen of tonal illuminosity encompasses the entire surface. The pictures are uncomfortable in their monochromatic brightness and in their immateriality, yet effective in the same way some of Frederick Sommer's are. However, their scale seems to me to be unpersuasive at present, as if suggesting that Metzker has yet to exploit fully this new sensuous experience with the control that was such a dazzling part of his earlier pictorial architecture. The lesson learned from Metzker's adventure thus far is that solutions to problems are not easily settled and, for him, solutions evolve only to suggest further problems. A climactic summing-up should not be expected from this artist; rather Metzker's significance may be found in his involvement with dimensions of change hitherto inarticulated in American photography.

PAUL CAPONIGRO /
PHOTOGRAPHY 25 YEARS

Paul Caponigro, from the portfolio *Stonehenge 1967–1972*, 1978

IN THE QUARTER of a century that Paul Caponigro has been a serious photographer he has produced work of superlative quality and he has established himself as one of the contemporary masters of the medium. His earliest photographs were vitally alive with the robust flavor of his youth. Influenced by those whom he admired or with whom he studied, he frequently made photographs containing pictorial elements that were clearly reminiscent of their virtuosity. The sheer possession of nature was his aspiration. In the mid-60's Caponigro's work changed significantly as it came to reflect his more personal and mature approach to selection and visual

"Introduction," *Paul Caponigro / Photography 25 Years* (Philadelphia: The Photography Gallery, 1981). © by Peter C. Bunnell.

206

articulation. Elements of his music and his personal philosophical studies came to manifest themselves more gracefully. Now he was clearly on his own, searching out the reasons for life's existence, its starting point, and its source. Decisive was his interest in how man fit in with the landscape, or more properly, the communion of man and nature. Whereas before Caponigro focused on pure nature, he now grasped that what would be particular to him was to see nature in human terms – sacred terms. He sought out some of the places in the world where he believed this could be most richly explored. In 1966 he went to Europe, specifically to Ireland in order to study the great stone architectural creations there. He also went to England and France, to Stonehenge, Avebury and Carnac. He has photographed these stones and these sites with an unflinching eye many times since and the subjects of his photographs are not the awesome constructions themselves, but the acts of those men who built them in an effort to measure and to symbolize their relationship to nature. His photographs reflect his understanding of the intensity of their effort, and the character of certain of his images clearly echos the eloquence of the ancients and, even, how their creations rival the monumental stature of the universe.

Out of this experience in Europe it was inevitable that, in 1973, he chose to move from the New England of his birth to the Southwest. Seeking out the consecrated places of the American Indian he began to photograph again on his native soil. He continues his search to this day, having paused only briefly in the spring of 1976 to explore the opportunities for photography and reflection in the gardens and temples of Japan. His work over these twenty-five years is unified by the absolute precision of his beliefs and insofar as iconography is concerned, the pattern on the skin of an apple, or in the cluster of sunflower ovules, or on a prehistoric stone, or in the tracings of pebbles in a Japanese garden, these are documents of no specific place or thing, but of spiritual devotion.

Caponigro's articulation of photographic technique is expressionist. Working in his own way, he looks back purposefully to an older *modern* tradition – that of Stieglitzian photographic expressionism as perceived in the purity and sensuousness of black and white photographic materials. It is the tradition with which Caponigro began his work in the 50's and he has not abandoned it. He sees the photographic process in almost mystical terms: it is for him a large part of his pictorial content and it is one of the foundations on which he establishes the meaning of his pictures. Infrequently there

is a breakdown between his romantic aspirations and his re-
alized conception. For him the sparkle of tonal definition and
the tissue of chiaroscuro are like the fiery heavens, constituent
parts of a magic universe. These chemical/optical illusions
are no less real than the stone and trees and flowers from
which he also draws portents.

Paul Caponigro's complete work has to do with the
changes in man's attitude toward nature. These changes take
place very slowly; contemporaries do not notice them because
the time frame spans several generations and thus exceeds the
capacity of the collective memory. It is this concern for man's
history which is at the root of Caponigro's photography. His
concern for ancient meaning and the purity of original belief
may be a kind of learned archaism, but such deeply felt pas-
sion can enrich us with its challenge to mere progressiveness.
While photography may be seen today as the height of fash-
ion, a deeper perspective reveals its suitability for historical
analysis in the very fact that it must always focus on what is
remaining now, and at the instant of its recording it too
becomes a part of the historical past. Linking the sort of
photography Caponigro practices to astronomical time is not
whimsical. Light from a distant star having its origin very
long ago and only now detected in our time just as it descends
into our history is analogous to our guardianship of domains
like the Connecticut rock wall, or a great butte in New Mex-
ico, or Stonehenge; left to us today in their grandeur, not as
relics but as examples of God's work which can be revitalized
by the photographer. Caponigro links his pictures to this
trajectory and this spirit, and sometimes in his best work he
reveals a more powerful transcendence than that which we
sense in nature itself. The attention and affection that he gives
to his pictures is the counterpart of our most exalted mental
process: in the beauty of his pictures Caponigro seems delib-
erately intending to mirror a concept of absolute beauty.

One might ask if Caponigro's life is less moving to him
than history itself. Not necessarily, for his fifteen-year ob-
session with the great stoneworks of the ancients is testimony
to his linking the heroics of these people to the potentiality
of action by contemporary man; as if to say that the dead are
always present among the living, in certain places and at
certain times, but their presence is perceptible only to a few.
For instance, those who are the artists and the poets. There
is no question that Caponigro believes that these persons
transport us into a world which is vaster than our own, and

his complete concern for the quality of his tangible work further suggests that he believes this other world – the world that he identifies with the phrase "beauty of image" – may be more beautiful than our own.

Emmet Gowin, *Poggibonsi, Italy*, 1978

CAN A PHOTOGRAPH have the significance of art? Alfred Stieglitz asked this question just over sixty years ago and like a Zen koan, there are many ways to consider the statement. One way to extract its wisdom might be to reflect upon the photographs of Emmet Gowin, whose approach to photography is to relate significance to tradition. Rejecting the belief of the avant-garde that the past is to serve only as the dishonored foil for the new, Gowin seeks to infuse a wide variety of established artistic values and age-old techniques into his work. This proven set of practices is the starting point for his efforts and the locus of his identity as an artist. And while

"Introduction," *Emmet Gowin / Photographs, 1966–1983* (Washington: Corcoran Gallery of Art, 1983).

he appreciates many other fields of endeavor, Gowin believes that making art is perhaps the highest calling. For him, together with the love of his family, art is the center of his life. He reflects on this when he says, "I feel that whatever picture an artist makes it is in part a picture of himself – a matter of identity." Just how Gowin expresses his cultivated intellect and his philosophy, together with how he seeks to establish his individuality, may be seen in the way he has utilized the photographic medium and identified its critical issues.

Several years ago Emmet Gowin was fond of quoting D. H. Lawrence's observation that "even an artist knows that his work was never in his mind." While one can be sure that Gowin would not disavow this attitude now, he would surely add the qualification that one cannot deny knowledge nor stop growth. Gowin is unusually aware of how we learn and form ourselves as individuals. He understands that this process is both a willful act and an unconscious evolution from the simple to the complex. He has in his mind the kind of work he likes, and he knows the kind of work he wishes to produce. On a basic level all of his work is characterized by what is called straight photography. He identifies his primary and personal photographic mentors, Harry Callahan, Walker Evans and Frederick Sommer, as all working in this approach and demonstrating to him the validity of accepting the reality of camera vision. In pursuing the unique qualities of the photographic image all of these men place their trust in the belief that reality is the fountainhead from which their inspiration will flow. The work of each of them is a celebration of both clarity and fact, and within this technical bias each artist has done much to demonstrate the range of possibilities. We can see, therefore, that when one respects the standards set by such skilled figures and seeks to find his place in the contemporary world, not by any savage gesture but rather by the exquisiteness of finish and the clarity of rendering, then the purism of the photographic medium presents no handicap. In following through with this attitude, which is by now fundamental to him, Gowin has sought to find the subjects that will fire his personal imagination.

A man of religious and spiritual upbringing, with a sensitivity and respect for the quality of human life and for personal feelings, Gowin found his first important subject matter in the circle of his wife's family. Years and layers of reality were represented both in the multiple generations of people and in their living environment in Danville, Virginia. Their breadth of life and openness to the world was in contrast

to what his own family provided, and this homestead was to be the arena in which he matured as an artist. "I admired their simplicity and generosity," he has said, "and I thought of the pictures I made then as agreements. I wanted to pay attention to the body and personality that had agreed out of love, it seemed to me, to reveal itself. My paying attention was a natural duty which could honor that love."

His first substantial pictures, which date from 1965–1966, were of a quasi-snapshot appearance. They were taken, however, with large format equipment and they were pointedly posed such that the sitter and the photographer shared in the picture making experience. This is a crucial understanding for it identifies the linkage that places even his first photographic approach, characteristically, outside of much contemporary photography. The accomplishment of these pictures originates not in formal factors, but in the intensity of their intimacy and in the charged atmosphere of symbolism that is to be found in them. All of the people participating in these pictures are linked sexually to each other; they all know it, but speak little about it, and this is the hidden dimension of family life that energizes the commonest of picture taking situations. As viewers we sense that we are privileged in that what we are seeing is the human naturalness of expression even in the presence of the camera, a quality Gowin describes as "loosing the shadow that the process holds over one," and this quality places these pictures in a realm beyond the candid or the usual captured moments that we associate with so many other photographs – both amateur and artistic. Indeed the candid, or decisive moment aesthetic, as it has been called, had been Gowin's earlier camera approach during college and at the start of graduate school as he worked his way through the example of his early models, Henri Cartier-Bresson and Robert Frank. Gowin still considers the snapshot as one of the richest sources of strong images and it was during the years 1966 to 1970 that his admiration for what he called the homemade picture was the highest. "I was becoming alive to certain essential qualities in family photographs," he has explained. "Above all, I admired what the camera made. The whole person was presented to the camera. There was no interference, or so it seemed. And sometimes the frame cut through the world with a surprise. There could be no doubt that the picture belonged more to the world of things and facts than to the photographer." However, Gowin was learning to be an artist and as much as he appreciated the qualities of innocent photographs he had to extrapolate from them a

critical aesthetic and a conscious methodology for his own work. This is what he knew Harry Callahan had done out of similar inspiration. It was also the pictures by Walker Evans, together with the vividly descriptive and unabashedly personal prose of James Agee, that demonstrated for Gowin a way. These influences, together with others that had been accumulating, suggested to him that his route toward an approach to photographing would be philosophical and not merely formal. He gradually turned from the inspiration of Cartier-Bresson and Robert Frank, recognizing that he did not have the cosmopolitan view of the world as reflected in their work. "I realized," he has said, "that that was not my character at all, that I didn't have any kind of cosmopolitan understanding. I had a very local kind of understanding. I was a local person living in a local situation." He continues, "I realized that my own family – Edith's family – was as miraculous as the most distant people in the world and they were at the same time, the most available to me, and perhaps available only to me. So I turned my interest to them – my interest was already with them – but I had not realized that art could be made by simply telling the story of your own life, of your own experience. I should have understood this, but I didn't. I realized that telling my own story, using as subject matter the people I knew and loved, that this automatically involved an intimacy I could not have had in any other way."

Perhaps in no other body of his work is the sense of intimacy and growth so deeply revealed as in the pictures of his wife, Edith, whom he met the year he began to photograph. Edith gave him his invitation to her family and she has been his guide through it, but most importantly she, together with their two sons, Elijah and Isaac, have been Gowin's primary personal focus. Among his pictures of her are some of the most tender, loving and quiet images in his *oeuvre,* and also some of the most explicit and dynamic. The underlying energy in all of these pictures is warmly sexual, but the relationship between the partners is so totally natural and trusting that its depiction is singularly poetic. Viewers have naïvely wondered if these pictures are not embarrassing to her, and Edith is known to have replied that we have not even seen the pictures that are *too* personal. These two people know more than what they render in these images and they do not reveal everything they know about each other. This is meaningful because through these pictures of flesh and spirit Gowin is aspiring to elevate his feelings to the realm of public

expression, and as with those images of the entire family, his purpose is to "tell those things he feels have a chance poetically of fitting back into life. That means fitting back into the feelings of other people." It is in this way that his photographs become most symbolic, even religious. The pictures of Edith are crystallizations of enlightened human experience. The expressions range from Edith, seminude and ringed with a garland of berries and vines, as the goddess of fertility, to the earth mother herself, reveling in the ecstasy of pregnancy. These depictions originate in the most fundamental and collective pictorial tradition known to our culture, though for Gowin, they are perhaps less antique in source than an inheritance of the Renaissance.

The light in the pictures of Edith is especially beautiful. No two pictures of her are alike, not in the sense of pose or the locale, but in the light that makes itself felt as Gowin's own presence as husband and lover. He knows when the light is right and he projects through these pictures the entrancing feeling that we would not even see Edith if the light were not as it is, wrapping around her face, embracing her body and at times, radiating from her. The metamorphosis of their union is magnificently displayed in these luminous pictures. Like Blake's watercolors, some of which have inspired Gowin's pictures of Edith, they only come alive when they are palpably present – when, for instance, one has an unmediated view of the pulsations that his printing imparts to the sensitive paper.

The benevolent and simple social richness amongst Edith's family continues in Danville to this day, and the Gowins return there often from their home in Pennsylvania, but there have been important changes, too, and these have altered his work. By and large he has abandoned the family subject and even the style he used in making their pictures, and some of his admirers, probably with some criticism but without malice, express a certain loss. Gowin describes his new direction in this way: "If things happen to our advantage and we find ourselves in a situation we really love and cherish, and it nourishes us, it would be a mistake to hope that we would find that exact situation again. Everything belongs to its season, to its place. I think of the family, for instance, and that family had a different sense at that time. Then the grandmother died, then two uncles died, and the children who were the babies in the pictures were having their own babies; there is that sense of change and our job is simply to take things the way they are. We have to accept what nature

214

presents us." He continues, "as photographers our feelings
also change. And we grow in complexity. These people, my
wife's family, were in a sense farmers, weavers, cotton mill
people, workers, simple people in touch with nature. And
that was affected by where they lived and how they lived,
and the way they carried on their affairs. That is exactly what
is at the heart of my newer pictures, but the family, in a sense,
has grown to be a larger one. I have begun to visit people in
Italy, to see different parts of the world, and what fascinates
me the most is what man does in his friendship with nature.
In a word, to cooperate, to make it more productive, and to
advance his relationship with nature."

Beginning in 1973, and over the next two years, Gowin
began to turn his attention to making pictures that he char-
acterized as "working landscapes." These pictures are again
about the process of change, but now also about a theme he
increasingly sensed, both aesthetically and politically; that of
man's relation to nature and with a place. At the same time
he was sensing the disruptions in the family structure, he had
come to understand that the family also belonged to a par-
ticular space. That the family was a part of a collaboration
between man and the landscape and as the family itself re-
ceded from his subject interest he realized that the setting for
the family, the setting for personal feelings, could be a mean-
ingful subject. He then began to look at nature and consider,
"does the landscape just sit out there? Or have we built our-
selves a roadway into nature – when we look on nature, don't
we imagine how it may be improved?" He first worked
around the Danville homestead; the circular pictures of build-
ings and landscape details are a part of this investigation, and
on his first trip to Italy in 1973 he was drawn to the cultivated
fields and gardens near Siena. Over the years this quest to
understand man and nature has grown to encompass a variety
of depictions and sites. In some images, like those made in
the American Southwest at such places as the Canyon de
Chelly, he is interested in nature working alone – the process
of erosion, for instance – and in other images, particularly
the European pictures in Ireland and Italy, about man using
the land – cultivating it, living on it and making it comfort-
able. In all of this work there is the deeply spiritual allusion
to God's presence. For Gowin, pictures are gateways to imag-
ination but such travels of the spirit are not ones of pleasurable
fantasy into the picturesque; rather there is always a certain
hesitancy together with the excitement. Like all of us he is
confronted with the acts of man and nature that are in every

sense violent. To deal with this violence Gowin has come to understand that we must live imaginatively. This may be the greatest lesson he has learned from Frederick Sommer. Gowin believes so deeply in the potential of pictures that he transfers all the emotion he feels for a place or a belief into his pictures. Some of his landscape photographs have a kind of thriving energy, not physical energy, but an energy that derives from the feeling that there is no emotional escape from the pictures. His manipulation of our emotions in these images is forceful and subtle, and in the few natural land-scapes, the canyons and those of St. Helens, for instance, we can meditate on his identification of the difference between these places and those like Danville or Italy where one finds a civilized harmony between man and nature. In the pictures taken in the latter places there is a sense of the humane, of a certain imperfection or incompleteness, but always with na-ture's controlling presence – a blowing tree that becomes a blur, a sheep grazing, a coat hanging on a wall in Matera – all understood to relieve an otherwise rigorously constructed pictorial environment. In the pure landscapes Gowin edges precipitously close to a feeling and a rendering where stasis exists, where there seems to be a perfection in the abstract, formal order. These pictures, it would appear, are closer to those of Frederick Sommer's vision in the same way that Gowin's other pictures share a conception with those by Walker Evans, or even by Atget, whose photographs he also admires.

Gowin's most recent photographs, those which have been the focus of his attention for the last three years, are of the volcano, Mount St. Helens in Washington. They continue his fascination with pure landscape and importantly with the ever constant manipulations nature has wrought on the land. In them it is as if the stakes have become ever higher and his continued attraction to this difficult site suggests this. In speaking about his recent pictures Gowin has said, "man cannot afford to conceive of nature and exclude himself. It is an interesting dilemma because people at one time were very much in the habit of saying that nature is full of disorder and chaos, and they wanted to say that art in man's activity is an attempt at ordering. This is all in a sense, very very true; this is a correct perception. But nature doesn't consist purely of disorder. What do we say of Mount St. Helens? We say that it is a natural disaster, meaning that disaster is natural. I would not like to see that kind of play on words get transferred into man's convictions about what is char-

acteristic of human behavior, because if you would do this, you would say the disaster is natural and man will always forever bring himself to the brink of disaster. He will always, in fact, stumble into his own disaster. So I am for survival. And I am for the survival of beautiful images."

Out of this fantastic and inhospitable environment Gowin has produced a series of beautiful and expressive images. He has not ordered the landscape, or conquered it, as we might be tempted to say, but he has given it over to us in a willful form that can be contemplated with the respect it deserves. In so doing he filters nature's violence, this violence of incomprehensible magnitude, through his imagination. He is most enthusiastic about the aerial photographs, in part, because they demonstrate his mastery of a challenging camera technique and also, because while they accurately image the terrain below, they are stunningly allusive as well. These are not topographic photographs, but new manifestations so laden with information that they transcend the rational mind, as does the very scale of the eruption which caused such a vast geography to be formed in this way. Pleasurably, however, certain of the pictures remind us of drawings by Leonardo; those remarkably accurate bird's-eye views of river flows seen from high above. The St. Helens pictures are transformations; they take away something from the actual site on their way to being something else. The pictures provide experience, but one that is very different from actual experience. Gowin sees no need for the photograph to render expediently legible all essential information for an understanding of its content. To approach such refined and non-analytical photographs one must be prepared for and attuned to those guidelines, those entry points that he does provide. Sometimes our only pathway into one image will be a repeated element or land formation already seen in another photograph. The act of photographing may allow the photographer to acquire something he has not understood or comprehended, but the goal for the finished picture is to be revelatory and it can only do this by resisting its power to obscure, by asserting its transformation and positioning itself in our understanding. These are marvellous works, at once deeply moving and entertaining.

With regard to his prints, Gowin believes in and relies on the knowledge that the graphic arts have a rich and still meaningful lesson for us. The example of the work of Northern European artists such as Dürer, Schongauer and, especially for the conception of the landscape, Hercules Seghers pro-

vides him with the guidelines for finished pictures. From these artists and others, notably some of the Surrealists of our own century, he has also learned that pictures may have a narrative content – containing moral messages – and these are the kind of objects he seeks to create. In the small images by Dürer, for example, he admires the compression of information and substance that he believes is extraordinary. Likewise, he feels that the engraved line describes something that is like photographic description, and it is this realization of the integral relationship between the rendering of a photographic print and its content that has given rise to Gowin's obsession with the craft of photographic printmaking.

To some, Gowin's efforts in the making of a print are directed mostly toward casting himself into a kind of self-mythologist. But to him, the insistence on taking care of every minute particular is simply the recognition that making a fine print is not a casual affair. The basic distribution of subject matter is taken care of in the making of the negative, and in terms of composition, the print is generally visualized at the time of exposure. However, the effective positioning, the effective weaving together of elements, the feeling of equilibrium across the picture field, this must be conceived and executed when the print is made. It is in this endeavor that Gowin spends his most concentrated time and why, on occasion, he believes he creates just one finished print. Further, it is not true that Gowin is insensitive to chance or that he does not make mistakes. Indeed, he gives the impression that he relishes errors since he views such mistakes as the basis of the few "semi-original" things he does. He has shrewdly observed, "It's just taking care of the photographic process that makes me feel like I'm making progress. I learn most when I make the dumbest mistake. A mistake means you have to go to the darkroom with patience, with some time on hand, to work out a solution. It means things are not done the way you used to do them." In a like manner he recognizes that he too learned through apprenticeship and therefore, especially in the matter of technique, he accepts the responsibility to be enthusiastic about teaching and spend time with students.

The beginning of Gowin's understanding of the interrelationship between the print and its content dates from his first meeting with Frederick Sommer in 1967. Prior to that time Gowin had a student's conception of quality photographic prints; mostly that they were a function of negative size. It was Sommer who, during a private conversation in

218

Providence, articulated the idea that prints must be individually tailored to the content and meaning of the picture. This came as a considerable surprise to Gowin, as did Sommer's belief that there is a fundamental relationship between the picture one means to take and that which one actually takes. Gowin has refined this truism when he says, "We are not actively able to predict our work; it is seen in the work afterward. We have a certain intent but all must come out from the experience and the work." Nonetheless he expresses considerable respect for Edward Weston's notion of previsualization, noting that what most appeals to him is Weston's "force of preparedness" in the sense that when Weston articulated the idea of seeing the photograph finished, before exposure, he knew what he was talking about and he knew how to achieve it. But Gowin goes further than Weston in his visualization of the picture in that he is freer of the subject. Weston's reverence for the actuality of place or thing, that which he called the "quintessence of the object," Gowin shifts to a focus on the truth of the pictorial idea and the uniqueness of the finished print. It is through this device that Gowin, like Sommer, articulates the conception of images about images; meaning that pictures are about other pictures and that they derive from the world of pictorial art. Following this scheme, reality becomes a complex relationship involving fact and imaginative vision. Images thus become more memorable than experience. The dynamic of experience is complex and at a distance, while an image is remarkable as an imaginative instrument of this realism; it shines in miniature and it may be studied, close at hand and only inches away, where the photograph is.

Responding to Sommer's initial instruction, Gowin went on to learn from this master craftsman and others the importance of quality lenses and the complex printing methods which he uses to advance his pictures: such processes as selective and over-all bleaching, combination developing, toning, and a form of print masking called contour mapping. Some images are the result of as many as twelve operations. Gowin makes no secret of these workings; he teaches them in his classes and workshops and he has published his methods in a volume on darkroom procedure. He likes to point out that none of these practices are new, that earlier manuals were the most descriptive and detailed on the subject of toning, and that bleaching out the sky in the view of Matera, for instance, would have been common practice in the nineteenth century. Gowin's recent prints are like few others, including

those by his teacher and now colleague, Sommer. He considers certain of them monoprints, in that the chance actions of certain chemicals can never be repeated, or at least not repeated by design exactly the same way, and in accepting these visual formulations he settles on a final, unique conception for a picture.

In the end we recognize that Gowin's intent in making photographs is symbolic. For him, the photograph is not a surrogate thing; the thing photographed may not be important at all. In photographing we do not replicate the object before the camera – we produce a photograph and this is a symbolic operation. To view his work in this way, even early in his career, is something that sets him apart from many of his contemporaries and it is especially so today. Gowin has no interest in obscuring those qualities that make pure photography essentially what it is. He has been much impressed by the notion of defamiliarization as articulated by the Russian, Victor Shklovsky, such that the "challenge of photography," as Gowin sees it, "is to show the thing photographed so that our feelings are awakened and hidden aspects are revealed." But what so fascinates him are the unique qualities of the photograph, the tone that is infinitely nuanced and, particularly, the mystery in an extremely sharp and detailed image. He feels that when you see the finished print you know more than when you are actually at the site, or as he phrases it, "that you have an understanding of the place without ever having been a resident." It is this desire to provide more for his audience that drives Gowin to have such a respect for his medium and, ultimately, for his audience. Through this endeavor he wishes to extend photography into the domain of serious and traditional artistic expression. Not for some desire for the respectability of the medium itself, that is irrelevant, but in a personal sense he wishes to "mirror in the work the feeling that stimulated [him] to think that working was worthwhile." For this creative enterprise he relies on the density of implication and the intensity of feeling that he recognizes are his legacy from the tradition set out by those before him and which he accepts as his responsibility to continue.

This sophisticated understanding of creating can be illustrated through a reading of a typical photograph, *Book, The Medical History of the War of Rebellion,* of 1979. The old book that Gowin photographed is not a still life in the usual sense, that is, a depiction of something dead. Rather, it is alive within transition. In the peeling away of surfaces, so that the

old is revealed from within the new, we recognize a process we often observe in nature. In building culture, we place the newest interpretations of meaning at the top of our order. These too age and in time form the complexity of our collective wisdom. Emmet Gowin discloses this process in all his work. He seeks no end to this cycle, because he knows there is none, and instead he shares the possibilities offered by the contemporary modifications of ancient fables. This analysis concerning the logic of imagery, expressed in Gowin's own idiom, is one answer we might offer in response to Stieglitz's question. A work of art cannot reveal its wisdom until we ourselves, imaginatively, poetically, find some of its order in the idea of life. Ideas survive and whatever the art, whatever the material of art, over the longer view, only ideas can resurface with the vividness of art.

NINA ALEXANDER / PHOTOGRAPHS

Nina Alexander, *Untitled*, 1984

MAKING A POETIC photograph involves the art of transformation; that is, the ability of the artist to translate the expressive, but sometimes unpoetic material of the world into a work of pictorial art. Nowhere in photography is this recognized as such a fundamental concept than in still life. The central idiom of photography is normally spontaneity – the majesty that is sensed from capturing the moment. But this is only one strength of the medium and, as innumerable photographers have shown, there is this other opportunity for the ambitious artist bent on taking photography into the realm of poetics. Nina Alexander has focused her attention

"Introduction: The Photography of Nina Alexander," *Nina Alexander Photographs* (Billings: Yellowstone Art Center, 1987). © by Peter C. Bunnell.

on this alternative genre, and she has become involved with still life. In addition, she finds a satisfying place in what, at first view, might be seen as the domain of the macabre. Her world is of deep, private meanings that generate from within, but it is also a visionary and arresting world. Through her pictures it is a world full of interest for us.

Nina Alexander took up photography in 1964, the year following her graduation from Sarah Lawrence College. Married and with a family, she initially concentrated her attention on photographing children. This series continued for a few years, but in about 1970, having now adopted the small, hand held camera, she took up a project of making street photographs of inhabitants of the Bowery in New York. A self-portrait set followed in 1975 and 1976, and early in the latter year she collaborated on photographing a woman cancer victim. One partner photographed the woman alive in the last period of her life, and Alexander photographed her after she had died. When these pictures were exhibited in the summer of 1976 one critic described the subject in Alexander's pictures by writing, "Toni was photographed eight and forty-eight hours dead: half smiling, lying on a metal tray and a mean block of wood, she seems to know something we do not; in profile, her spirit appears to rise; prone in a pine box, her presence floods the coffin's space; shrouded in a white sheet, she is dumb as a newborn, as luminous as a new mother."[1] Already in her work Alexander was challenging herself with a difficult subject; she had embarked on a kind of adventure in picture making where curiosity and knowledge feed off one another, committing her to an endeavor of questioning and self-revelation. Also, as will be clearly evident later, Alexander had found in this subject a quality of mystery – a kind of ultimate knowingness – that seemingly can be emblematized only through such images of death. The critic of these early pictures who is quoted here sensed this strongly, and this quality will again be seen to belong to Alexander's most recent animal still lifes.

In the fall of 1977 Alexander moved from New Jersey to Montana. There she gravitated toward the large working ranches as places where she might find new subjects. She hired herself out and became involved with various operations such as calving and lambing, shearing, and branding, all jobs that put her in contact with animals. Out of this

1 Judith Goldman. "The Camera Confronts Death," *The Village Voice*, June 28, 1976, p. 120.

attention to ranch work and the pleasure she derived from it, she began a new series of photographs that indicated to her that her interest was definitely turning toward these creatures as subjects. Following an encounter with the photographer Stephen Shore in 1982, at which time he encouraged her to take up the large 8 × 10 camera, she began to concentrate her work in this format. She has said, "a new world opened up and the still life work commenced."[2]

In considering her still lifes one must bear in mind that the most convincing photographs always stem from the most intimate knowledge. When the process of art is merely the solving of formal or technical problems, and not the result of asking important questions, the art is negligible. It is clear that the search for self-awareness is the binder that links the best works by an artist and, indeed, one artist to another. In Alexander's case, she is particularly aware of how closely integral her photographs are to her own experience. For instance, her photographs of children were executed at the time of having her own family, while doing the New York street pictures she was working part time, first at the women's prison in Clinton, New Jersey, and then at the men's prison in Trenton, and later in juvenile probation. Her self-portraits were made while she was in therapy, and while working on the husbandry series she was involved with ranching. On commencing the still lifes she was working as a veterinarian's surgical assistant. She has said, "the images seem to roll out of these inner-connections and play a deeply functional role in my own psychological stability. This became increasingly true when I started doing the self-portraiture where the desire to control the artistic side was relinquished for the sake of creating images which offered clues to my own life and [my] hope of realizing things I felt were either confused or incomprehensible. It was as if I was allowing the process of image making to stabilize my existence."[3]

What Alexander is saying here is that for her, imaging is the celebration of an uncommon consciousness; of stimulating a thought process that while involving and using the senses sets up a communication with the deepest emotions, and with the spirit. This is not a unique use of photography. Minor White, for instance, was widely practiced in this approach and he wrote, "thru consciousness of one's self one grasps the means to express oneself. Understand only your-

2 Letter from Nina Alexander to Peter C. Bunnell, November 8, 1985.
3 Ibid.

224

self. The camera is a [sic] first a means of self growth."[4] What concerns us especially in this case is the very explicit and specific nature of Alexander's recent imagery. In the most elemental terms it may be characterized as revealing a fascination with the dead. To breach death's privacy, whether in man or animal, is the ultimate trespass. It is clear from the entire body of Alexander's work that she has an obsession with trying to analyze the wholeness of life. She has said, "death imagery expressed for me deep feelings I [have] had about my own dark side. The main characteristic of which I have finally and painfully learned was for a long, long time deadness. It was sustaining to me to be able to give expression to and reveal that deadness." She continues, quoting the photographer Frederick Sommer, "nobody ever goes into far country. If you find yourself going to the zoo too often, it's because you belong in a zoo in the first place; you're at home there."[5]

Alexander's meticulously crafted and luminous prints are out of a tradition with firmly established roots – in this century, from the Magic Realism of the German 1920's, to Edward Weston and later Frederick Sommer, down to the contemporary Emmet Gowin. Nina Alexander once lived in Princeton, New Jersey, where Gowin teaches, and between the fall of 1974 and 1976, and not as a student at Princeton University, she worked informally with him. She considers Gowin one of her principal mentors, the other being Lisette Model. Gowin has always been fascinated by, and even dependent on, strong juxtapositions between life and death; indeed, his photographs have always dealt in some way with the cycle of life. In the 1970's he concentrated considerable attention on the still life, with one of his primary subjects the symbolical, aged book, but it is his picture *Ice Fish, Danville, Virginia* (1971), or *Sheep Fleece, Yorkshire, England* (1972), or that of the deceased Rennie Booher (1972) that perhaps more accurately may be seen to lie behind Alexander's admiration for his work. Gowin is a champion of Frederick Sommer's photography, and his pictures of dead animals, rotting carcasses, and of the notorious amputated foot, are most frequently thought of when considering Alex-

4 Minor White, "Memorable Fancies" (MSS in The Minor White Archive, Princeton University), February 11, 1947. Alexander pursues this approach in aspects of her professional work today, conducting workshops or teaching sessions in "self-awareness through self-portraiture." Letter from Nina Alexander to Peter C. Bunnell, March 2, 1987.

5 Letter op. cit. See also Frederick Sommer. "An Extemporaneous Talk at the Art Institute of Chicago, October, 1970." *Aperture.* 16: n.p. Number 2, 1971.

ander's recent photographs. However appropriate the comparison might seem to be, it is of no real importance to Alexander. As much as she admires Sommer's work, it is not necessarily the pictures of animals that draw her to him. It is more the aspects of composition and structure, as seen in images like *Venus, Jupiter & Mars,* or *Paracelsus,* or *Medallion,* that are the focus of her feelings. The meaning for which she strives in her recent photographs is the aesthetic pleasure sensed in the interconnection of life with death; her hope being to show the ultimate or interior beauty of life and the spirit that can be gained from the knowledge of death. She does not perceive this to be the theme of Sommer's wartime still lifes. She does not believe his images are analogical like hers are and she, like many others, considers his more as anxious representations of the grievous disaster of war. She is seeking to remind us of death as part of the continuum of life, to suggest healing, to call up the astonishment associated with the confident vision of an intense and intimate experience.[6] In this perception she is closer to Gowin, an artist very much concerned with healing and with the confrontation of reality as the pathway to the imagination – an aim not unlike that of a shaman. Death is turned toward life and life is given its greater meaning by the eidetic depiction of death's image.

Alexander's work with Lisette Model is also a link not to be left unexamined. A teacher and artist of special significance to American photography in the decades after World War II, Model was a guiding inspiration for Diane Arbus among others.[7] Through her work, more so than Model in hers, Arbus insisted on a sort of independence of subject choice, and she passed this freedom on to many younger artists who succeeded her. Alexander's photographs of the cancer victim certainly owe a debt to Arbus, though there is nothing exactly similar in her *oeuvre.* And both Arbus and Alexander can be seen to have benefited from Model's most significant precept with regard to a photographic approach: that in order to reveal the matrix of truth one needs to concentrate on rendering the specific. Model practiced this understanding in her own work and she passed this lesson on to others through

6 The statements contained in this text that refer to Nina Alexander's thoughts or concerns, sometimes not directly quoted, derive from interviews with the author on September 19, 1986 and March 11, 1987. The former interview is also the source of considerable biographical data and information regarding the photographer's working methods.

7 See Peter C. Bunnell, "Lisette Model: An Aperture Monograph," *The Print Collector's Newsletter,* 11: 108–109, July–August, 1980.

her teaching. Alexander, it must be remembered, is intimately knowledgeable of photography's history and its tradition; she knows where she fits in. As such she is aware of how her pictures are rooted in their imagistic sources and whence they come, from both her own interior mythology and her options within the pictorial tradition. Alexander, remembering her photographing the dead cancer victim, has said she felt the person was a specimen. This is the ultimate expression of Model's philosophy. That is, in seeking to get at the center of understanding through photography one must not seek a kind of generalized vehicle, but rather one narrowly specific – the specimen. It was not only the specificity of the corpse itself, but that the "personality"of the individual had disappeared, and only in the physiognomy, in the features, could one reach to represent what it is that is known and believed. Alexander's animal still lifes are remarkable in this respect. Perhaps because these are animals, whose death does not cause us grief, we can gaze even more clearly into the recesses where the answers to our questions lie. We feel this most in the eyes of these creatures where Alexander, in certain of her most moving pictures, has caught only tenderness. We sense in them a look that implies they know something very special that we do not understand.

Alexander studied with Model at New York's New School for Social Research in the winter of 1975. For the following two years she studied with her privately, discussing her pictures with Model once each week or so. It was Lisette Model who taught Alexander to work from the "gut." She told her, "it's the stomach, if you do not feel it in the stomach it is not it!"[8] For Alexander, as for all others who encountered Model, it was her strong feelings that informed and remained with one. All the while she was studying with Model, Alexander was also working with Gowin, a person of equally deep feelings, and she characterizes them by saying that Model "concentrated on ideas while speaking in cryptic phrases and Gowin, on the other hand, would go on and on about all the little details."[9] It is clear that the thoughts of both teachers pervade Alexander's work and her creative method.

Alexander has recently completed her graduate studies to become a therapist and counselor, and she sees the still life pictures as again relating to her personal self in a highly spe-

8 Interview with Nina Alexander, September 19, 1986.
9 Ibid.

cific way. Turmoil in her own life brought on her search through photography in the first place, and in doing these recent photographs she senses even more the restorative power such creative work can have. She has said that in making the arranged setups she is engaged in "a process of healing" – of herself and in respect to the dead animals. She had, she said, "a lot of healing to do herself."[10] She is obsessive in seeking the kind of therapy that comes from making these very studied arrangements; finding their "inner beauty" as she calls it, and in crafting the exquisite photographs themselves. In the end she wants to make her subjects more perfect in these pictures than they could ever have been in their individual lives. As a work, the photograph thus becomes a symbol for the goal of an illuminated, more meaningful life and an unmasked expression of the maker's aspiration. In talking about these pictures, Alexander refers to the parts of herself that were dead, that she had to get back in touch with, to make alive again. In her arrangement of the subject she literally achieves this sense of touching, of correcting, and she is clearly interested in that tension between rejection and acceptance which she has posited in the pictures of dead flesh and bone. Beauty of being – even in this surreality of death – is the key and serious idea being approached here. In the peace of death, in the beauty of composure and stasis, we have her vision of her living self.

These are very carefully created images. In the process of making, her power to direct and to correct is made manifest. Alexander has stressed the difficult process of setting up, arranging, of giving quality to these creatures. There is the deep, recessive part of these pictures that is so well presented that the animals do not appear coarse or even physical, but in a state of gentle sleep.

Her working method is deliberate in the extreme, and she proceeds very slowly, making ten or twelve exposures of each setup. She processes each sheet of film after exposure to see what she has and how the image is supportable as a picture – something she cannot previsualize readily. It is all something she does in "slow motion" like dreaming. In some cases she must work more rapidly because of the changing conditions of the skins and carcasses (these she has usually kept in a state of suspended animation by freezing). She photographs directly down on the subject, or at a slight angle,

10 Ibid.

using no mirrors. Her equipment is straightforwardly simple, and her use of it is another testament to the classic large format system that has served so many before her and which fulfills her demand for the extremes of precision, of a near hallucinatory apparition.

The slow and deliberate working method is revealing of the love and motherly attention she pays to these creatures. Her feelings are all transferred, even metamorphosed, into the realm of the pictures, and while in conversation she speaks mostly of the animals themselves, she is very conscious of their picture presence. She does not see herself in the usual role of the photographer – that of a taker – rather she understands exactly what she is doing in *making* photographs. The lighting, while elegant, simple, and unobtrusive, is contrived; the light seems to emit from the subject, and it exceeds the light falling on it. This further enhances the pictorial venture, this sense of centrality, and it is a feature uncommonly seen in photographs.

Alexander recognizes the relative safety, if that is the word, that is encapsulated in a photograph that dares to enter the sensitive realm of what many think of as being morbid. This is a world that must be cautiously approached. In this sense, perhaps, Alexander's work may be drawn into a satisfactory comparison with Sommer, not only his works mentioned earlier, but all of his photography. Alexander can accept this and her understanding of the revelatory power of the photograph may go back to the work of many others too, and what may be called "supra-realism," a level of expressive intensity that can only rarely be achieved in any representational medium. It is an added feature of Alexander's works that the quality of suspended time, of permanence in a state, places these animals in opposition to the reality of their often driven existence in the food chain. There is also safety for Alexander herself here. One might say that the beguiling quality of these pictures shields her from us, she as their maker and the person responsible for them, and this may be a part of her strategy not only for self-healing, but for self-protection. To be the author of such intense statements is to cause a certain deflection away from the maker and one recalls, for instance, in this context the recent and highly confrontational works by Richard Avedon. Such a fanatic use of the literalism of photography's power to reveal can arise from anxiety and such revealment may or may not suppress doubt as well. So in Nina Alexander we sense a state of opposites:

to render microscopically the frightful in a beautiful arrangement is a pathway to insight, but it may also serve to conceal the insecurity of the maker.

Even in her sources for the hides and carcasses one observes certain contradictions or at least a duality of positions. Alexander has become well known in Montana. Hunters and others will inform her of the availability of skins or a dead animal, but she selects her subject only on the basis of "whether it can become beautiful."[11] This is a most imprecise and personal criterion. Certain people, whose experience is more with the hunter's instinct than with pictures, are frequently curious as to how the animals were killed. It is an inquiry that focuses more on what the animals were about than what they are about now. Alexander is interested in none of this; however, this is a point of vulnerability in her philosophy. Most of the hides she uses are of trapped animals and this is one of the most violent methods of killing. Trapping in Montana is done in fall and winter; it produces animals that have more perfect hides, and it is from the companies that deal in hides that she acquires many of her subjects. As those who are used to hunting and trapping talk about action and force, she only wants these creatures to achieve beauty in death in spite of the circumstances of their demise. The conflict here between killing and natural death is clear. Beauty in any state is a pictorial sense and one does ponder whether her labors can fully dispel the memory of the kill.

In the details of their composition the pictures are further revealing of Alexander's aims. Referring to a particularly well designed picture, the vertical image of the fox, she describes the pictorial space as "an environment that is safe for him."[12] It seems that in this desire to be safe we truly have the expression of Alexander's own self; it refers back to her need for healing, for exploring her dark spaces, but not leaving herself too open, and for not allowing us to get too close. It connects also to making the animal beautiful in repose. In determining the success or failure of a particular work she judges it, "from my relationship with the animal when I am with it."[13] In the case of the fox, when asked about the close cropping at the top of the frame, Alexander remarked she did not know why she did it, not to stress the pictorial manipulation of the space, but she described how in the first exposures she had a lot of empty space around the fox. She felt the fox was vulnerable

11 Ibid.
12 Ibid.
13 Ibid.

which was not her relation to it. To make him "safe" was to also assure his beauty and thus to symbolize her own safety.

Alexander is acutely aware of the art historical implications of her pictures. The lamb with the ring of zucchini leaves reminds her of aspects of ritual, of tondo reliefs by Renaissance artists. Other works have decorative, even humorous environments such as the raccoon and the fish in their starry universe. But her imagery is not mere art historical conceit. After recent visits to New York museums and galleries she wrote, "I understand that my ability to produce photographs at all is dependent on being able to feel a daily deep connection, interaction to the land and with animals."[14]

Such a comment brings to mind another woman artist, Georgia O'Keeffe, who was deeply imbued with similar feelings. There is a distinctive character in certain of Alexander's pictures, those of bones and skeletal remains, and especially the most recent images using these together with snakes, that remind one of O'Keeffe's perplexing works of the 1930's and after. Critics interpreted her paintings as meditations on fate and death, as reactions to nameless fears and even as expressions of occultism, and unconcealed sexual symbolism was always mentioned. The two women are certainly alike in their fascination with a charged subject and one that is open to multifaceted, highly personal interpretation along all the lines just mentioned. O'Keeffe's pictures never achieve the descriptive literalism of Alexander's, their mediums are different, and Alexander's recent photographs using snakes are different from even her own earlier work. These pictures are more surreal, even theatrical in that the relationship between the dead and the living is more roundabout and difficult to read. In this sense these current works seem to be reflective of Alexander's reaching out to engage a wider range of concerns, to enliven and add more tension to her imagery and to the thoughts she is addressing, but wanting to do so without ever committing to an obvious interpretation or a simple statement of meaning.

What is it that makes all of these photographs interesting to us? Is it their lack of morbidity in the aftermath of killing and decay? Alexander believes that in their photographic beauty we are separated from the physical facts and instead function in an ideal state. These pictures do not assault us, however much they invade the privacy of our beliefs. This invasion comes, I believe, from the import of the fundamental

14 Letter from Nina Alexander to Peter C. Bunnell, October 6, 1986.

meaning – mortality. This is a subject with a limited history in photography. There are ample examples, especially in journalism, of pictures of the act, process, and aftermath of killing and dying, but little by way of studied contemplation of the larger theme. To be admitted into death's privacy through photographs implies exploitation. For many this is even the case with these animal still lifes. Today we have lost much of the nineteenth century's notion of the publicness of death's image. Post-mortem photographs and other grotesqueries were once incredibly popular and widely accepted even with the sort of bittersweet that tainted their reality. In time, arranged still lifes assumed a larger place in photography, bringing the medium in step with art generally. The symbolic representation of most of these traditional works, usually made up of a clutter representing the artist's repertoire, tempers their ultimate meaning and only serves to mask the outrightness of mortal death. But in Alexander's simple and frank photographs the subjects are, so to speak, pushed right to the surface – like in a mirror – and we find ourselves a partner in the unpretentious spirituality of them. We are mesmerized, we want to look, to see, to feel affection not simply for the creature, but for ourselves as we perceive the state of the creature. Even with its history of sometimes tragic death, the animal is now in repose, is assured and even stoic. The lesson is clear. We must confront our realities, as we believe Alexander does, in confident hope. This is the challenge of her pictures that makes them so difficult. They take exception to the cannon of middle-class taste that dictates that art must aspire to beauty that pleases. Not beauty that may vex, but beauty that reassures. Alexander balances on this thin edge between hope and dispair like a woman gymnast on the balance beam. It is this quality that so clearly separates her from the anguish of Frederick Sommer, and further allies her with Emmet Gowin. Sommer is a man of sophisticated taste who sees photography as a statement of facts. Alexander, on the other hand, is a woman of unbridled faith and altruism. She believes in compassion and in the restorative powers of confronting our fears and insecurities in the spirit of release. She is saying that even the victims of cruelties can be considered by our sensory imagination. It is in this sense that pictures such as these can be restorative. They are apart from us, but they are of us. They tempt us not with bloody experience, but with a virtual experience of order and clarity from which we can regain our trust. Such is the wonder of photographic representation and, in this case, it is the key to the importance

of these images. By their very literalness they transcend fact, they exist outside of time, and they encourage us to speculate on facets of our lives that we are unable to do in real time. They elevate the experience of self to what else it may be, and in so doing exact a higher knowledge. To view photographs such as these is to enter on a kind of pilgrimage, so that while Nina Alexander probably receives more of their restorative powers in the act of creating them, an aspect which is inherent in creativity itself and which ultimately links it to prayer, we, as the audience, also reap the goodness of spiritual sustenance. These animals become idealized in her presentation, immaculate in their visual formation, and our wishes are fulfilled in their condition of tranquillity. Sorrow and regret are set aside and we are better prepared to look upon human life with greater knowledge.

INDEX

PHOTOGRAPHIC CREDITS

1. Gertrude Käsebier, *Alfred Stieglitz,* 1902. Private collection.

2. Alfred Stieglitz, *Old and New New York,* 1910. Private collection. Reproduced from *Camera Work,* Number thirty-six, 1911.

3. Clarence H. White, *Morning,* 1905. Private collection. Reproduced from *Camera Work,* Number twenty-three, 1908.

4. Frederick Sommer, *Valise d'Adam,* 1949. Private collection. Courtesy Pace/MacGill Gallery, New York.

5. Lee Friedlander, *Filling Station – Rearview Mirror – Hillcrest, New York,* 1970. The Art Museum, Princeton University. Gift of J. Michael Parish, Class of 1965. Courtesy of the artist.

6. Duane Michals, from the sequence *The Fallen Angel,* 1968. Courtesy of the artist.

7. Walker Evans, *License-Photo Studio, New York,* 1934. Private collection.

8. Robert Frank, *Fourth of July, Jay, New York,* 1955. Courtesy Pace/MacGill Gallery, New York.

9. Diane Arbus, *Gerard Malanga, New York,* 1966. Courtesy the Estate of Diane Arbus. Copyright © 1984 by the Estate of Diane Arbus.

10. Lisette Model, *Woman at Coney Island,* 1940. The Art Museum, Princeton University, Museum purchase, anonymous gift.

11. Minor White, *Thomas Murphy,* from the sequence *The Temptation of St. Anthony Is Mirrors,* 1948. The Minor White Archive, The Art Museum, Princeton University. Copyright © 1989 by the Trustees of Princeton University.

12. Brassaï, *Prison Wall of La Santé, Paris,* 1932. Private collection.

13. Wright Morris, *Straightback Chair, Home Place,* 1947. Courtesy of the artist.

14. Elliott Erwitt, *Las Vegas,* 1957. Courtesy of the artist. Copyright © by Elliott Erwitt.

15. Edward Weston, *Dunes, Oceano,* 1936. The Art Museum, Princeton University. Gift of David Hunter McAlpin, Class of 1920. Copyright © 1981 by the Arizona Board of Regents, Center for Creative Photography.

16. Barbara Morgan, *Martha Graham, "Extasis" (Torso)*, 1935. The Art Museum, Princeton University. Gift of Douglas and Liliane Morgan. Courtesy of the artist.

17. Aaron Siskind, *Chicago,* 1949. Private collection. Courtesy the Aaron Siskind Foundation.

18. Harry Callahan, *Eleanor, Port Huron,* 1954. The Art Museum, Princeton University. Gift of Mrs. Saul Reinfeld. Courtesy Pace/MacGill Gallery, New York.

19. Naomi Savage, *Enmeshed Man,* 1966. Private collection. Courtesy of the artist.

20. Eugène Atget, *Saint-Cloud,* ca. 1921–22. Private collection.

21. Installation view, "Photography Into Sculpture" exhibition, 1970. The Museum of Modern Art, New York. Photograph by James Mathews. Courtesy the Museum of Modern Art, New York.

22. Jerry N. Uelsmann, *Rock Tree,* 1969. The Art Museum, Princeton University. National Endowment for the Arts and an anonymous matching gift. Courtesy of the artist.

23. Jerry N. Uelsmann, *Untitled,* 1972. Courtesy of the artist.

24. John Pfahl, *Blue Right-Angle, Buffalo, New York,* 1975 (Original in color). Courtesy of the artist.

25. Lynton Wells, *AYYYY, 74,* 1974. Private collection.

26. Ray K. Metzker, *Pictus Interruptus,* 1977. The Art Museum, Princeton University. Museum purchase, gift of Mr. and Mrs. Max Adler. Courtesy Laurence Miller Gallery, New York.

27. Paul Caponigro, from the portfolio *Stonehenge 1967–1972,* 1978. The Art Museum, Princeton University. Gift of David Hunter McAlpin, Class of 1920. Courtesy of the artist. Copyright © 1978 by Paul Caponigro.

28. Emmet Gowin, *Poggibonsi, Italy,* 1978. Courtesy of the artist.

29. Nina Alexander, *Untitled,* 1984. Courtesy of the artist.